PREHISTORIC ART

Editorial Directors
Soline Massot and Anne Zweibaum
Layout
Sandrine Roux
Iconography
Hélène Orizet
Translation
John Tittensor
Copy editor
Catherine Roussey
Lithography
L'Exprimeur, Paris

© **FINEST S.A./ÉDITIONS**
PIERRE TERRAIL, PARIS 2002

Publication Number: 293
ISBN: 2-87939-233-0
Printed in Italy
September 2002

© FINEST SA /
ÉDITIONS PIERRE TERRAIL, PARIS 2002
25, rue Ginoux, 75015 Paris - FRANCE

Cover
Two giant giraffe
They have been pecked into the
smooth, horizontal rock of
Debous in the western Air, Niger.
Perhaps 7,000 – 5,000 B. P.

Acknowledgements:

The author wishes to thank for their assistance and advice: Zoia
Abramova, Jean Airvaux, Emanuel Anati, Jean-Marie Appelaniz,
Dominique Baffier, Paul G. Bahn, Robert Bégouën, Gerhart Bosinski,
Jean-Jacques Cleyet-Merle, Jean Clottes, Henri Delporte,
Geneviève Pinçon, Renaud Ego, Valérie Féruglio, Carole Fritz,
Marc Groenen, Henri J. Hugot, Ludmila Iakovleva, Jean-Michel Geneste,
Yanik Le Guillou, Michel Lorblanchet, Arlette Leroi-Gourhan, Michel Menu,
François Sacco, Georges Sauvet, Yvette Taborin, Ian Tattersall,
Gilles Tosello, Ms Jean Vertut, Daniel Vigears, Denis Vialou,
Agueda Vilhena-Vialou, Philippe Walter, Randy White.

I should also like to thank for their editing and publishing skills:
Catherine Aygalinc, Annie Fortune, Pascale Martinat, Soline Massot,
Hélène Orizet and Sandrine Roux.

JEAN-PIERRE MOHEN

PREHISTORIC ART

The Mythical Birth of Humanity

TERRAIL

CONTENTS

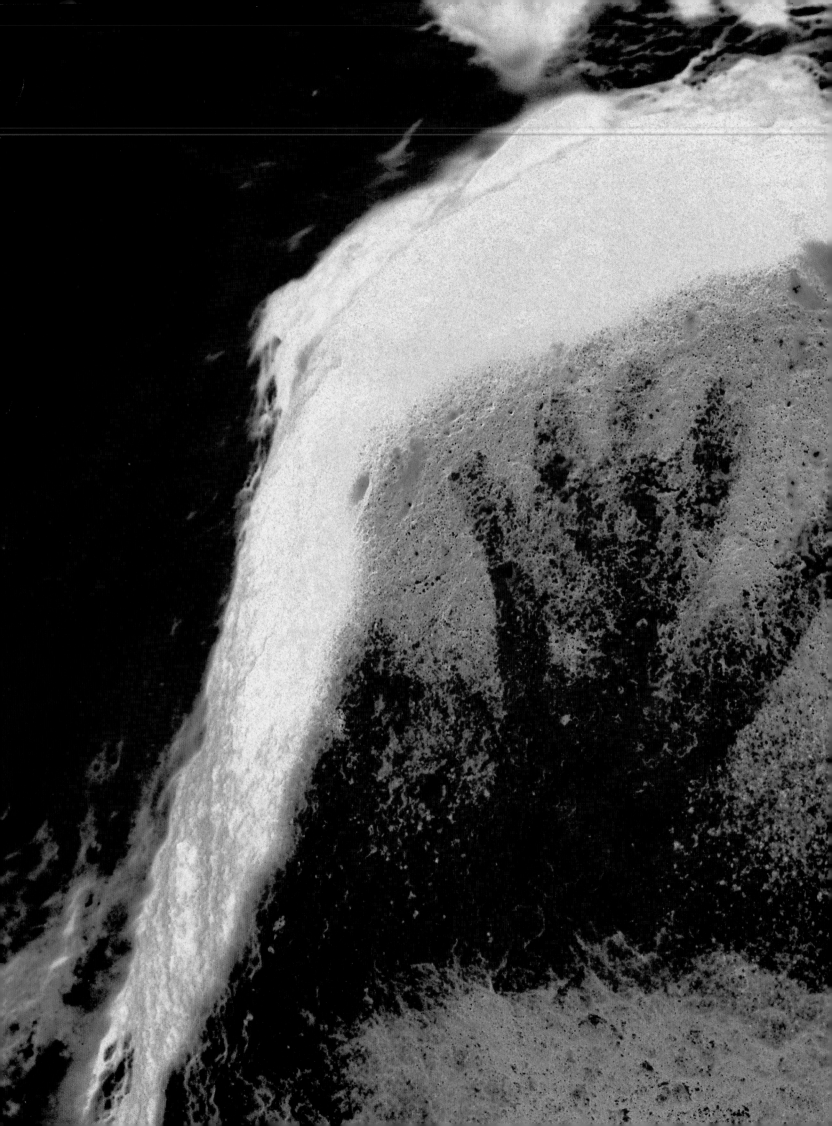

"Like a man delving into darkness"

1

Precedent page
● Hand of an initiate
Real left hand, negative stencil
spattered with black, incomplete
fingers and complete thumb.
In a niche in the center of the
"Sanctuary of the Hands" in
the Gargas Cave at Aventignan
in the French Pyrenees.
c. 27,000 B. P. (before the
present day)

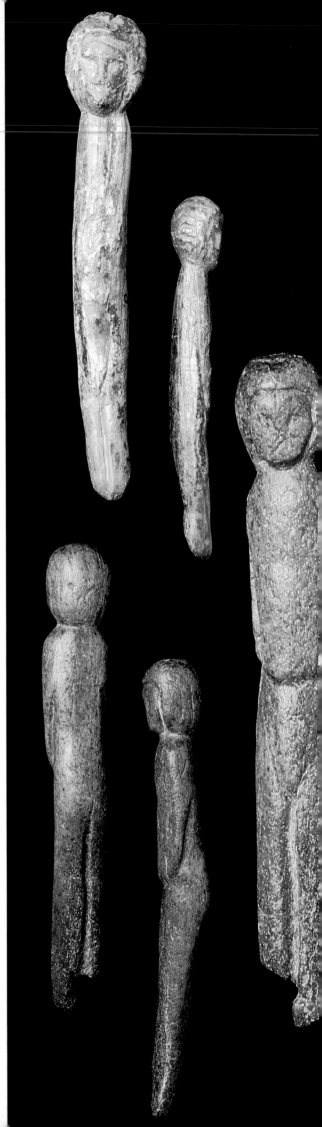

These words were uttered by the eighteenth century French ceramist and glass-maker Bernard Palissy, holding in his hand a glazed pottery cup from Italy and utterly spellbound as he strove to penetrate the mysteries of its making. Yet today we might just as easily respond in the same way to two other situations. The first is that of those speleologists and archeologists who for a century have been tirelessly delving into the darkness of prehistoric caves, emerging with news of works of art so astonishing that for decades their accounts were not believed. Advancing like Bernard Palissy, they feel their way through lightless, uncharted galleries, their lamps unveiling stunning new landscapes and the awe-inspiring evidence that others were there thousands of years before them: painting or carving the rock face with images so potent that these explorers, these involuntary witnesses to the distant past can only contemplate them in wonderment.

No ordinary experience, this; yet as regular press reports testify, one that repeats itself year after year, in Spain, France, Italy and, less frequently, other parts of the world like most recently in Borneo. Delving into dark-ness with only one's hands as a guide into the unearthly immensity of a world made by fellow-humans who must remain forever unknown: truly, no ordinary experience.

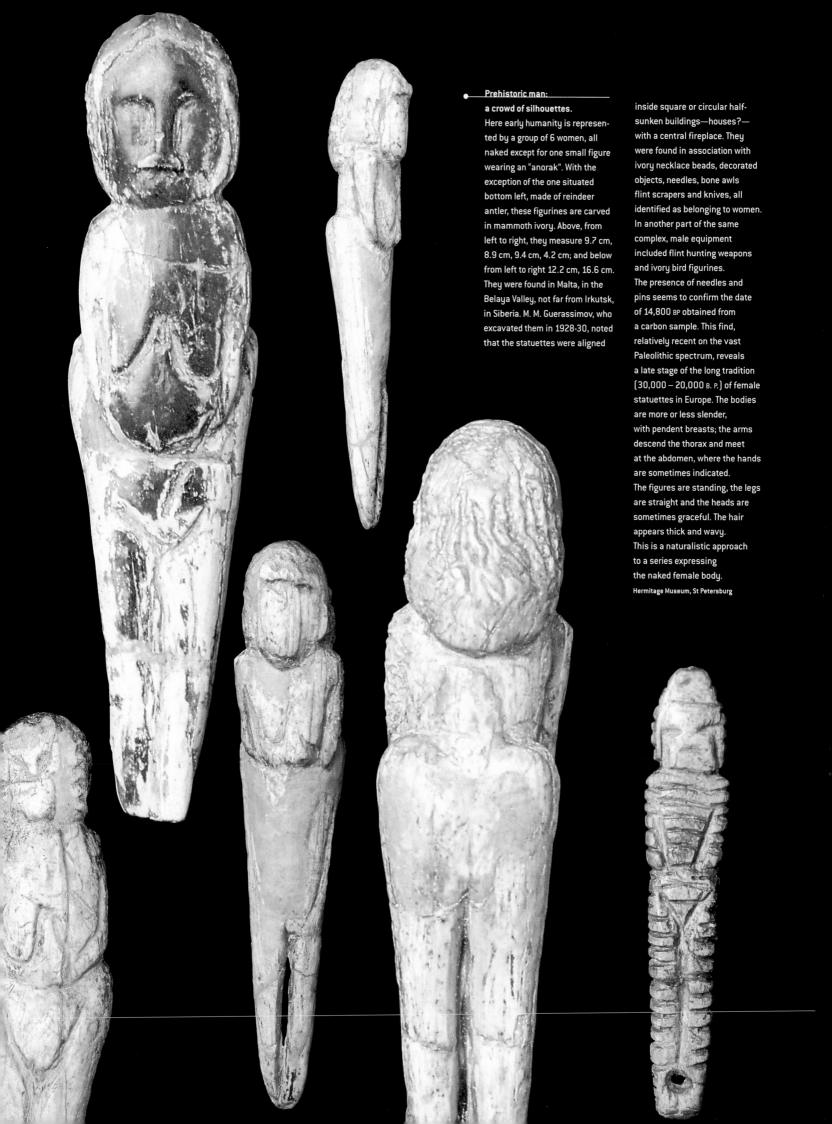

Prehistoric man:
a crowd of silhouettes.
Here early humanity is represented by a group of 6 women, all naked except for one small figure wearing an "anorak". With the exception of the one situated bottom left, made of reindeer antler, these figurines are carved in mammoth ivory. Above, from left to right, they measure 9.7 cm, 8.9 cm, 9.4 cm, 4.2 cm; and below from left to right 12.2 cm, 16.6 cm. They were found in Malta, in the Belaya Valley, not far from Irkutsk, in Siberia. M. M. Guerassimov, who excavated them in 1928-30, noted that the statuettes were aligned inside square or circular half-sunken buildings—houses?—with a central fireplace. They were found in association with ivory necklace beads, decorated objects, needles, bone awls flint scrapers and knives, all identified as belonging to women. In another part of the same complex, male equipment included flint hunting weapons and ivory bird figurines. The presence of needles and pins seems to confirm the date of 14,800 BP obtained from a carbon sample. This find, relatively recent on the vast Paleolithic spectrum, reveals a late stage of the long tradition (30,000 – 20,000 B. P.) of female statuettes in Europe. The bodies are more or less slender, with pendent breasts; the arms descend the thorax and meet at the abdomen, where the hands are sometimes indicated. The figures are standing, the legs are straight and the heads are sometimes graceful. The hair appears thick and wavy. This is a naturalistic approach to a series expressing the naked female body.

Hermitage Museum, St Petersburg

The second situation is no less unsettling, as we ourselves imagine a prehistoric figure venturing into the midnight depths of a cavern with only a feeble, flickering torch or animal-fat lamp to light the way. He too was "delving into darkness" as he sought to descry and record the images seething in his mind. What was the meaning of this extraordinary, self-imposed ritual? Bernard Palissy felt a duty to comprehend and duplicate the marvel of glazed clay, and thus magnify the god who had created humanity out of this very same material. Did prehistoric man, too, have to prove something to himself? Was he in search of some vital point of convergence in the mirror of the rock face?

Thousands of years later the visitor inspecting these images is conscious of an odd sensation; for while his eye reacts at once to the artistic quality and formal skill of the drawings and sculptures, he is aware that the most basic methods have sufficed to bring such vividly expressive life to these beings and their fathomless, endlessly perilous settings. What words, what elaborate turns of phrase can do justice to even a tiny part of these prehistoric worlds? The many illustrations in this book are a necessary complement to the text and fill certain gaps; yet their contribution is limited by their two-dimensional representation of three-dimensional volume, by their inertness once removed from their original context and that permanent interplay of light and shade so characteristic of life itself. To do the fullest possible justice to prehistoric art, we must then approach it with a true openness of spirit.

Accidents of nature and the painter's mark

The bison's head in the El Castillo Cave at Puente Viesgo (Cantabria - Spain) is a natural animal mask drawn out of the darkness by the prehistoric imagination: the artist recognized the curve of the forehead bounded by the cup marks suggesting the horn, to the right, together with the muzzle and the beard in the fissured rock. To clarify what he saw in the stone, he added a short line of black paint for the nostril and an eye of the same color, characterized by the inner tear-duct angle. An incised line separates the cheek from the beard. A closer look shows a cup mark in the lined rock, in front of the nostril: a suggestion of the breath of an animal 13,060 years old.

Wise Images

2

The ceiling that was the first
prehistoric art discovery was
seen for the first time in 1879
by the daughter of Marcelino Sanz
de Sautuola, accompanying her
father on his dig in the Altamira
Cave, not far from Santillana
del Mar in Santander province,
in northern Spain. A controversy
then broke out between two
camps: one refused to accept the
great age of the paintings, the
other was inclined to accept it.
Official recognition came in 1906
with the findings of Emile
Cartailhac and Abbé Breuil. The
ceiling shows standing or lying
bison painted in ocher and black
on a rough area of rock;
a doe and a wild boar are
also present.
Between 16,480 – 13,130 B. P.

T he arts of prehistory made their appearance 100,000 years ago, although certain isolated or instinctively produced indications such as esthetic considerations in the choice of stones, a tendency to shape symmetrical tools, go back much further. In the course of the last thirty years archeologists working in the cave at Qafzeh, in Israel, have discovered the earliest known burial sites showing human bodies laid out according to a plan (a woman with a baby at her feet) and in association with ocher, jewelry (pierced shells, one of them painted with ocher) and offerings (a slaughtered deer). This combination of esthetic gestures denotes a practice we describe as "artistic".

The arts of prehistory have their root in an emotional reaction to the conscious realization of being. Study of these ancient remains indicates that the first persons to be interred in this way were representatives either of *Homo neandertalensis*, a species close to our own which died out some 30,000 years ago, or of *Homo sapiens sapiens*, among the oldest of our direct ancestors. Both these groups possessed an artistic capacity characterized by true inventiveness in psychological, social and esthetic terms.

Surprising as it may seem, the findings in the decorated Franco-Cantabrian caves—the first to have been identified, barely a century ago—are now seen as jewels in the artistic crown of early man, jewels scattered over the five continents. These paintings (or pictographs) and petroglyphs—images incised into the rock—had been there for thousands of years, but no one had been bold enough to think that people having lived so long ago might have felt the urge to express themselves "artistically"; and no one, in the caves where a few pioneers were starting to search for flints left behind by "cavemen", thought to pay any attention to the shapes carved or painted on the walls. No archeologist was ready to take seriously, or even consider, the notion of prehistoric art, since it ran counter to prevailing ideas of prehistoric man as a creature not far removed from apes.

We owe the decisive discovery to a child, the young daughter of the Marquis Don Marcelino de Sautuola, who had begun excavating the Altamira Cave at Santillana, near Santander in northern Spain. The entry to the cave had been spotted by a hunter the previous year. Once inside, Don Marcelino realized that the floor was simply the top of a thick layer of ashy soil mixed with shellfish remains and architectural vestiges, so he dug down in search of tools and other objects that would allow the site to be dated. He was expecting, in fact, to find the kind of pieces he had so much admired at the 1878 Universal Exposition in Paris, a startlingly curious collection from southwestern France. A series of excavations was undertaken. On one occasion De Sautuola had

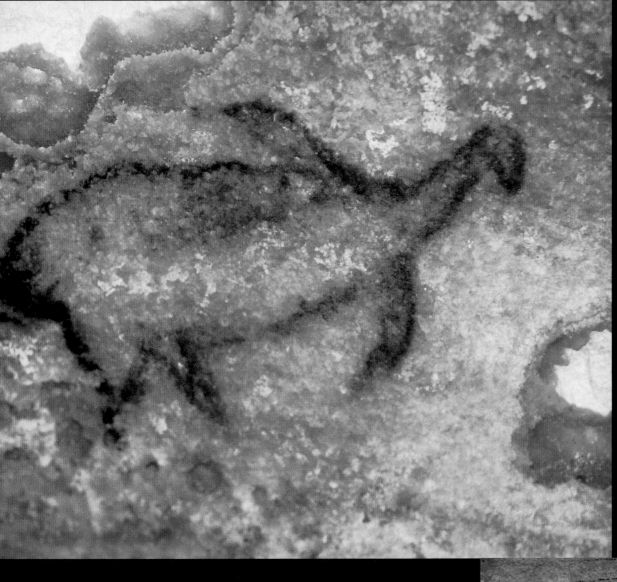

New life for a baby mammoth in the cave at Arcy-sur-Cure, France (below). This red painting in the Salle des Vagues had been hidden for centuries beneath a layer of calcite, and was only discovered in 1997, when the concretion was thinned back with a special diamond-tipped tool. The animal is 45 cm wide and was painted in 28,000 – 27,000 B. P.

An incredible find

The discovery of a prehistoric cave is always a spectacular event— but one that must be subjected to a critical evaluation. The paintings and engravings in the Cosquer Cave at Cassis, near Marseille in France, were found in 1991 when an entry was discovered 37 m beneath the sea. (*see* sketch below) The very cold climate of prehistoric times meant water was retained by glaciers and the polar ice cap, the result being that sea level was 100 m lower than today. One inexplicable feature here was the presence of rare animals, such as the three penguins side by side: their first appearance in prehistoric painting. However the thin layer of calcite covering them was proof of their authenticity, which was later confirmed by carbon dating of the paint used to 18,530 ± 180 B. P.

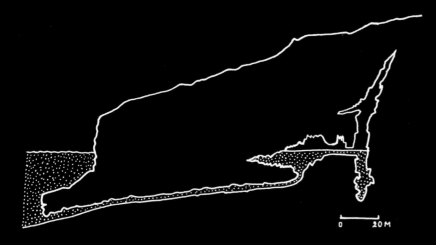

0 20 M

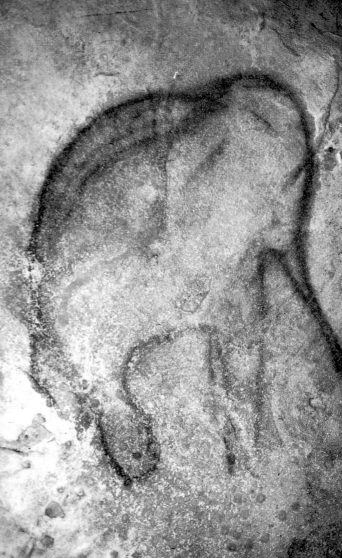

Skilled painting

Detailed study of the parietal paint, tools and other material left behind by the artists—in the archeological layers at the foot of their walls or in neighboring caves—allows a very clear idea of what prehistoric artists wanted in geological, chemical and esthetic terms. In the La Vache Cave at Alliat (Ariège, France), situated 150 m from the decorated Niaux Cave, investigators found quartz pebbles used to grind the red and black pigment. The pigments themselves were ochers—mostly hematite—of different shades which were heated to obtain goethite, a source of a whole range of yellows and reds. The black came from charcoal or small blocks of manganese oxide. Once ready, the pigments were made more solid by the addition of filler —clay or biotite—and fluidized with water or animal fat. In the La Vache cave, the specific "recipe B" for paint uses feldspar filler; the same recipe has been detected in the Salon Noir of the Niaux Cave, where some of the bison were first drawn with charcoal. They date from 13,850 ± 150 B. P.

Musée des Antiquités nationales, Saint-Germain-en-Laye, France

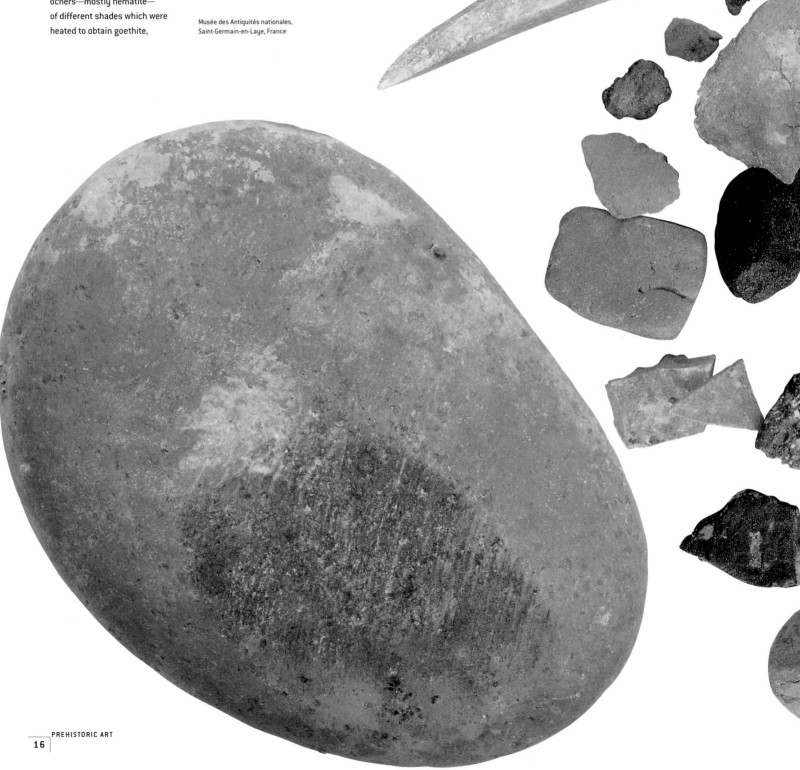

brought his young daughter with him; able to move about more easily than the adults under a ceiling that was sometimes very low, and examining everything with all the liveliness of her age and a naturally sharp, curious mind, she suddenly cried out, being the first to see the picture of an animal on the ceiling. Looking up they saw a painting, and then others, in red and black and in most cases portraying animals, mainly bison; images of whole animals or headless bodies, some in the most unlikely poses while others were more or less faded. There was also a hind in its entirety and a horse's head; perhaps twenty in all without counting some outlines, their sizes ranging from 125 cm to 150 cm and a few up to 220 cm.

Thus did Emile Cartailhac and Abbé Henri Breuil recount the discovery of the prehistoric paintings of Altamira, in a magnificent book published in 1906 under the enlightened auspices of the Prince of Monaco. The appearance of their study was to settle the heated debate that had been going on since 1880, when Don Marcelino himself had publicly announced the finds made at Altamira. The primary aim of subsequent comparisons of the paintings, petroglyphs and prehistoric statuettes with those of subcontemporaneous hunting societies was to prove that this was not just the work of people with nothing better to do, nor the expression of a simple esthetic urge: the unacceptable notion of art for art's sake was thus excluded.

Taking Sir James Frazer's 1890 analysis of magical thought in *The Golden Bough* (1890) as its point of departure, Salomon Reinach's 1903 study interpreted Paleolithic art as sympathetic magic in its two basic forms: hunting magic and fertility magic. Reinach saw totemic concerns as strictly secondary: prehistoric art had a precise function, which was to ensure a constant supply of game (fertility magic) and help bring about the death of the prey (hunting magic). The hunting magic interpretation as proposed by Reinach became the target of fierce criticism. Abbé Breuil, however, gave it an original twist with his notion of a "sorcerer", a "priest" wearing an animal-head mask and casting spells: the evidence was the marks of blows on the animals in the Montespan Cave in France and representations of traps and hunting weapons identified among the painted and sculpted material. This magicoreligious view of prehistoric art was accepted by many archeologists and still enjoys considerable standing with the general public.

In 1967 A. Lommel took things further with his suggestion that the sorcerer be replaced by the shaman. A frequent practice among hunting peoples, shamanism has to do with the idea of curing certain illnesses through trance and magic; this notion was taken up again in 1996 by J. Clottes and J. D. Lewis-Williams, for whom the shaman/priest-magician in a state of trance has the ability to traverse the three levels of the world beyond and enter the domain of the spirits, where he intercedes on behalf of living creatures on earth, who may be animal or human.

The most pertinent criticism of these magico-totemic interpretations is that they tend to see each action and each representation in an excessively narrative way: this reduces prehistoric art to a juxtaposition of images accumulated as one ceremony succeeds another. It would seem that above and beyond these practices there exists another dimension revealed by the undeniable unity of certain decorated caves, such as that of Lascaux, discovered in 1940. A. Laming-Emperaire (1962) and André Leroi-Gourhan (1965) rejected all ethnographic comparisons, gave up all attempts to find meaning in Paleolithic cave art and devoted themselves to a linguistics-based analysis of

its structural organization. For Leroi-Gourhan the basic iconographic unit of decorated caves reflects a cosmogonic conception of the universe founded on a male-female dualism. D. Vialou, while acknowledging the value of Leroi-Gourhan's work, stops short of his most daring blanket interpretations, putting more emphasis on the expressive variety to be found and the host of coded messages this implies. Over and above the major themes common to all of them, each cave asserts its own cultural identity via the arrangement of the figures, their sizes and proportions. Working on different surfaces allows for an infinitely subtle range of expression and this, in Vialou's opinion, points up the basic aim of Paleolithic artists. What is probably a foundation myth is restated by the image in line with a social and psychological identity specific to the group. Formalized and readily recognizable, these underlying subtleties are the source of parietal art's wise images.

In a collection of essays by psychoanalysts and prehistorians (Sacco and Sauvet, 1998) edited by Vialou, he demonstrates that the expression in prehistoric art of an unambiguously adult sexuality confirms the great maturity of these Magdalenian peoples, who possessed the imaginative capacity needed to achieve the socialization of sexuality. The study of funerary rites (Mohen, 1998) leads to the same conclusions: the funerary practices of prehistoric people (*Homo sapiens sapiens*) develop only in contexts of adult reasoning within complex societies. The image created by the community to express collective symbols interacts with the multiple facets of human behavior.

These interpretative approaches have been brought back into the foreground by recent astonishing discoveries. One of the most extraordinary finds of the last few years, the Cosquer Cave at Cassis in southern France, was still met with skepticism in the early 1990s and the early date assigned to the Chauvet Cave in France shortly after its discovery has been challenged. Foz Côa in Portugal is doubtless the Paleolithic site that has stirred up most controversy in the scientific community in the last ten years. At the same time attention is being focused on marvelous rock art sites—regularly comprising thousands of imagesin often uninhabited parts of the Sahara, Libya, the Negev, Siberia, Mongolia, Australia and the Americas, and these are beginning to be the subjects of serious study. Interest in Australian, American and African subcontemporaneous ethnographic sites—especially Aboriginal, Dogon and Bushman—has brought to light enormous sanctuaries all over the world. D. Vialou (1991), E. Anati (1995), P. Bahn (1998) and M. Lorblanchet (1999) have embarked on summaries of what is a universal form of artistic expression, one that draws on modes of thought that are the oldest we are capable of grasping and also, doubtless, the most far removed from our own conceptual habits.

The existence of intuitive understanding of unknown ways of thinking would seem to be confirmed by the following anecdote: a group of Ngarinyin Aboriginal people left their tribal territory in Australia for the first time in June 1997 for a trip to Europe. Surprised but relatively unaffected by the radical change of setting, they nonetheless began to weep when taken into the Lascaux Cave in southwestern France; for while not recognizing exactly what they saw there, they believed that their sacred painted sites had crossed the world to meet them. Thus without necessarily seizing the symbolic significance of the paintings, they had discovered a context and a cosmogonic approach very close to their own. In such a case the actual meaning of the

signs was secondary to the primeval setting, wellspring of a vital force corresponding to the symbiosis between humankind and nature described in the law governing the order of things the Ngarinyin call *wuman*. This mythical concept has it that humanity was born of water; and so the specific relationship with water enjoyed by a sacred lake, water-based painting, mother-of-pearl necklace, storm, ritual scarification portraying aquatic animals, or a particular damp cave, means they will all play their part in human destiny.

The anecdote related above immediately raises the question of the difference between the Aboriginal view of parietal art such as non-portable rock carvings and paintings and the non-Aboriginal conception of its underlying sequences. A valuable study by G. Chaloupka in 1993 tells us that the rock art of Arnhem Land, in Australia, springs from ceremonies, cosmologies and myths. The Aboriginal people of the area speak of the feeling of *gun*, of an intimate relationship between people, the landscape and the Dreamtime. They divide their rock art, which they call *bim*, into the five following categories (Chaloupka, 1993 [1997], p. 87):

1 *Mimi bim*: This is the art bequeathed by Mimi, ancestor of the "First People" and now so old that he no longer has any relationship with the society of today. Aboriginal people did not invent *Mimi bim*, but acquired it by adopting or copying original paintings that have now disappeared. *Mimi bim* associates human beings and spirits, together with animals found in the styles of the pre-estuarine period.

2 *Bim gurrmerrinj*: the term means "that which changes itself into painting". Ancestors, evil spirits and dangerous creatures inhabit the landscape and the paintings; they are not mere representations but actual living things. The representations themselves are of three kinds:

• images of the ancestors, including those portraying the rainbow serpent on rocks that women, children and non-initiated men may look at, but whose deepest meaning is not revealed;
• representations of ritual significance and sacred drawings only initiates may see;
• paintings of dangerous creatures such as the serpent *djurrang* or *taipan* (*Oxyuranus scutellatus*) and other harmful species threatening to become too numerous. These are only accessible to the elders, who ensure that the paintings do not deteriorate and so, by their presence, are keeping these species in check.

3 *Bim banemeng*: age-old paintings executed according to stylistic conventions established in more recent times. A species of animal, for example, may represent a totemic ancestor who is the guarantor of paternity or plentiful food. Paintings of sorcerers (*bim bawabon*) are also placed in inhabited or much-visited rocky shelters.

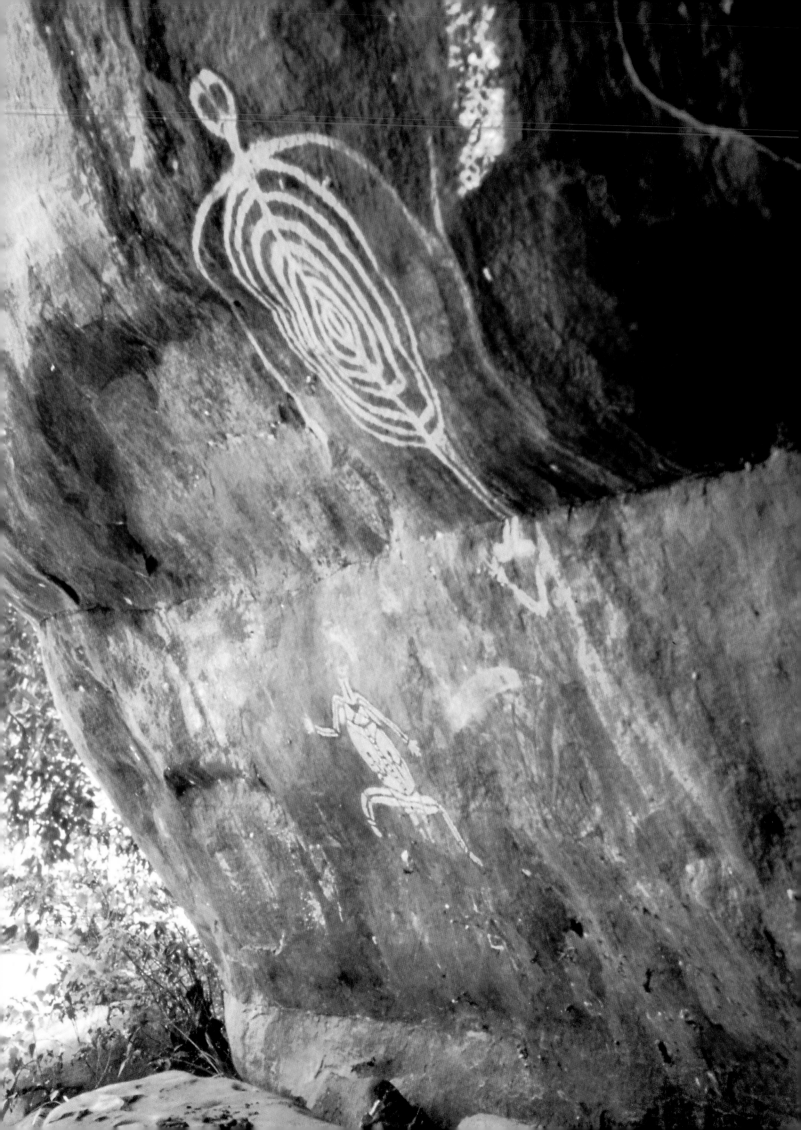

4 *Bim bawarde garruy* or art created inside a rock shelter. This category excludes representations of human or animal footprints, considered as signaling lines (*gunbok*) left by Nagorrgho or Namarrgon.

5 accidental paintings, crudely executed, most often in white.

The Aboriginal vision of rock art reveals the intimate functional variety of these vestiges and clearly points up the limitations of outside interpretation. At the same time there also exists the possibility of other, non-Aboriginal origins of sequence in parietal art.

The abundance of paintings and petroglyphs identified on the 2,000 sites of the Arnhem plateau and the multiple stylistic criteria applied by Aboriginal people do not provide an ongoing comprehension of the phenomenon. The notion of Mimi, for example, is in the final analysis a synonym for "everything not usual at the present time" or, more exactly, everything "not familiar" in the field of weapons, utensils, animals and mythic and cosmic figures. Thus the Mimi rock art category is only interesting as a means of overall interpretation when an appropriate methodology is brought to bear. Attempts at establishing such a methodology initially set out to define subjects and styles: working by comparison they looked for superimpositions and relative chronologies, while noting the absence and presence of specific features in various styles.

However, the approach had to broaden its scope to cope with questions regarding extinct species of animals, the sudden abundance of fish, color composition and other matters. Studies carried out in the fields of climatology, geomorphology, geology, zoology, botany, archeology, history and physicochemical dating (carbon 14, thermoluminescence, dendrochronology) make their separate contributions to the building of an impressive, but still incomplete sequence of periods including successive or overlapping styles.

It is only when prehistoric art has been looked at in the light of this enormous methodological exercise—unimaginable a century ago—that the issue of interpretation can be taken up. The wealth of experience Australian Aboriginal people have acquired through their age old oral and artistic traditions clearly shows that these rock engravings, paintings and sculptures are responses to social and symbolic tensions, highly meaningful visual inventions that play a part in integrating individuals into the community.

The mythical couple
This couple is painted on a rock face at Cannon Hill in Arnhem Land, northern Australia. The man on the right has a ghostly look and a highly stylized anatomy comprising a target and an arrow—suggestive of a phallus —in its lower part. Known as the "Old Lady", the woman on the left is 75 cm high and is shown in the traditional birthing position, with legs spread. The transparency of her body, obtained by the X-ray technique, reveals a female descendant to the left and a male one to the right. This is a recent painting illustrating an Aboriginal tradition.

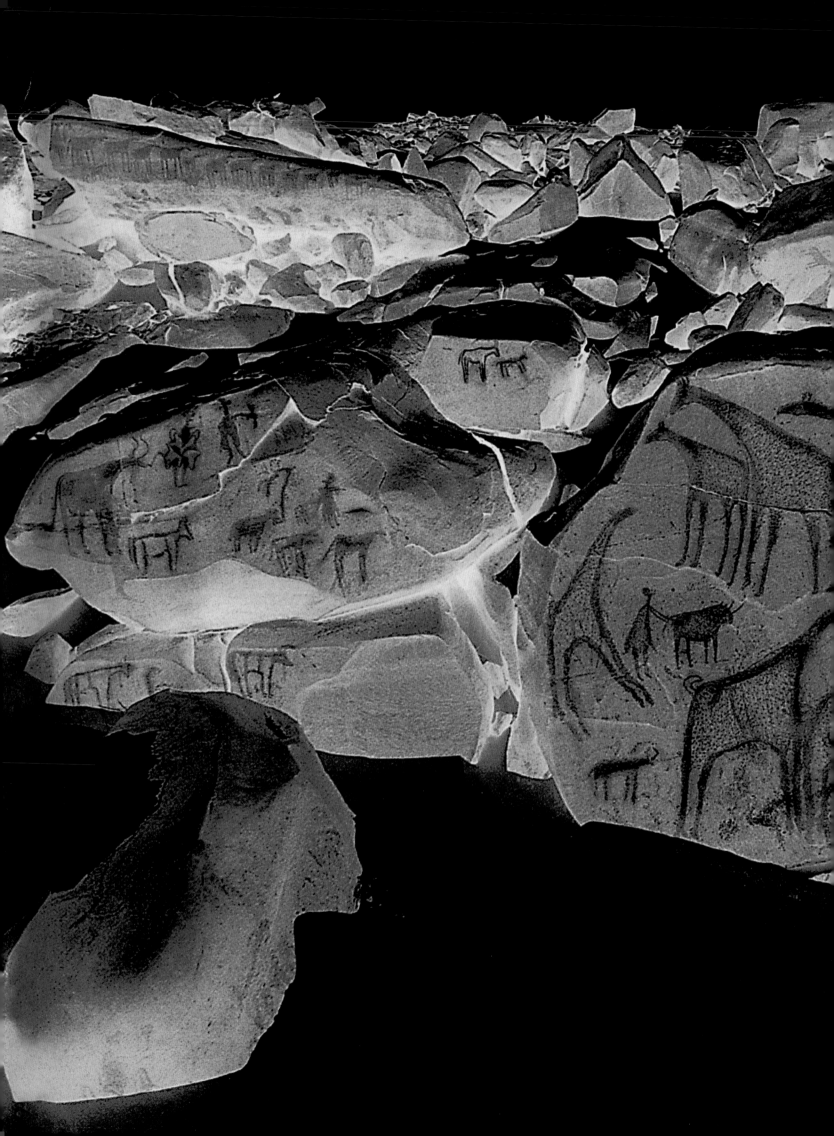

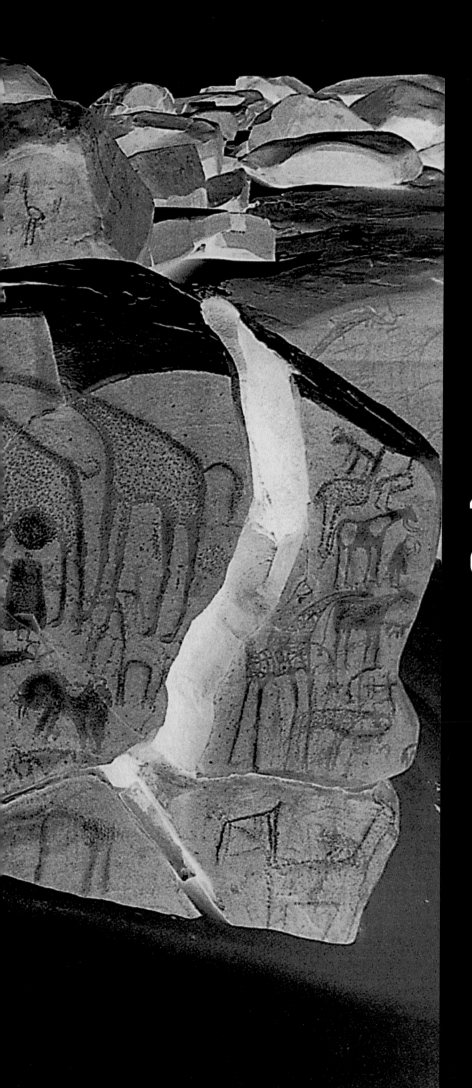

40,000 Years
of Creativity

3

The variety of prehistoric art includes geographical disparities and chronological changes that we should examine more closely by extending our investigation to all five continents.

AFRICA AND ITS
ANCIENT FOUNDATION MYTHS

Here, in a continent which saw the appearance of the first humans at least 200,000 years ago, the origins of prehistoric art seem to go back no further than 40,000 years, in spite of the discovery of an older, head-shaped jaspilite pebble that long ago may have caught someone's appreciative eye.

Art in southern Africa: a very ancient tradition

Found during the 1976 excavation of the Apollo 11 shelter in southern Namibia, two butt-jointed small slabs, or plaquettes, show a black quadruped, while a third portrays a white-painted animal. All three come from an archeological level accurately dated to 26,000-28,000 years B. P. A baboon bone decorated with twenty-nine parallel notches found in Border Cave in Swaziland represents an older, more abstract approach, dating back to between 37,000 and 38,500 years.

In more recent periods examples of portable art are much more common: the Wondewerk site north of Cape Town has been the source of a number of small, incised stone slabs 10,000 years old. Two millennia later painted pebbles were being placed in graves at Goldstream, in southern Cape Province. In the same area, at Boomplaas and Klasies River Mouth, a number of stones bearing paintings of animals and geometrical figures have been collected and dated, using microliths—tiny flints—from the same context, to between 6,400 and 2,000 B. C.

A more ancient naturalistic style used for delicately incised animals could go back as far as 10,000 years. These portraits of wild animals such as Cape eland, rhinoceros and ostrich, were found at Magaliesberg in South Africa. In the Kondoa and Singida regions of central Tanzania there are shelters decorated with painted elephants. In the Cape region the bichrome animals of the Drakensberg form large-scale compositions that are certainly of a later date: the Cape eland is the commonest subject, accompanied by several species of graceful antelope which contribute to the striking elegance of these paintings. The mighty herds that cross and overlap on the wall are the work of groups of Bushman hunters who have been identified via a tradition that has continued down to modern times. Some prehistorians (Jean Clottes and David Lewis-Williams, 1996) have seen shamanic rituals in these southern African paintings; in support of this interpretation they cite accounts by nineteenth century missionaries living among the San, a Bushman group responsible for the most recent rock paintings in South Africa, mainly portraying processions of eland. This sacred animal is invoked in the course of rites of passage relating to puberty and marriage and seems to play a part in shamanistic ceremonies as intermediary between the visible world and the spirit kingdom. Shelter walls are thus not only a surface to be painted on, but also

● Precedent page
Image country
The sheer proliferation of prehistoric art is quite spectacular at some sites, an example being these rocks at Tanakom in the Air desert in Niger. By "pecking" with a stone striker on smooth surfaces artists could obtain differences of color and long-lasting, visually effective subtleties of level on the patinated rock. Here can be seen giraffe, ostriches and antelopes of 20-50 cm. The range also includes a number of human figures: on the rock in the foreground is a herder touching a bovid. Herding period, approximately 5,000 B. P.

the medium for a unique contact with the world beyond. For Clottes and Lewis-Williams the paintings illustrate the different stages the shaman traverses in a succession of altered states of consciousness.

Doubtless of prehistoric origin, the traditions of the Bushmen spread throughout southern Africa and proved extremely long-lasting, surviving until the nineteenth century. However, they were not alone and existed along-side others introduced from the north, notably those of the Hottentot and, later, the Bantu. These northern traditions differ in that they include representations of such domestic animals as oxen, sheep and goats. In the case of the Bantu who, in addition to cattle raising and farming, also introduced the working of iron, the patterns become more schematic, especially those representing human beings. Purely geometrical, non-figurative patterns became much more numerous; the petroglyphs found in western Zambia are all of the schematic type and have nothing in common with the naturalistic representations of animals from the north and east of the country. In Zimbabwe the recent schematic tradition diverges sharply from the original naturalistic representation of wild animals. In northern Transvaal and Cape Province groups of wild animals can be readily distinguished from domestic herds.

North African and Saharan styles of the pre-desert period

In North Africa art made its appearance with the Capsian jewelry and portable works of the period 8,000-4,000 B. C. G. Camps (1974) mentions graves yielding a bone pin, a pierced wild boar tusk and a tubular bone bead. Several pierced fragments of human skull have been found and were doubtless worn as amulets. In the eighth millennium B. C. the Capsians were also incising plaquettes with geometrical patterns that are difficult to identify, except perhaps in cases of sexual symbols such as the vulva. There are also a few sketches of birds and quadrupeds. Sculpted stones from El Mekta show human and animal heads, with other examples coming from Tisnar (Erg d'Admer) and Tazruk in the Hoggar.

Incised ostrich eggshells are more numerous in the Neolithic period and examples representing animals have been found in Tarfaya, Tarentule and Redeyef. The earliest Saharan parietal style, from the period H. Lhote has named "Bubaline", would seem to date from 8,000 years ago and is characterized by highly naturalistic petroglyphs. Elephants are frequently depicted on rocks in the central Sahara, as are giraffes, antelopes and various members of the cattle family, including the giant buffalo. The fact that these animals are rarely found in central Saharan paintings would seem to indicate that they belong to a pre-herding period. Only one group appears contemporary with the first herders, 7,000 years ago: the large, incised wild animals in the northern sanctuaries of Tassili n'Ajjer (Oued Djerat) and Tadrart Acacus (Tin Lalan), in southern Fezzan (In Habeter, Tilizzaghem) and northern Tibesti (Gonoa). In addition to these Saharan sources, mention should also be made of the examples to be found in the Atlas Mountains of the northern Sahara and the High Atlas in Morocco: here are found drawings of big cats—lions and panthers—together with elephants and, more rarely, ostriches, antelopes and a variety of wild horses.

Some of these figures are gigantic: at Oued Djerat one giraffe measures 6 meters and another 8.5 meters. An elephant measuring 4.7 meters has

been found, but by contrast the incised rhinoceros at Tin Affelfellen is only 70 centimeters long. The skill of the rock carvers in producing subtle, deeply incised work is superbly illustrated by the frontal view of a charging elephant found at In Habeter, while jewelry bears highly detailed images of women. Half-human figures with dogs' heads occur in the Tassili, the Acacus and at Messak (J.-L. Le Quellec, 1998), as well as in the Fezzan and the Hoggar. They portray mythical figures, often with penis erect, and thus introduce an imaginative, religious dimension. Others have the heads of antelope, birds and big cats (Tilizzaghen). The Tazina style, a naturalistic subgroup appearing in the Saharan Atlas, achieves great elegance in the tapering feet of the wild animals it portrays.

The second or "Roundhead" parietal style seems to be the direct successor of the first and mainly comprises paintings. Its large-scale mythical creatures are characterized by deformations and muscular swellings, by the absence of a neck and by large round heads sunk between their shoulders. They are found in the Tassili, the Acacus and the Eunedi. Also present in the Tassili are figures smaller than the classic Roundheads: decorated with feathers or wearing horns, they are painted red and probably represent an earlier phase. G. Bailloud discovered images of imps bearing round shields in the Eunedi. The next phase is one of light-colored, white or yellow, paintings outlined in red, exemplified by the giant gods at Sefar and at Sivré in the Eunedi. The bodies of these figures are often covered with geometrical patterns, probably symbolizing ritual scarification. In the Eunedi these giants are decorated with a feather at shoulder level or with a crozier, while in the Tassili they wear polychrome headdresses.

The third Saharan rock style, that of "Cattle", appeared during the herding period. It comprises many paintings over an area extending from Libya to Mauretania, in the Tassili, the Eunedi, the Tibesti and the Tchefdest to the north of the Hoggar. H. Lhote sees the carvings of domestic cattle from the Hoggar, the Tibesti, the Fezzan, the Ahnet and elsewhere as forming a group in their own right with others from the central Sahara and the Atlas, where beautifully painted rams are found at Tissoukai. In one painting a group of herdsmen wearing loincloths, carrying spears and sticks, with feathers in their hair, is portrayed in the company of small livestock. Another, much more numerous group of works shows cattle herders carrying triple-curved bows. The herdsmen at Rhardes wear horned headdresses and long sleeveless tunics. Here we have direct information on the daily life of these Neolithic groups, black and white-skinned peoples who lived in these areas before desertification set in sometime during the third millennium B. C.

The fourth or "Horse" style is principally characterized by figures riding chariots drawn by galloping horses. The handsomest examples of this style are to be found at Tamadjert, where they have been dated to between 3,000 and 2,000 B. C. In the last few centuries B. C. the horse is replaced by the dromedary, an animal better suited to a desert existence. The Libyan-Berber style, reduced to no more than graffiti, marks the end of the high rock art of North Africa and the Sahara.

A remarkable cave painting center and its ceremonial practices: the great Dogon sanctuary at Songo, Mali

The great rock overhang at Songo in Dogon country is covered with painted patterns, some of which, more faded than others, are clearly earlier and doubtless very ancient. According to Marcel Griaule (1938), these paintings are of two kinds: the first, called *banni*, are red and have a religious function: they retain the *nyama*, the spiritual energy of every human or animal, and particularly of the dead. The paintings of the second type, predominantly in black or white, have no special purpose and are the work either of children or of adults simply filling in time. The Dogon refresh their religious paintings, preferring to rework an ancient mythical image whose power, enhanced by time, may in fact have come from ancestors who themselves once reworked the painting. The sacred images in the Shelter of the Circumcised likewise show signs of this "freshening up". Drawing on the evidence of ritual cycles including the making of wooden masks that were then left on the site, Griaule suggests that the paintings at the Barn Shelter are over 200 years old and those at Ibi more than 500.

The religious life of the Dogon is founded on the rite of Sigui, or Pardon, which regenerates the foundation myth by simultaneously actualizing and reinforcing it. "The purpose of the itinerant Sigui rite is to regenerate the Great Mask as the serpent-shaped ground for the soul of the dead mythic ancestor, and to ensure its protection by Initiates (*olubaru*). These Initiates are considered the new guarantors (*nani*) of the ancestral soul" (Griaule, 1938, p. 166). Mythically speaking the masks as an institution are directly linked to the execution of the paintings. The village elders had first to coat the wooden Great Mask with a mixture of blood from sacrificed chickens and dogs, red earth, millet and rice. They then had to introduce into a serpent carved on the Mask the *nyama* of a recently dead old man. Black and white were used to clearly define the serpent's shape. Attracted by the odor of the sacrifice, the dead person's soul and *nyama* then merge with the shape of the Mask. The red color produced from the ingredients of the sacrifice was then used to paint the mythical serpent on the cliff wall; touched by the Great Mask, the serpent became the ultimate receptacle for the dangerous power of the dead person's *nyama*.

Other rituals were then developed, using the same technique to ensure that the rock painting would receive the *nyama* of animals killed during the hunt. Among the Dogon, on the first day of the Sigui festival—a Pardon festival lasting five years and held every sixty years—the oldest man in Songo carries out the sacrifices on the Great Mask and partially effaces the remains of the great serpent-shaped sign representing the Mask on the cliff wall. This sign was invented by the first ancestor, who originated the myth, to drive away the evil word. The oldest man in Songo regenerates the image by painting over the ancient version in red and thus restoring all its power. In this way the rock painting becomes the ritual embodiment of the social group's foundation myth. The ingredients of the layer of color evoke the life of the sacrificed creatures and the fruits of the earth and thus testify to the ritual generational cycle.

Next page
The Great Eland Panel
Measuring some 250 cm, this scene from Eland Cave in the northern Drakensberg in South Africa, shows a herd of Cape eland of various sizes—the dominant male, females and fawns—assembling during the rainy season. Observed from above, the densely composed herd is given real vitality by the exactness of the detail and a multiplicity of bichrome shades that make this a truly polychrome painting. Obviously this is not just some animal documentary; what is conveyed with absolute genius is the natural, living vibrancy of this annual assembly of eland. People —who play a strictly secondary role in such a spectacular context —appear to one side: hunters, shamans or simple witnesses to the inexorable rhythm of time and rain. Perhaps 500 – 350 B. P.

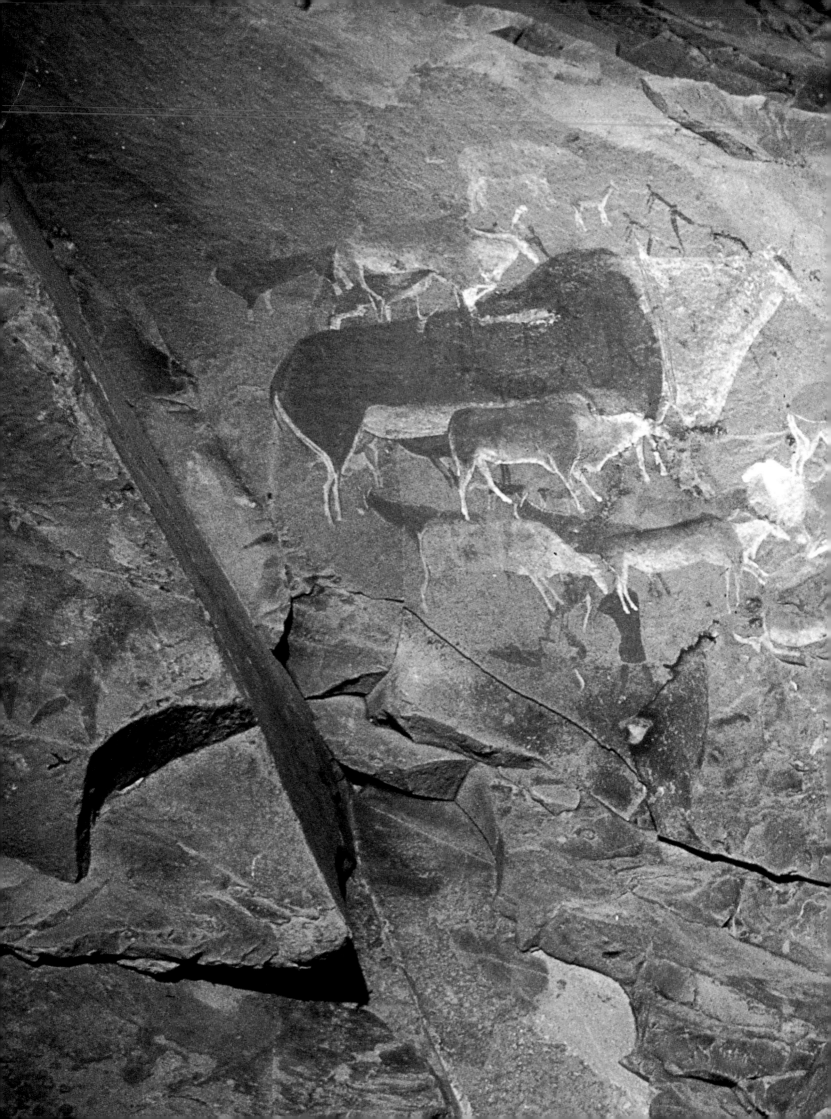

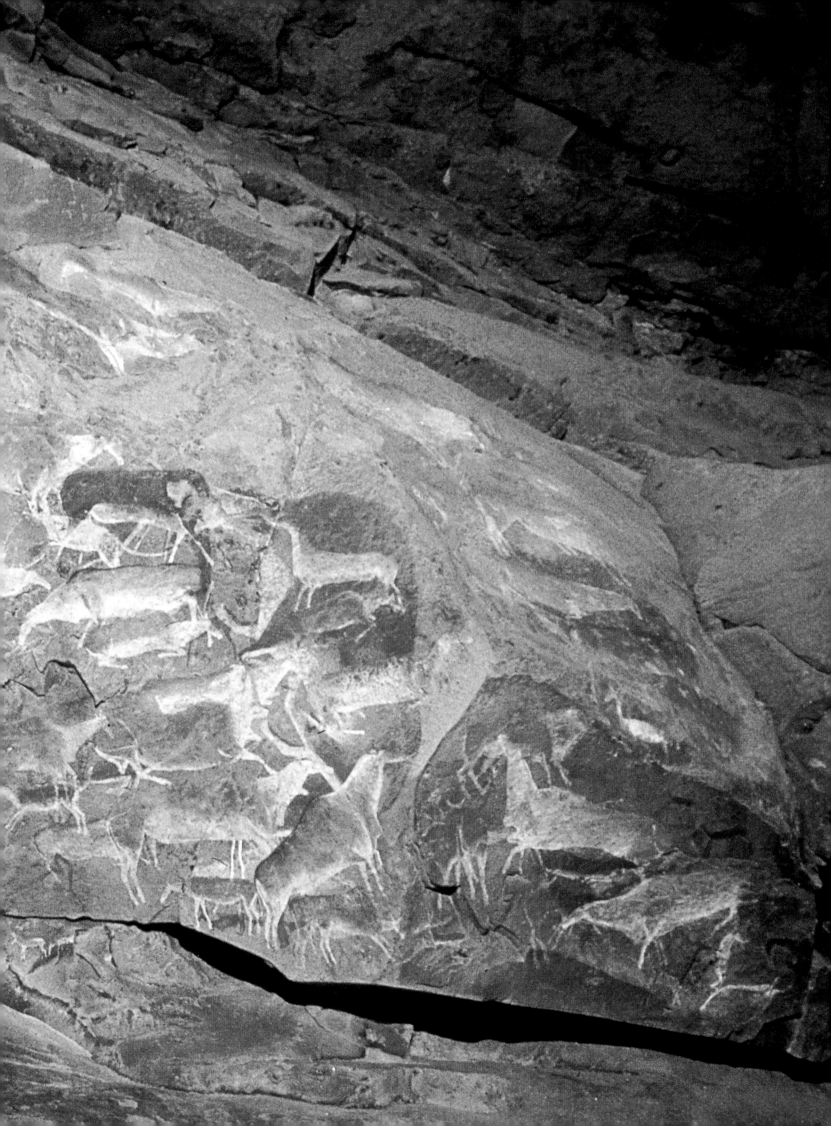

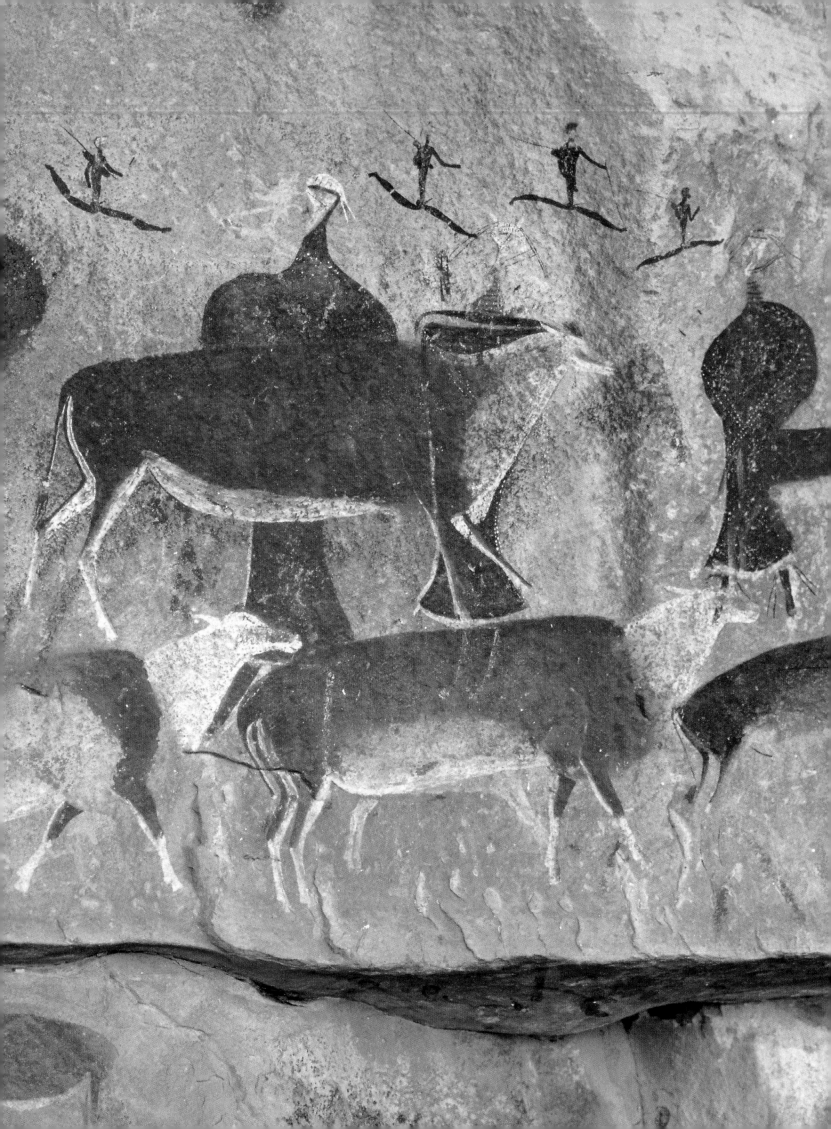

Elands and animal-men

The central part of the painted
panel (approx. 250 cm)
in the Kamberg region of
South Africa shows
a herd of Cape eland advancing
to the right in two lines. They are
observed by 3 figures wearing
voluminous coats and with
strange heads which, on closer
examination, turn out to be those
of eland. In the upper part of
the composition smaller hunters
move at a flying gallop. In addition
to distinctly different styles,
overlap of the paintings attests
that they are not all from the
same period. The work as a whole,
however, has a unity that
suggests a single function.
Perhaps 500 – 350 B. P.

Below
The dying eland

In South Africa an eland
68 cm long lies stretched out,
obviously exhausted.
For the last time he reaches
forward with his front leg, turning
his head towards the viewer;
his crossed rear legs are useless.
He is being helped by
an eland-headed man who holds
him back by the tail; he too has
his legs crossed, each terminating
with a hoof. Full of compassion,
this extraordinary scene is
interpreted as illustrating the
shamanic relationship between
man and animal—especially
the Cape eland—in this region.
The therapeutic function of the
image seems quite deliberate,
as does its instructive function
for initiates. Perhaps 500 – 350 B. P.

The animal-man

Prehistoric art is a spur to
exploration of the imaginary
sphere and fantastic worlds.
This little creature—4.5 cm—
painted on a rock, near
Cathedral Peak in South Africa,
is remarkable for having 2 animal
heads and offering 2 distinct
readings: if its front is to the right
it is a young antelope,
but if its front is to the left we see
an antelope-headed man,
his arms stretched forward
and slightly bent.
Perhaps 500 – 350 B. P.

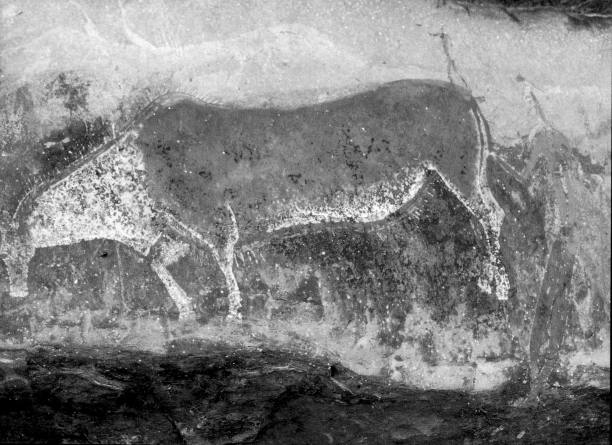

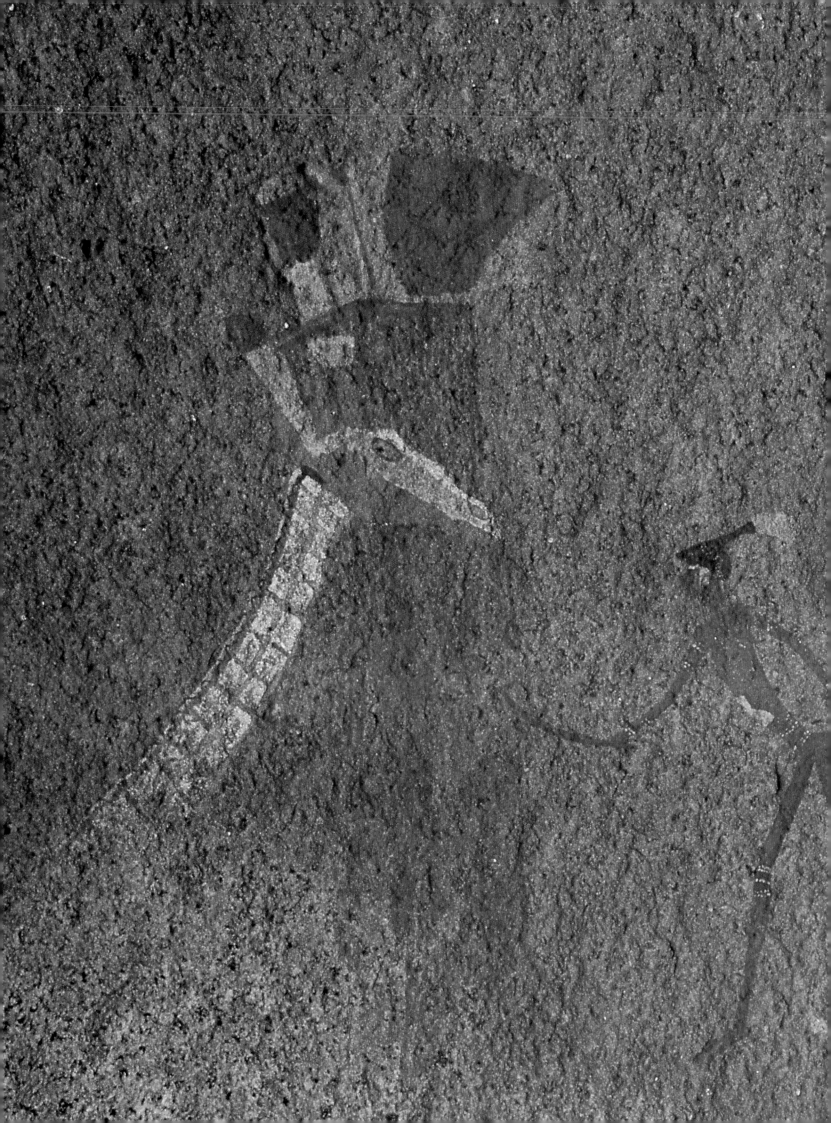

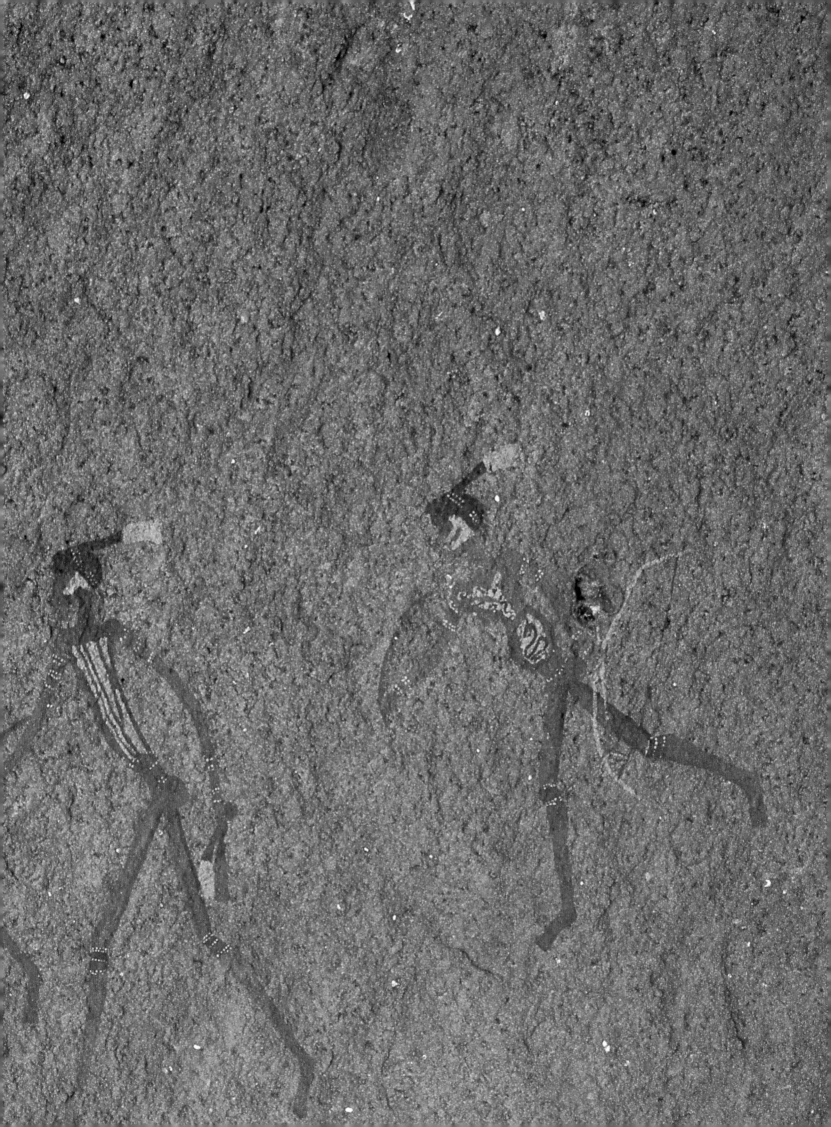

Inspired dance

Groups of 7 and 2
monochrome "dancing" figures
on a rock face at Mweni in the
northern Drakensberg, South
Africa. Each of them is some
10 cm high and in the absence
of any indication of the ground
under their feet the coordinated
movement of the whole is
a celebration of freedom and joy.
The abstract notion of a space
linked solely to the subject
and not to the context gives a
philosophical dimension to these
figures: their existential intensity
arises out of the gesture that
made them. There may be a
relationship between these
dancers and the "flying" warriors
also depicted with black,
charcoal-based paint, some
examples of which are four
or five centuries old.

Precedent page

The rain ceremony

Polychrome panel 96 cm long
in the Ga'aseb Valley near
Brandberg, South Africa. To the
left a giraffe seems to be crowned
with a rain harp pouring down a
sheet of water. Three human
figures with painted and
ornamented bodies approach
the rain, the first of them touching
it with his stick. This ceremonial
scene presents a space that is
both terrestrial and cosmic, an
abstract, symbolic discourse
enabling mastery of
the geographical and temporal
dimensions. The presence of a
wild and thus natural animal—
the long-necked giraffe with its
head in the rainclouds—is the
guarantee of a precious alliance
between the anxious hunter
and the secret animal with access
to the spirit world.
This type of polychrome painting
would appear to be several
centuries old.

Two giant giraffe

The giraffe on the left measures
580 cm from rear hoof to the top
of its head. Like its companion it
has been pecked into the smooth,
horizontal rock of Debous in the
western Air, Niger. This abundant
fauna, depicted by hunter-herders
—note the rope passed through
the nostrils of the two giraffe and
undulating down their long necks
—is contemporaneous with the
luxuriant vegetation of an area
since become a desert. It is not
easy to judge if each of the
species shown played a specific
part in an animal pantheon, or if
they simply express the vitality
the hunter and his group had such
need of. Perhaps 7,000 – 5,000 B. P.

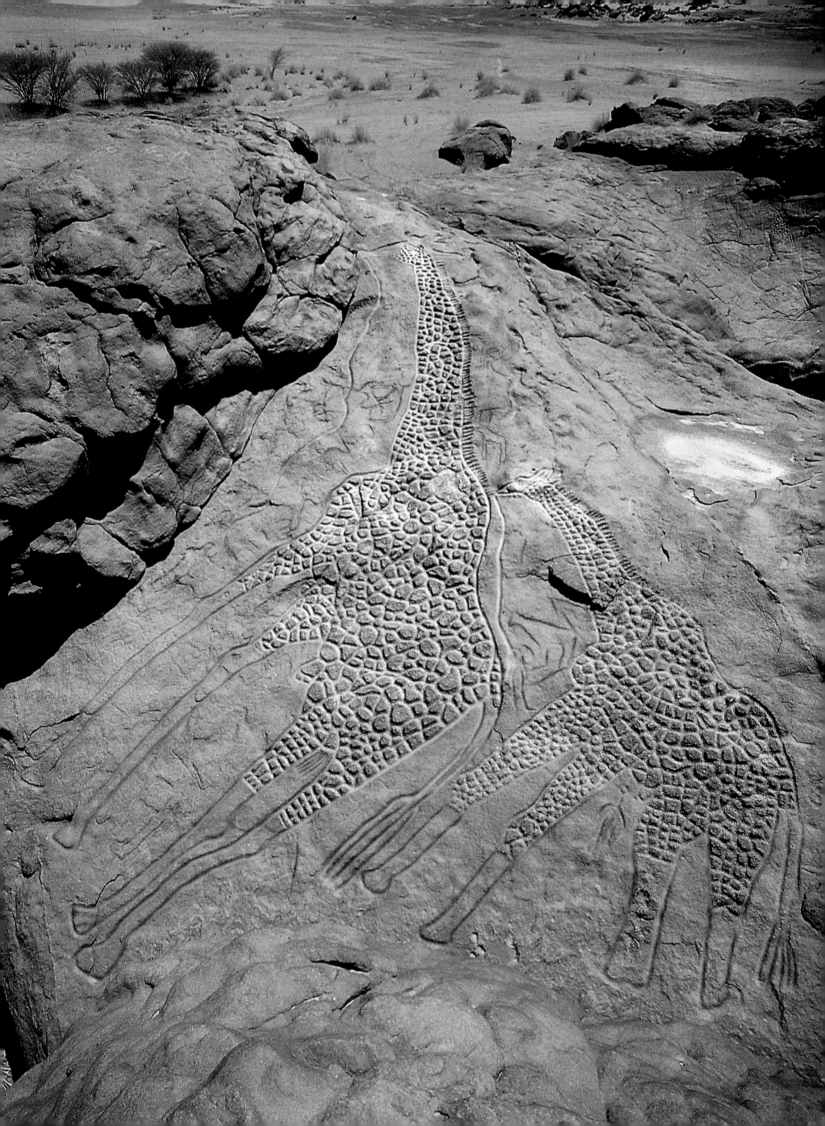

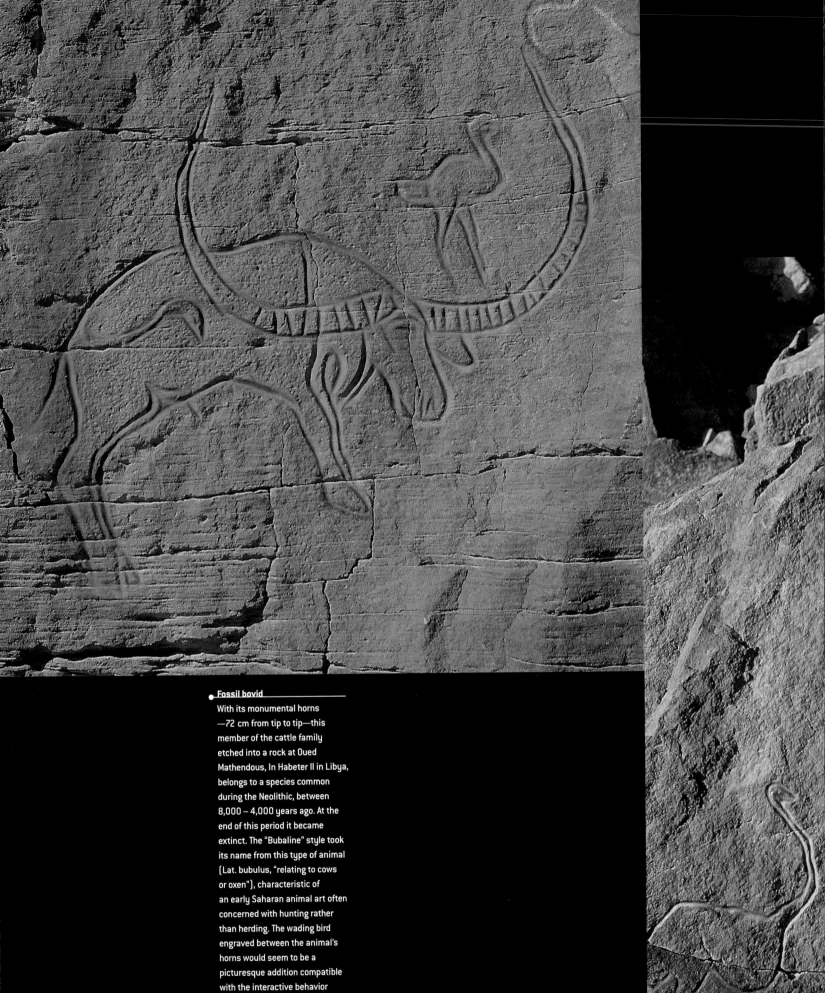

Fossil bovid

With its monumental horns
—72 cm from tip to tip—this
member of the cattle family
etched into a rock at Oued
Mathendous, In Habeter II in Libya,
belongs to a species common
during the Neolithic, between
8,000 – 4,000 years ago. At the
end of this period it became
extinct. The "Bubaline" style took
its name from this type of animal
(Lat. bubulus, "relating to cows
or oxen"), characteristic of
an early Saharan animal art often
concerned with hunting rather
than herding. The wading bird
engraved between the animal's
horns would seem to be a
picturesque addition compatible
with the interactive behavior
of the two species.
8,000 – 4,000 B. P.

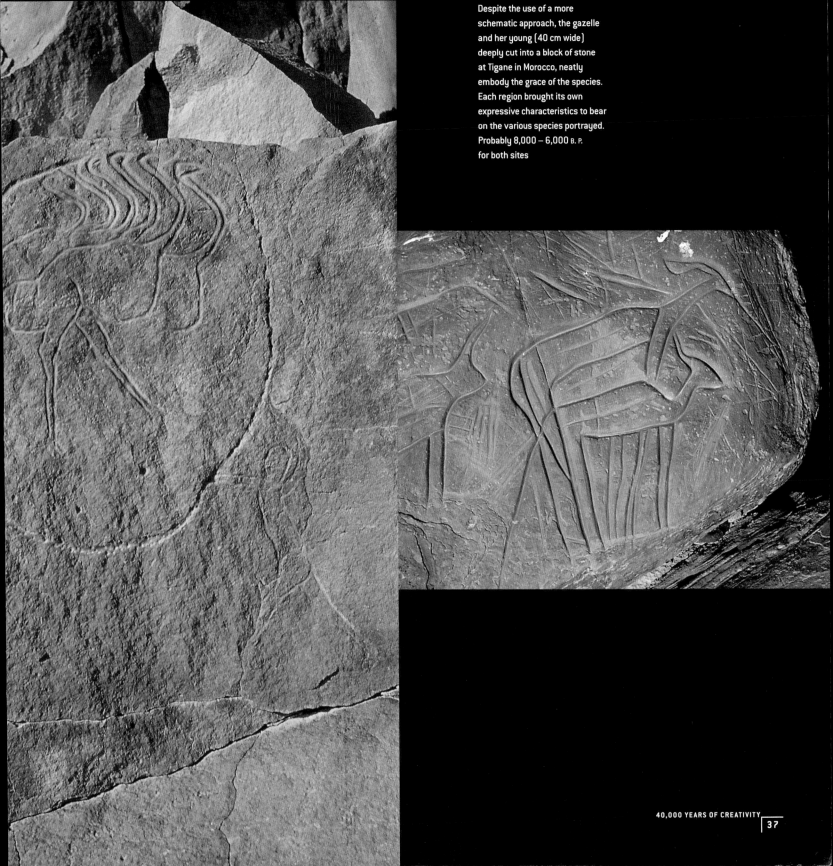

Despite the use of a more
schematic approach, the gazelle
and her young (40 cm wide)
deeply cut into a block of stone
at Tigane in Morocco, neatly
embody the grace of the species.
Each region brought its own
expressive characteristics to bear
on the various species portrayed.
Probably 8,000 – 6,000 B. P.
for both sites

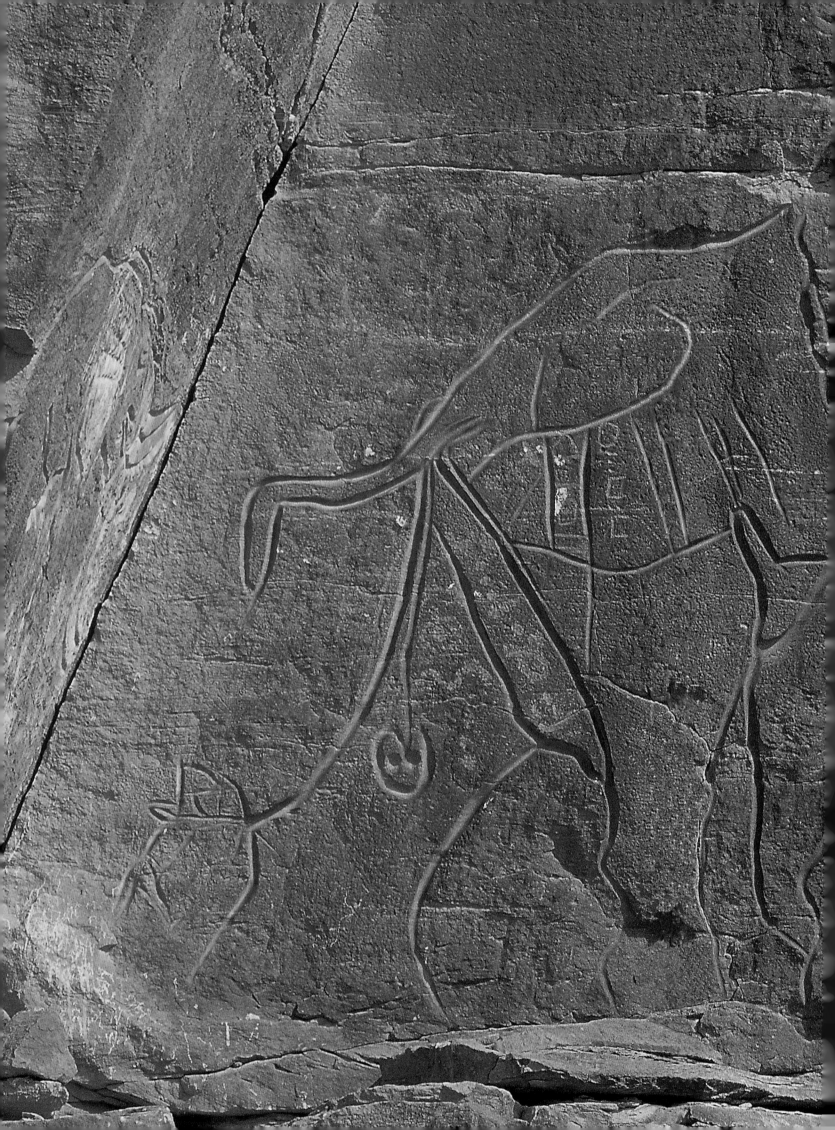

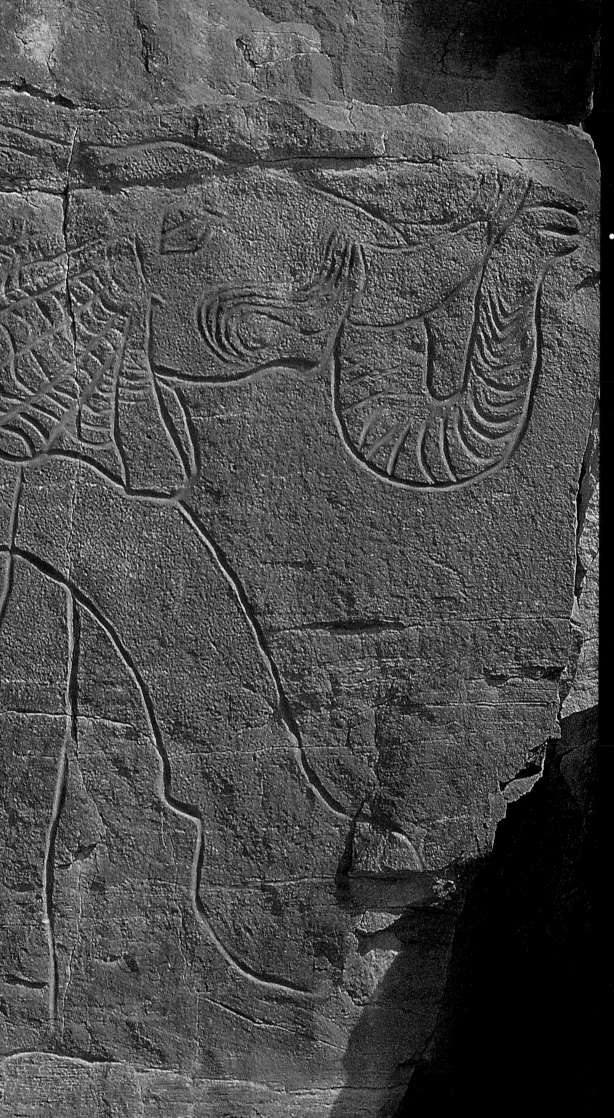

Splendid elephant

265 cm from tip of tail to tip of
trunk, this charging elephant cut
into a slab at Oued Mathendous,
In Galgien in Libya, is doubtless
trying to flee the hunter. The latter,
shown on a smaller scale, has just
released an arrow from his bow.
The sense of movement, the
anatomical accuracy and the
taste for decorative repetition
combine naturalistic observation
with real pictorial virtuosity.
However other images from this
region portraying human figures
with the heads of jackals
have taught us that these
representations are not simply
descriptive; they are, in fact, the
core of religious practices whose
meaning escapes us.
8,000 – 6,000 B. P.

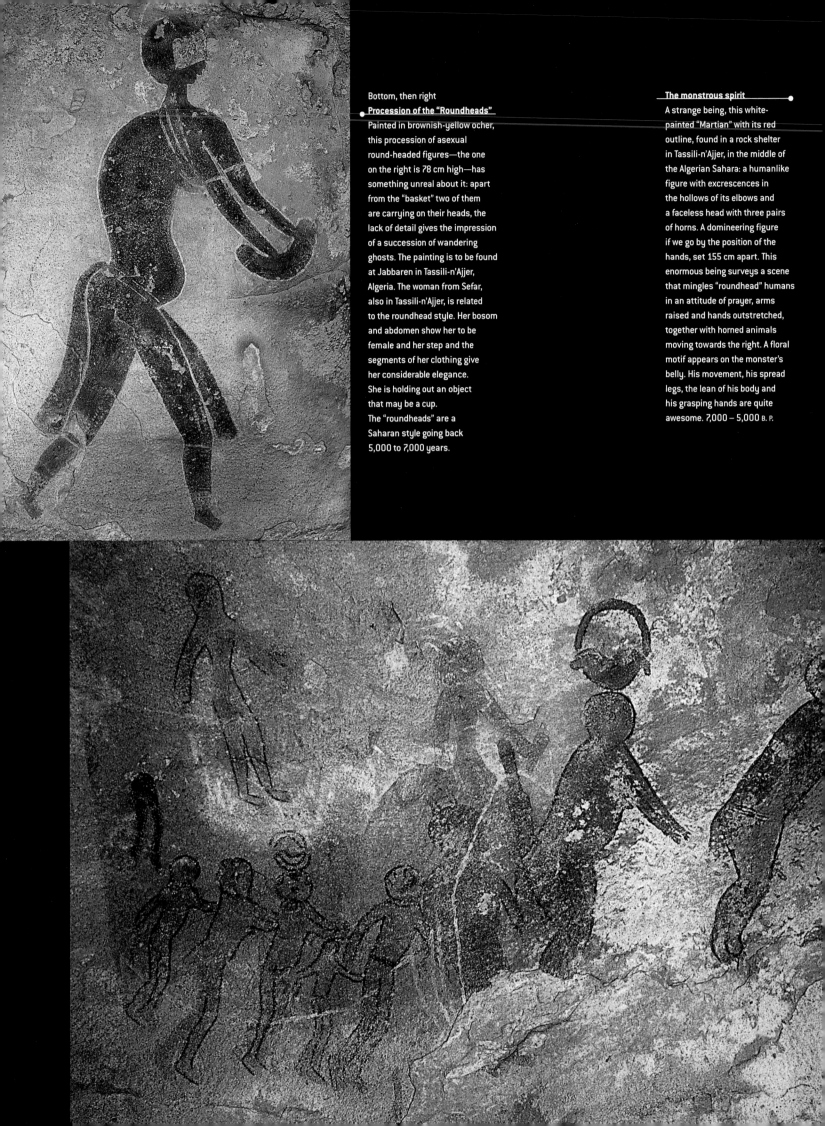

Bottom, then right
Procession of the "Roundheads"
Painted in brownish-yellow ocher,
this procession of asexual
round-headed figures—the one
on the right is 78 cm high—has
something unreal about it: apart
from the "basket" two of them
are carrying on their heads, the
lack of detail gives the impression
of a succession of wandering
ghosts. The painting is to be found
at Jabbaren in Tassili-n'Ajjer,
Algeria. The woman from Sefar,
also in Tassili-n'Ajjer, is related
to the roundhead style. Her bosom
and abdomen show her to be
female and her step and the
segments of her clothing give
her considerable elegance.
She is holding out an object
that may be a cup.
The "roundheads" are a
Saharan style going back
5,000 to 7,000 years.

The monstrous spirit
A strange being, this white-
painted "Martian" with its red
outline, found in a rock shelter
in Tassili-n'Ajjer, in the middle of
the Algerian Sahara: a humanlike
figure with excrescences in
the hollows of its elbows and
a faceless head with three pairs
of horns. A domineering figure
if we go by the position of the
hands, set 155 cm apart. This
enormous being surveys a scene
that mingles "roundhead" humans
in an attitude of prayer, arms
raised and hands outstretched,
together with horned animals
moving towards the right. A floral
motif appears on the monster's
belly. His movement, his spread
legs, the lean of his body and
his grasping hands are quite
awesome. 7,000 – 5,000 B. P.

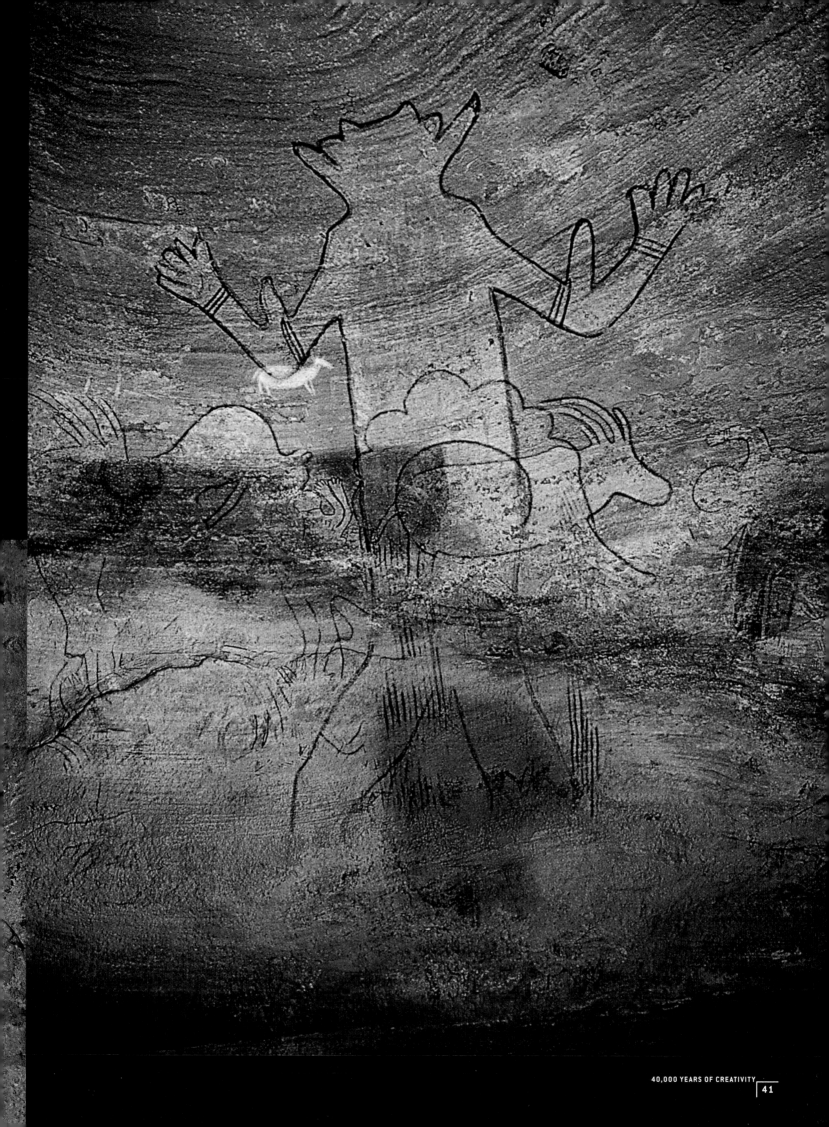

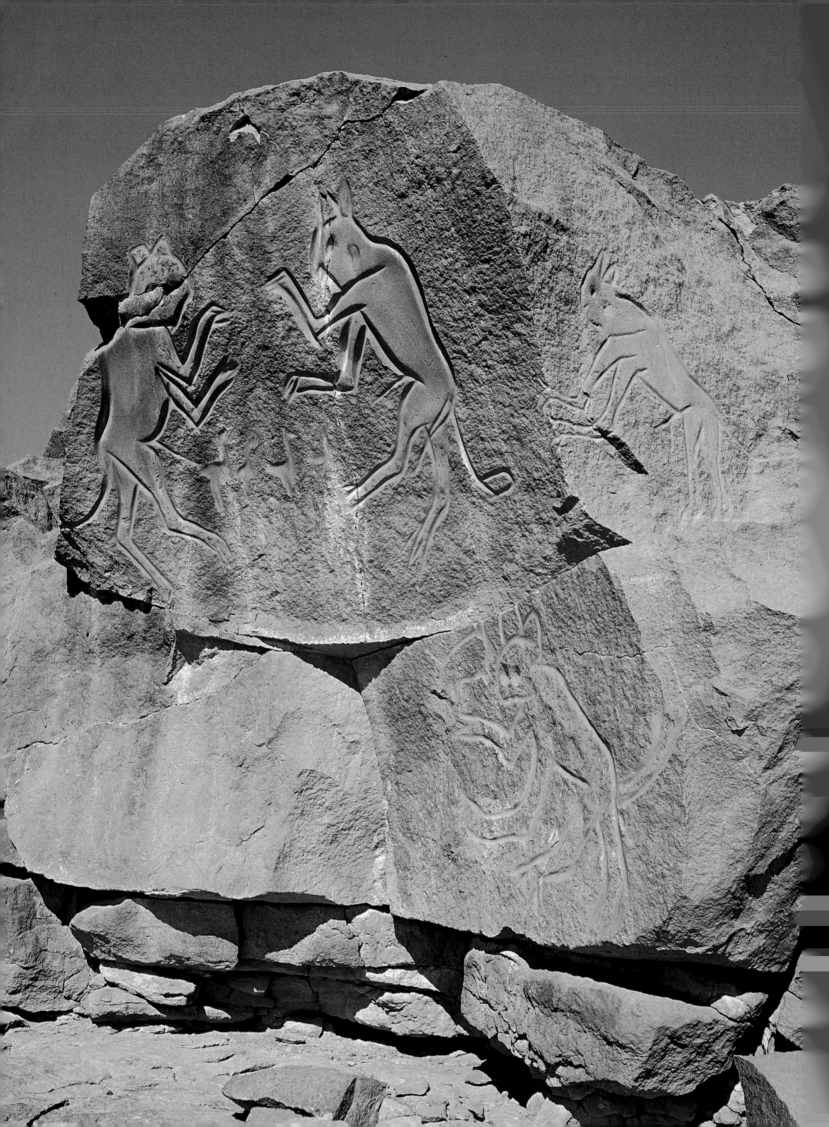

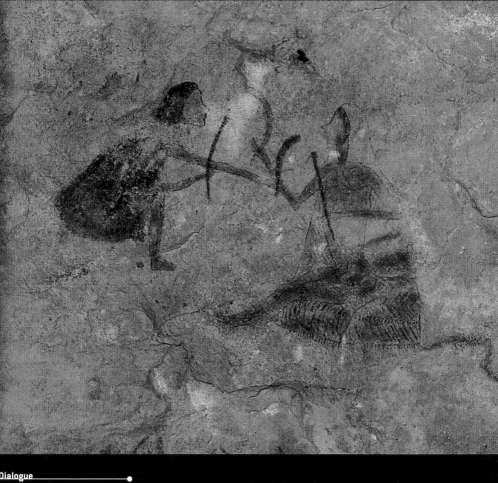

Dialogue
2 figures painted in ocher

Painted in dark ocher, his pose has a perfection that can only be termed classical. Measuring 20 cm from the outer edge of his bow to his left hand, he can be seen on the rock wall of a shelter at Jabbaren, in Tassili-n'Ajjer, Algeria. Wearing a headdress and loincloth, he was painted 4,000-5,000 years ago. At the same period dark ocher images of animals were also appearing, notably of herds like the cows at Ouan Bender in Tassili-n'Ajjer, a 87 cm high panel. The peaceful aspect of the herd indicates that these are domesticated beasts:at a time when painting was seeking realism, there is little movement and the detailed treatment of the horns and the dark patches on the hides is evidence of a"quiet life".

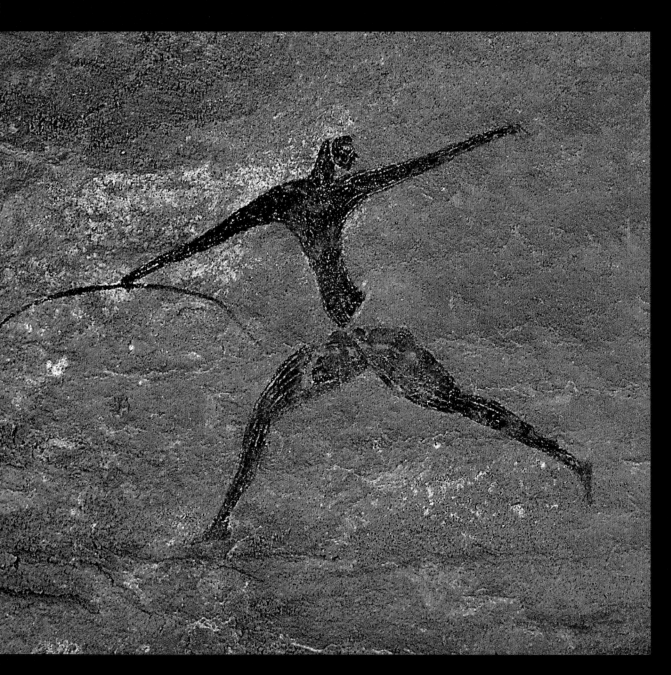

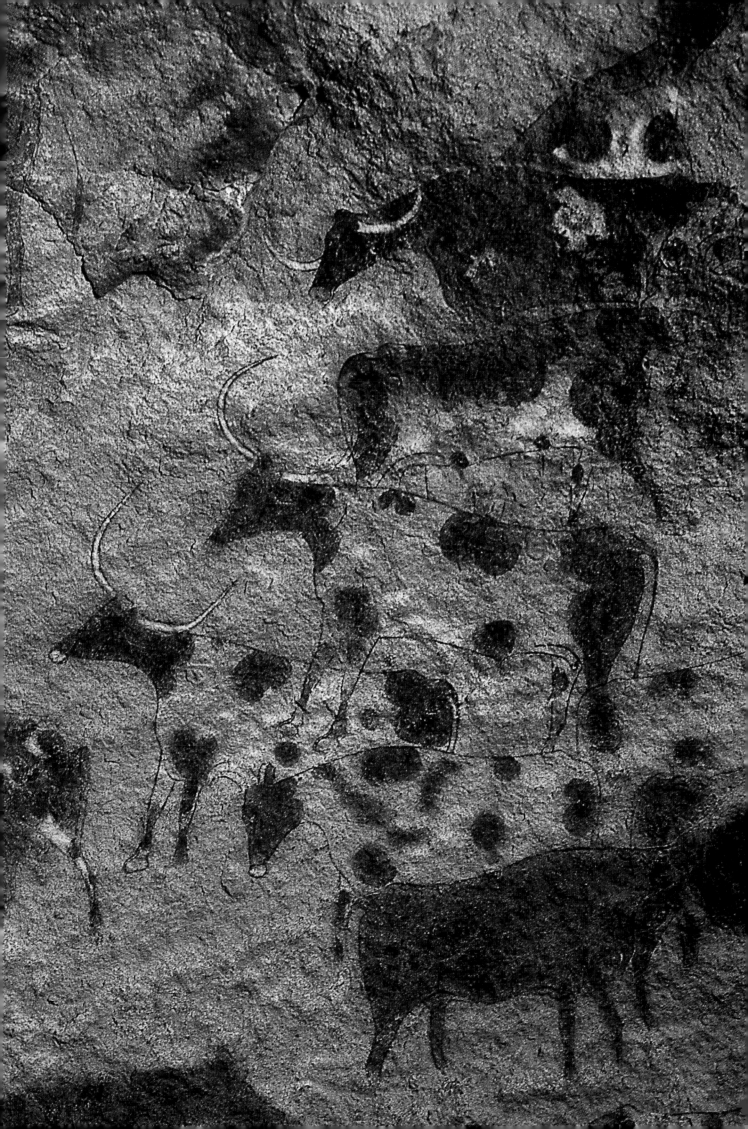

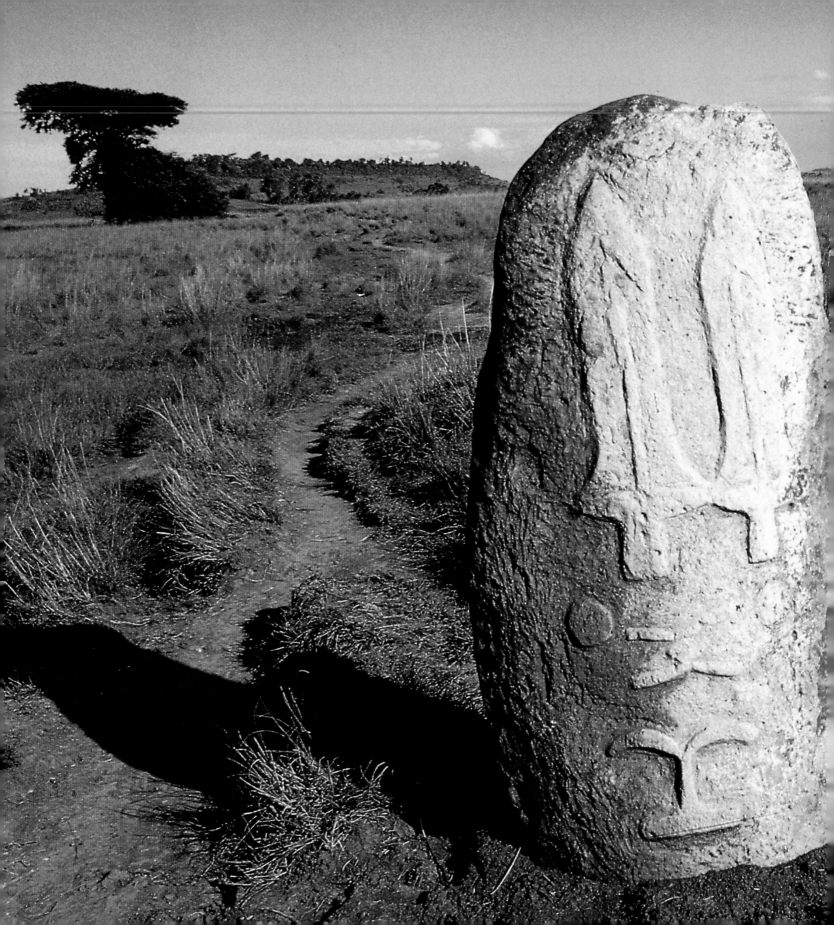

Stele and stone circle

To the left is one of the stelae at Tiya in Ethiopia; 210 cm high and erected on a religious burial site 750 years ago. Usually the buried part of such stones bears a hole symbolizing the passage from life to death. The carved symbols above ground level indicate the deceased's family line and the daggers testify to his social standing and status as a warrior. On the right, one of the circles of cut stone laterite monoliths at Sine Ngayene in Senegal marks the site of a filled-in collective burial trench. The internal diameter of the circle is 600 cm. Excavation of trenches like these has revealed remains of human skeletons, together with bracelets, rings, weapons and pottery approximately 1,000 years old.

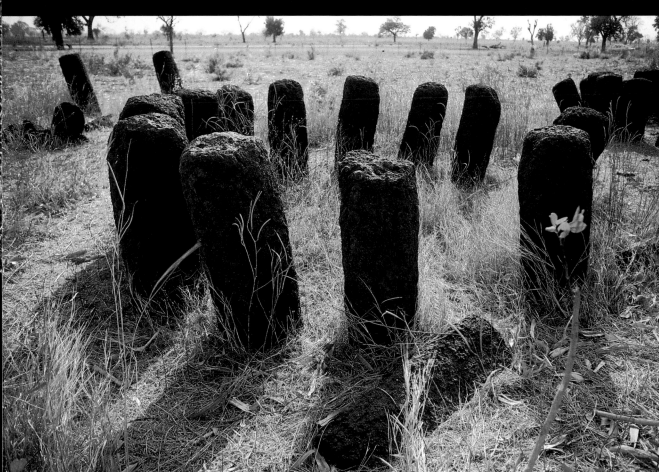

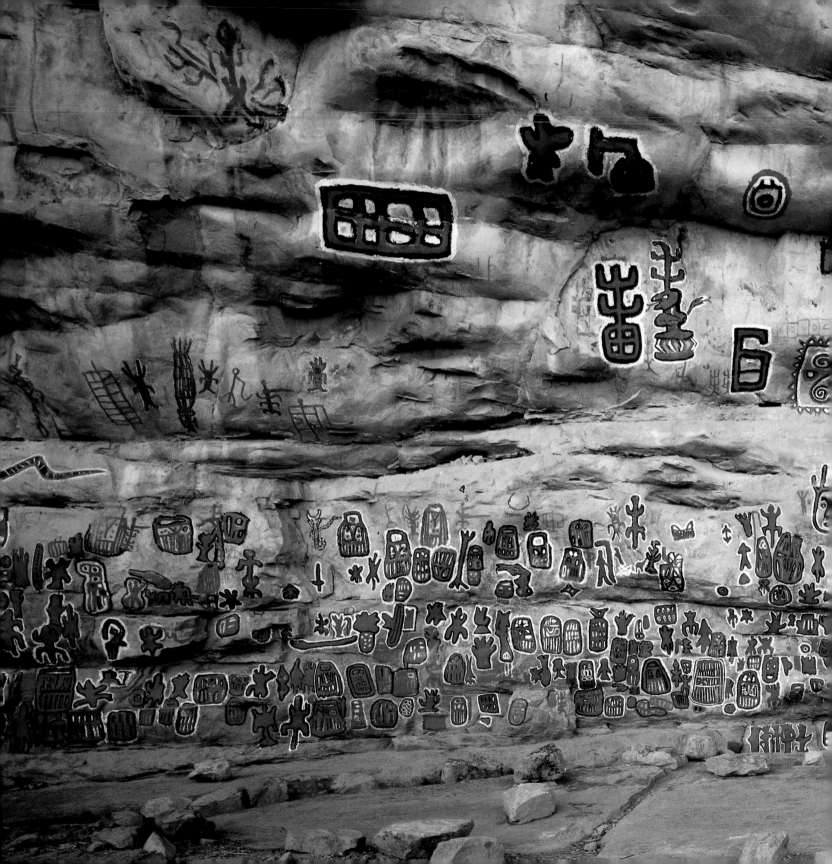

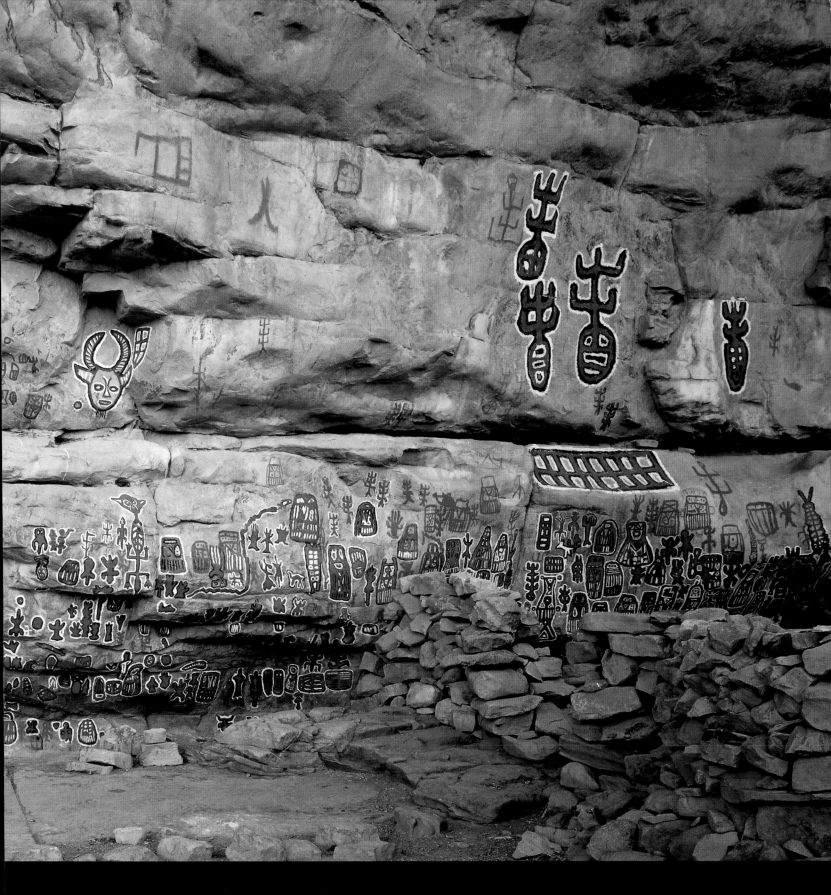

Dogon painted cliff face

Many of the paintings on this rock face in Mali represent masks, some of which have been repainted. The custom is to assemble the boys at the rock face for circumcision as part of the *Sigui*, Dogon society's founding Pardon rite. In the beginning Amma created man from earth; thus man has a blood debt towards the soil and for the Dogon circumcision is a sacrifice to the earth, which drinks the blood of the circumcised person. Such is the meaning of the *Sigui* Pardon. The ritual involves the use of a Mask, bearer of the soul of the dead ancestor in the form of a snake. The image on the Mask is cared for and repainted by the circumcised initiates. This regenerated image is not simply instructive: it is the material embodiment of a sacred memory handed on from generation to generation.

ICE AGE EUROPE AND THE WESTERN TRADITION

A handful of isolated, extremely ancient objects seem to provide proof that a concern with noting sequence can be found as far back as the Lower Paleolithic: incised bones from Bilzingsleben in Germany have been dated to between 350,000 and 230,000 years ago. A clumsily executed accumulation of strokes is thought to represent a member of the cat family. Between 50,000 and 35,000 years ago such examples of "esthetic" expression became much more numerous, with the chevrons incised on bone from Bacho Kiro in Bulgaria, the cupules—circular cup marks—on the stone from grave no. 6 at La Ferrassie in France's Dordogne region, and stone, ivory and bone beads. The ocher whose use goes back at least 150,000 years at Becov in the Czech Republic also became steadily more prominent.

The Aurignacian-Gravettian cycle (40,000-20,000 years ago)

One of the most ancient series is made up of the long, deep incisions in rock shelters and cave entries in El Conde, La Vina and Cueto de la Mina in the Asturias, in Spain. These belong to the Aurignacian stage of the Upper Paleolithic, and are some 36,500 years old.

A group of portable art objects, also very old, comprises some fifteen statuettes 4 cm to 9 cm high, discovered in the Swabian Jura, in southern Germany. A humanlike figure with the tail of an animal, carved in low relief on mammoth tusk, was found in Geissenklösterie and dates from 36,000-30,000 years ago. The Vogelherd site (32,000-30,000 B. P.) has yielded a humanlike figure, but also a very representative bestiary, including such dangerous animals as the big cats, the rhinoceros and the mammoth, together with less formidable species such as deer and horses. The statuette of a lion-headed man found at Hohlenstein-Stadel (32,000-30,000 B. P.) is carved into a piece of ivory 29,6 centimeters high.

A small number of deeply incised stones from southwestern France make up another series, characterized in this case by a marked emphasis on sexual repre-

sentation: of the twenty-odd examples found at La Ferrassie in the Dordogne, half include drawings of vulvas. The phallus makes fewer appearances, but is to be found carved from an aurochs or bison horn found in the Blanchard des Roches Shelter, also in the Dordogne. It is accompanied by other stones, of which five bear drawings of vulvas and three representations of animals in the forms of heads of a goat, a goatlike animal and, perhaps, a big cat. Neighboring shelters contain similar stones decorated with animal motifs. Also worth mentioning here are the bone plaquettes found in the Blanchard and Lartet Shelters; they bear parallel incisions that Alexander Marshack interprets, doubtless erroneously, as tallies of lunar months.

The second or "Perigordian" phase of this cycle is marked by over five hundred female figurines or "Venuses", occurring over an area extending from the Pyrenees to Siberia. The "Venuses" of Laussel, once again in the Dordogne, have been carved on blocks resulting from a cave-in inside a shelter. They are not portable and were intended to be seen in a sanctuary now dated to 28,000 B. P. The incised Pair-non-Pair cave at Marcamps, in France's Gironde region, is contemporary with the Laussel Shelter. Here horses, one of them looking backwards, ibex, cattle, mammoths and members of the deer family can be identified.

However, the cave most representative of the Aurignacian-Gravettian cycle in terms of the variety and power of its paintings is the Grotte Chauvet, discovered in the Ardèche area of France in 1994. The paintings were executed between 32,410 ± 720 and 30,340 ± 570 B. P. The Arcy-sur-Cure Cave in France's Yonne département is little by little yielding up its painted mammoths as archeologists free them from the accumulated calcite overlay.

Used 25,000-24,000 years ago, the cave at Pech-Merle in the Lot département is decorated with images that constitute panels indicating the existence of two distinct sanctuaries (M. Lorblanchet, 1995). The first, which is also the oldest, comprises the Combe drawings, a spotted horse frieze, hand stencils and perhaps a "hieroglyphic" ceiling, with finger tracings of women and mammoths seen in profile. The second and more recent sanctuary centers on the black frieze in the "Chapel of the Mammoths", executed in a more realistic style.

Among recent discoveries, the engraved animals of the open-air sites at Foz Côa in Portugal show stylistic resemblances to those at Pair-non-Pair. The archeological remains that may or may not be associated with them have been dated to a later period around 18,000 years ago.

The Solutrean-Magdalenian cycle (20,000-10,000 years ago)

The series at Roc-de-Sers in the Charente region of France comprises blocks carved with reliefs of various depths showing such scenes as a conflict between two powerfully built ibex and a bison charging a fleeing man. It is part of the Solutrean culture of Western Europe.

Sculpture of a similar quality is to be found on the fallen block of stone in the Devil's Furnace Shelter at Bourdeilles in the Dordogne. Two large overlapping members of the cattle family, the first concealing the legs of the second, create an interesting perspective effect.

Other major concentrations are also to be found in French shelters dating from the Magdalenian Period. The most renowned are at Cap Blanc (Dordogne), with its extremely handsome low-relief frieze of horses and bison; at La Chaire à Calvin (Charente), where we see three horses crossing paths with a headless bovine; and the most complex at Angles-sur-l'Anglin

(Vienne), with images of naked women associated firstly with bison, then horses and then ibex. Among the fragments yielded by this site is a block bearing a life-size realistic sculpture of a man with his skin painted red and his hair and beard black.

Small animal sculptures in stone have been recovered from the cave of Isturitz in the French Pyrenees, a site famous for the quality of its portable art. One of the distinctive features of this series is the quantity of bone and reindeer antler rods heavily incised with floral and geometrical patterns. The five thousand eight hundred and fifty-seven plaquettes from the Solutrean-Magdalenian levels of the Parpallo Cave at Gandia, near Valencia in Spain, have the same subject matter as the cave in the Pyrenees, but the plethora of geometrical decoration is complemented by images of horses, deer, cattle and wild boar. The Magdalenian represents the high point of Paleolithic portable art. The site that gave the culture its name, the La Madeleine Shelter at Tursac in the Dordogne, was discovered and excavated between 1863 and 1865 by E. Lartet and H. Christy. The reindeer antler sculptures—such as the Hyena and, above all, the Bison Licking Itself—are absolute masterpieces. A host of other sites in the neighboring area testify to intense activity in the production of portable art objects during the Magdalenian Period. Notable examples are the Laugerie-Basse shelter and the La Mouthe Cave at Les Eyzies-de-Tayac, and the Limeuil Shelter, all of them in the Dordogne. Further north, the stone plaquettes from the cave of La Marche at Lussac-le-Château (Vienne) are an extremely numerous series—there are one thousand five hundred of them in all—and are outstanding for the quality of their incised human and animal figures, even if overlap often makes identification difficult. Other rock engravings spread over a wider geographical range are also impressive in terms of quality. Examples include the head and forequarters of an ibex on a pebble from the Tagliente Shelter in Italy; a pebble from La Combière in the Ain region of France, showing a very handsome horse superimposed on other animals; a plaquette from the Trou de Chaleux Cave in Belgium, decorated with a reindeer and a bovine; and a grazing reindeer etched on a pierced rod of reindeer antler, from the Kesselerloch Cave in Switzerland. The Gönnesdorf site in Germany has yielded dozens of stylized female images engraved on plaquettes. A similar form of abstraction characterizes the portable art of Eastern Europe, as illustrated by the sites of Mezin and Eliseevichi in Ukraine, with statuettes and ornaments incised with geometrical patterns.

As Abbé Breuil put it, the Solutrean-Magdalenian cycle truly belongs to the "giants" of parietal art. Discovered in 1940, the cave at Lascaux in the Dordogne is 150 meter long and comprises two galleries leading off the Hall of the Bulls. The upper parts of the walls are almost entirely covered with one hundred and fifty paintings of animals and signs, and eight hundred and fifty incised or incised and painted figures. Dates obtained from archeological samples set occupation of the cave-sanctuary to 17,000 B. P.

The cave of Altamira, at Santillana near Santander in Spain, is home to two collections of paintings: the famous ceiling emblematic of the discovery of prehistoric art and the "black series". The first of which is near the entry, while the black series in the middle and furthest chambers of the cave constitutes the heart of the sanctuary with its cattle, bison, deer and ibex, and its quadrangular and ladder-shaped symbols. The female deer portrayed whole or simply as a delicate head on a long, graceful neck are similar to the incised drawings of the same subject in the neighboring cave of El Castillo.

Another Spanish cave, Ekain, at Cestona Guipuzcoa, possesses paintings whose quality is equal to that of Altamira, Niaux or Lascaux. Discovered in 1969, the cavern is characterized by three main panels of paintings and engravings in which the dominant figure is the horse. The Ekain style uses stump drawing to outline the bodies and especially the necks and heads.

The Niaux Cave, painted 15,000 years ago, is a network of galleries extending over two kilometers. The concentration of animal figures in the Salon Noir sanctuary is specific to this central part of the site, the abstract character of the message being indicated by the profusion of symbols. The Niaux bestiary is dominated by the bison, whose association with the horse and the ibex provides an insight into the system of ranking within the bestiary. Each species has its own symbols. Chemical analysis of the paint composition reveals that the central part of the Salon Noir is an entity in its own right, being later complemented by the paintings to each side. This analysis also revealed the similarity between the Niaux Cave and its neighbor, La Vache, home to an abundance of portable art incised in bone and reindeer antler and then infilled with color. The same approach seems to have been used in the nearby site of Volp at Montesquieu-Avantès, in France's Ariège département. Like Niaux, these caverns are part of the Pyrenees school and include the decorated caves of Le Tuc-d'Audoubert, Les Trois Frères and Enlène, used 14,000 years ago. One of the galleries leading into the Enlène cave is bare of ornament, but contains six hundred pieces of portable art, including incised plaquettes showing human figures and splendid bison, and such extraordinarily eloquent antler sculptures as the tip of a spear-thrower showing a combat between two ibex.

A few decorated caves have been discovered in Central Europe, but they lack the complexity of the caves in the southwest of the continent. The best known of the Eastern European caves is at Kapova in the southern Urals, where the visitor can follow a procession of fifteen animals, the majority of which are mammoths. These paintings date back 14,000 years.

The major sites of European Paleolithic art were subsequently abandoned. One of the last is Le Mas-d'Azil in the French Pyrenees: under an enormous overhang above the river Arize is a cave containing a series of archeological layers and an abundance of Magdalenian portable art dated to 13,000 B. P. Its quality is truly impressive and the head of a neighing horse from this site has rightly become famous.

The upper levels of the Mas-d'Azil site held a concentration of sometimes incised, but mostly painted "Azilian" pebbles; in all there are over a thousand of them, decorated with dots and lines and dated as being 11,000 years old. A few drawings of highly simplified horses and deer from the same period, found on pebbles in the Murat Shelter at Rocamadour, and others bearing geometrical patterns collected in the Rochedane Shelter at Villars-sous-Dampjoux testify to the end of the long tradition of figurative Paleolithic European art. It should be noted that this coincides with the ending of the Ice Age and the changes of lifestyle and concerns that went with it. The post-glacial period would be marked by other art forms, other media and other messages. Dating from around 9 500 B.C., the panel under the rock overhang at Levanzo in Sicily, with its engravings of female deer and women, is one of the last manifestations of Paleolithic art, even if the originality of its subject—a group of dancers—represents a fresh approach.

The recent Neolithic and protohistoric cycle

Postglacial prehistoric art retained all the earlier variety of forms, although some of these were to evolve or ultimately disappear. To take one example, use of the deep, decorated cave so characteristic of the Upper Paleolithic simply died out. On the other hand, monumental art forms began to appear and develop and portable art lived on as an expression of the creative urge of different societies. In some areas art practiced in shelters or the open-air gave rise to extensive sacred sites.

The Neolithic in Europe covered the period 7,000-6,000 to 3,000-2,500 B. C. and is characterized by the appearance of new centers of symbolic expression. The beginnings of the rock art of the Spanish Levant, in the Eastern Mediterranean, are perhaps to be found in animal paintings in a Paleolithic style: they portray cattle, but are mainly devoted to illustrating the everyday activities of the sometimes warlike farmers and hunters of the fifth millennium B. C. With pebbles carved with images of men and creatures that are half-woman, half-fish, the Lepenski Vir collection in Serbia dates from the seventh millennium B. C. and provides a fine example of the sheer energy of early rural societies. Two thousand years later terracotta statuettes of women and domestic animals spread throughout this region and into Central Europe, as part of the Karanovo and the later Gumelnitza cultures in Bulgaria and the Vinça culture in Serbia. Similar figurines came to be made as far afield as France, where finds date from around 3 500 B. C.

Megalithic ("great stone") architecture began to make its appearance early in the fiveth millennium, in an area along the Atlantic coast and, in a less well-defined way, around the Mediterranean. Later monuments are to be found in more inland areas such as the Causses in France, the Jura, Westphalia and the Caucasus. Traces of painting are not at all uncommon in megalithic centers in Portugal, Sardinia and the Caucasus, while "pecked" work dominates in Portugal, Brittany, Ireland and Malta. Stelae and menhir-statues began to be erected throughout Europe, a practice that continued on into the different metal ages.

Sanctuaries such as the one at Stonehenge in England were much used for several centuries during the third millennium. In the vast spaces of the meseta, the high plateau that covers most of Spain, at Monte Bego and Valcamonica in the Italian Alps, and in Northern Europe, various peoples left thousands of pecked patterns on the rocks in the course of the third and second millennia B. C. Not far from the White Sea the pecked drawings at Zalavruga, in Russian Karelia, show the hunting of reindeer, bears, seals and whales. Everyday events such as a mother giving birth are also featured.

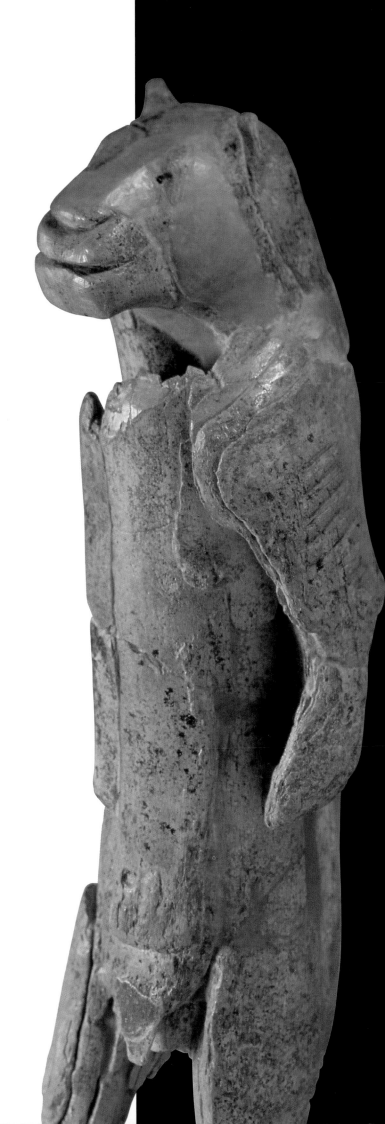

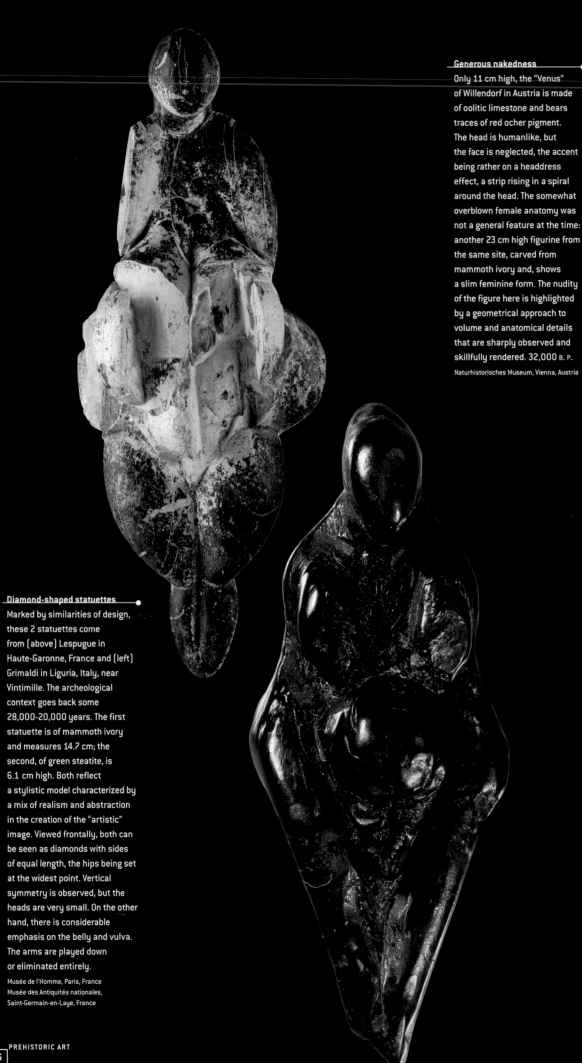

Generous nakedness

Only 11 cm high, the "Venus"
of Willendorf in Austria is made
of oolitic limestone and bears
traces of red ocher pigment.
The head is humanlike, but
the face is neglected, the accent
being rather on a headdress
effect, a strip rising in a spiral
around the head. The somewhat
overblown female anatomy was
not a general feature at the time:
another 23 cm high figurine from
the same site, carved from
mammoth ivory and, shows
a slim feminine form. The nudity
of the figure here is highlighted
by a geometrical approach to
volume and anatomical details
that are sharply observed and
skillfully rendered. 32,000 B. P.
Naturhistorisches Museum, Vienna, Austria

Diamond-shaped statuettes

Marked by similarities of design,
these 2 statuettes come
from (above) Lespugue in
Haute-Garonne, France and (left)
Grimaldi in Liguria, Italy, near
Vintimille. The archeological
context goes back some
28,000-20,000 years. The first
statuette is of mammoth ivory
and measures 14.7 cm; the
second, of green steatite, is
6.1 cm high. Both reflect
a stylistic model characterized by
a mix of realism and abstraction
in the creation of the "artistic"
image. Viewed frontally, both can
be seen as diamonds with sides
of equal length, the hips being set
at the widest point. Vertical
symmetry is observed, but the
heads are very small. On the other
hand, there is considerable
emphasis on the belly and vulva.
The arms are played down
or eliminated entirely.

Musée de l'Homme, Paris, France
Musée des Antiquités nationales,
Saint-Germain-en-Laye, France

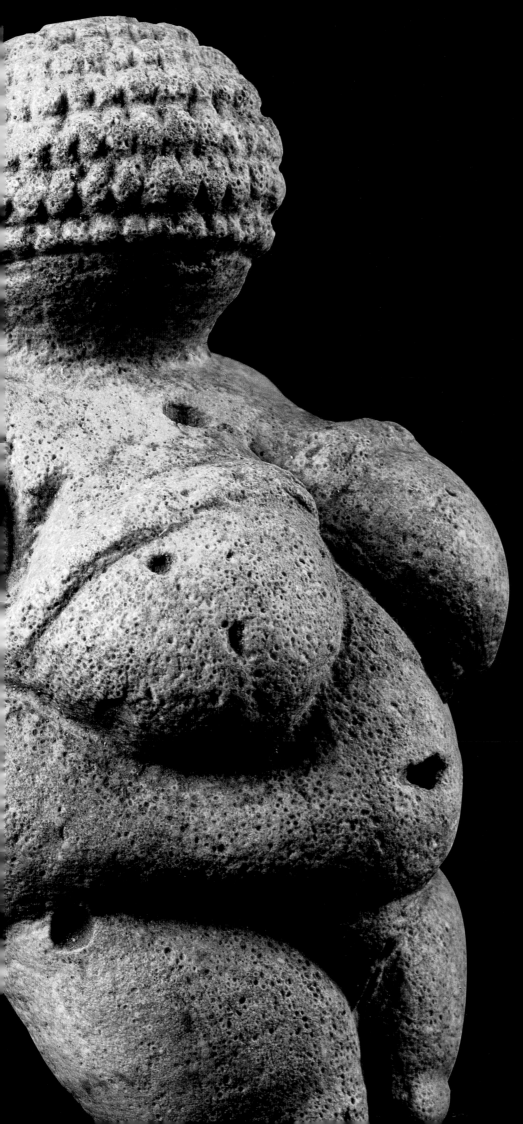

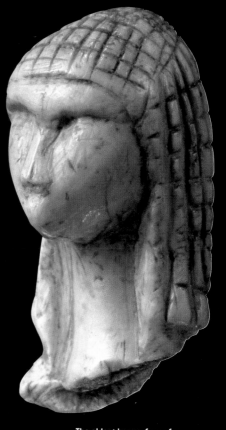

The oldest known face of a woman
Female head, 3.7 cm high, carved
from mammoth ivory and
approximately 25,000 years old.
When Piette discovered this piece
—considered the first human face
ever sculpted—at Brassempouy in
the Landes, in France, in 1894,
he named it the "Hooded Head".
The same general shape, with
its pointed chin, marks the
statuettes from Lespugue and
Grimaldi, but the detailed
treatment of the nose, neck and
the arch of the eyebrows adds up
to a bold rendering of a sensitive,
fragile human being. The hair—not a
hood—is given obvious volume
and complemented with
cross-hatching, with suggestions
of ringlets and perhaps waves;
it serves to emphasize the skin
of a feminine face that is finely
worked and delicately lit.
Musée des Antiquités nationales,
Saint-Germain-en-Laye, France

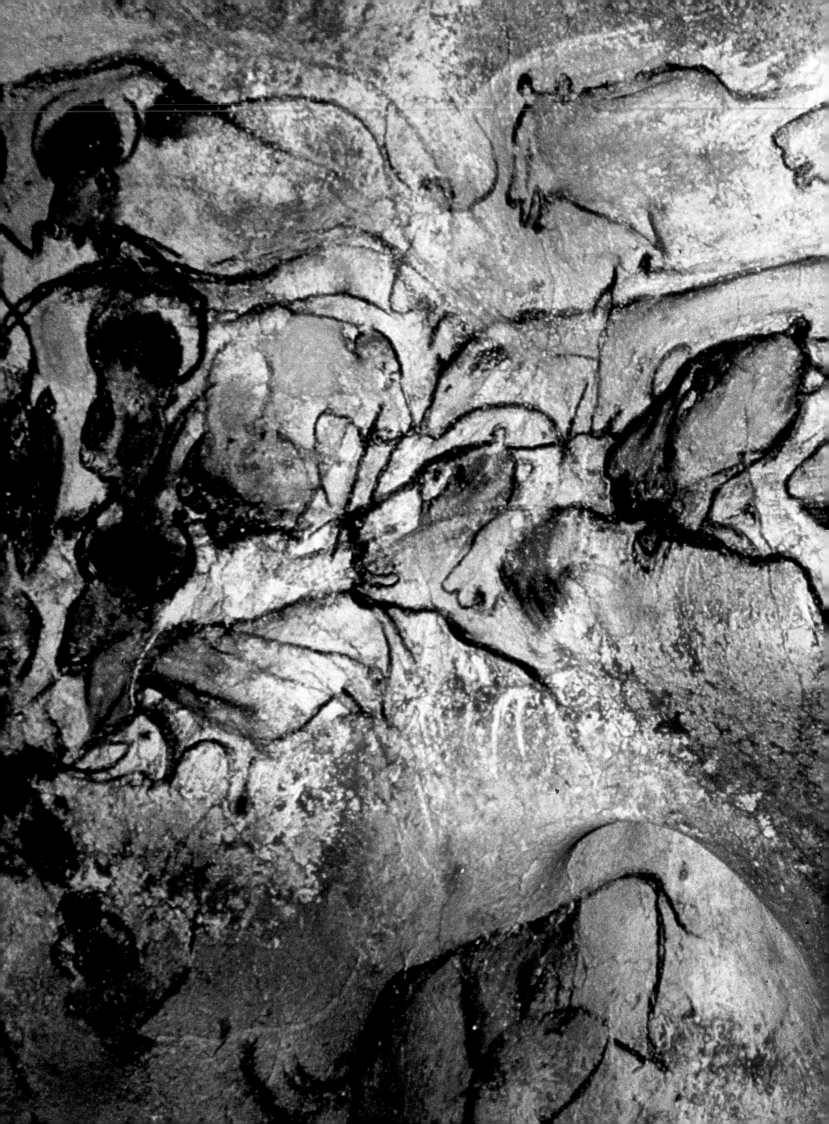

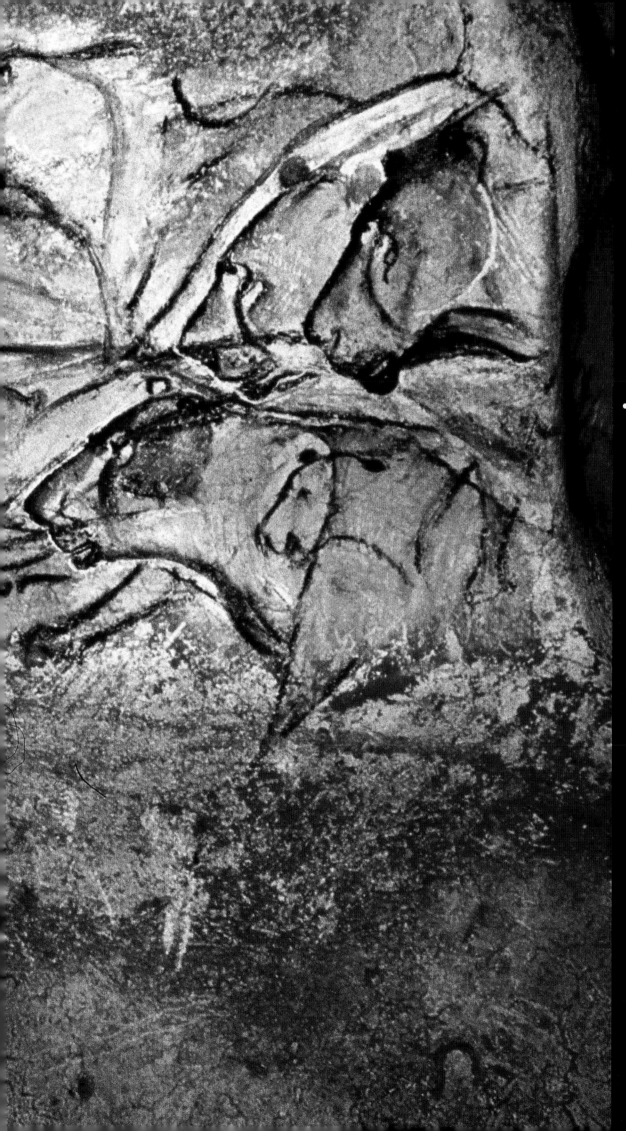

Lions hunting

Discovered in December 1994, the Chauvet Cave at Vallon Pont d'Arc in France's Ardèche region is a continuous source of wonders apparently dating from 32,000-30,000 B. P. . The Lion Panel covering some 2 m in the rear chamber uses black paint made from charcoal, unlike the paintings in the entry, which are red. These cave lions have no manes and are grouped together in a troop: only the heads and forequarters are portrayed, to heighten the impression of physical compactness and strength. Seen in profile, the big cats advance towards the left, necks outstretched and eyes fixed on the herd of bison, whose bearded, horned heads are turned to the left. There is real tension in this image of lions moving in on bison to attack them. A number of factors—the skill and fluidity of the technique, the prior scraping-down of the surface to be painted, the varying intensity of the strokes, the use of blurred areas, the engraving of the bisons' nostrils into the rock—combine to shape a vigorous, highly dramatic scene.

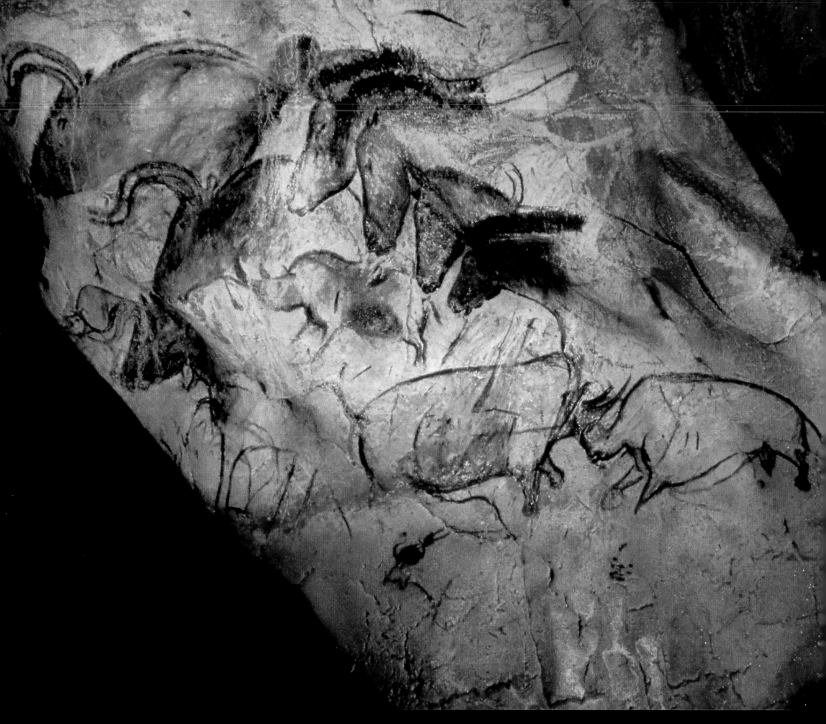

Composition with central horse

The Horse Panel, some 400 cm long and 30,000-32,000 years old, is in the Galerie des Croisillons in the depths of the Chauvet Cave in Ardèche, France. There appears to be a certain unity in the overall design, probably reflecting the intentions of a single painter: the work was carried out in 6 stages, following a preliminary phase of engraving (upper left). The engravings were partially scraped back at the same time as the panel was being prepared for painting. First came a collection of different animals on the left and the lower bison, followed by the rhinoceros combat in the lower central part. The black aurochs on the left partly obscure the initial paintings, with their eloquently curved horns seeming to indicate the painter's decision to broaden the scope of his work. 2 horses, followed by a third and 3 heads in perspective are added in the center of the panel. The last horse is then overlaid on the central area to give further depth and meaning to a magisterial bestiary.

Rhinoceros in perspective

On the left-hand part of the Great Panel in the rear chamber of the Chauvet Cave in Ardèche, France, is a herd of rhinoceros spread over 200 cm. The central part of the image employs a highly complex approach to perspective: true perspective obtained by overlapping the horns of the beasts in decreasing order of size, and false perspective using the overlapping lines of their backs. The rhinoceros shown in its entirety in the foreground is painted black, with blurring and scraped outlining used to bring depth to a scene that has undergone 6 phases of creation or modification. The red marks to the left confirm the stylized, abstract character of this astonishing composition as part of a codified system combining visual description with the realm of ideas. 32,000 – 30,000 B. P.

The "Irish elk", a fossil animal

In the depths of the Chauvet Cave in Ardèche, France, is the gallery of the megaloceros, a humped deer of a species now extinct and misleadingly called the Irish Elk. In the entrance to the gallery one of these animals, some 40 cm high, is painted in black on a surface whose history can be reconstructed: traces of broad, ancient brushstrokes have been noted on the film of calcite that has developed on the fine layer of clay covering the limestone. In addition, bears lived in the cave, leaving visible claw marks on the megaloceros's hindquarters on the rock wall. Later, a part of the images was scraped back: in the photo we can still see the upper profile of a rhinoceros, drawn in charcoal. The drawing of the megaloceros is the final episode of the saga of a rock wall where men, animals and geology intersected 32,000-30,000 years ago.

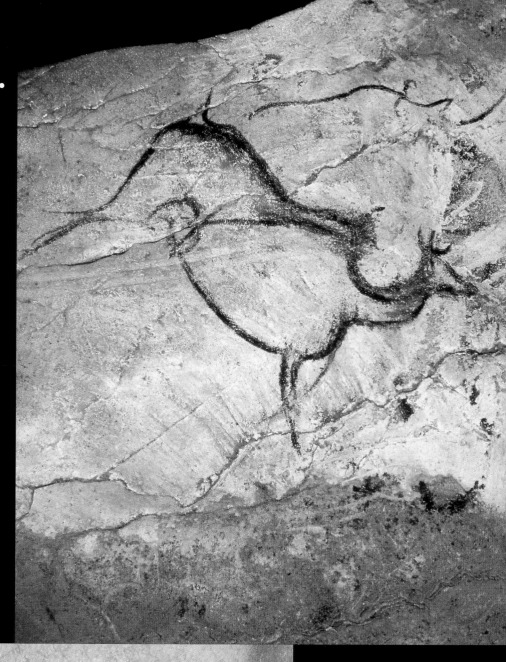

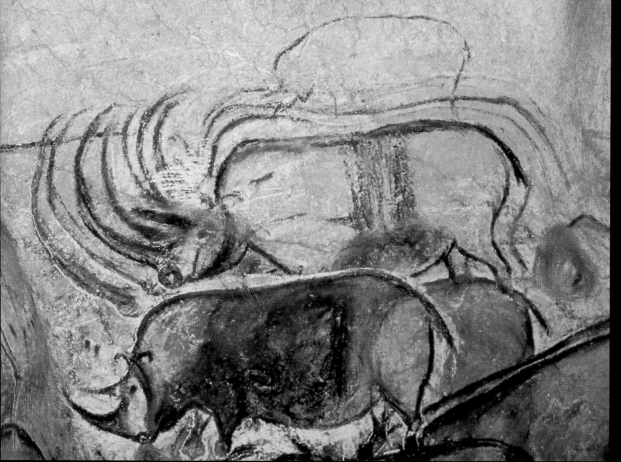

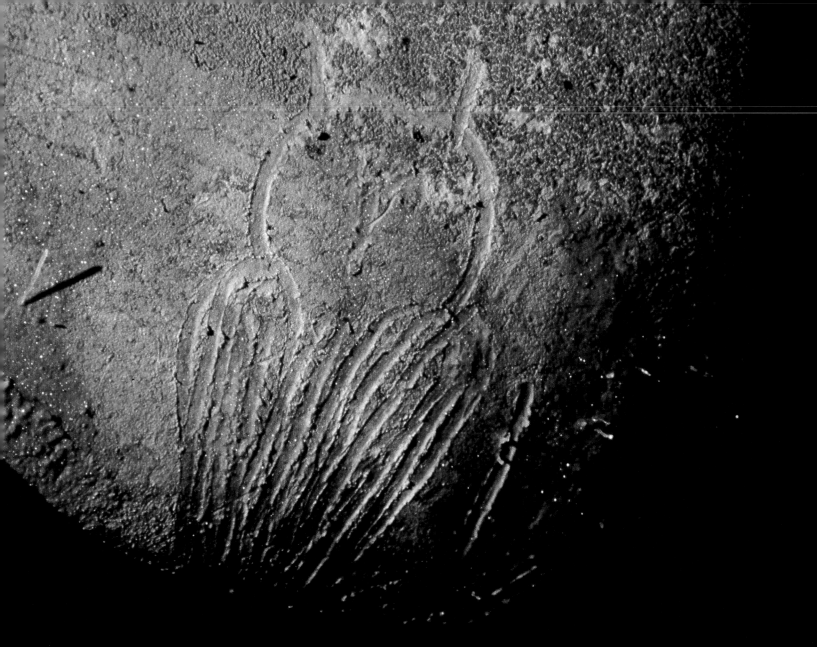

A night bird: the horned owl

In the damp Hillaire Chamber
—starting point for the 2 galleries
leading into the depths of the
Chauvet Cave in France, various
finger drawings in the upper
layer of the limestone reveal
the spontaneity and skill of
the artists of 30,000 years ago.
The horned owl stands out here,
apparently resting on a line
suggested by a rock-edge: the
striped upper part of his body
gives a clear impression of
feathers, while the head, sunk
down between the wings, is
readily identifiable by its 2 tufts.
The beak and eyes are also clearly
visible. There is a certain humor
in the way this caricature of
a night bird is slipped into
the cave's world of darkness.
The nearby vertical stroke is
one of those coded signs whose
meaning still escapes us.

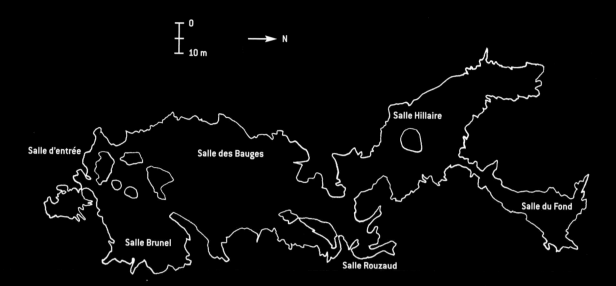

● **The Great Horse**

The Great Horse panel in the
Hillaire Chamber of the Chauvet
Cave measures 600 cm end to
end, with the Great Horse
occupying a third of it. He has
been created with a scraping tool,
but also with fingers whose marks
are visible on the neck. The
drawings overlap the bear
claw-marks that may have
inspired the prehistoric artist.
The horse's head and neck are
extremely well executed, but the
rest of the body is much more
schematic and rigid, witness the
front foot and the hindquarters.
The line of the belly betrays
hesitation and overt retouching.
The undulation along the length
of the body may represent the
outer limit of the colored hide
while also suggesting movement.
32,000 – 30,000 B. P.

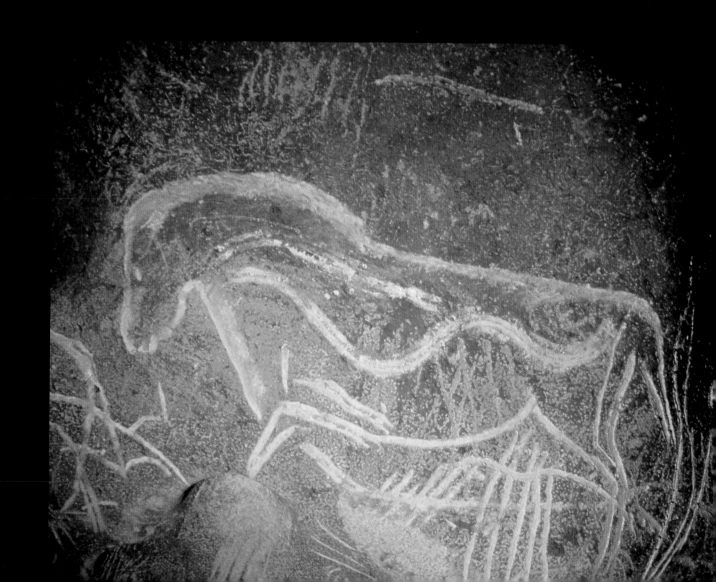

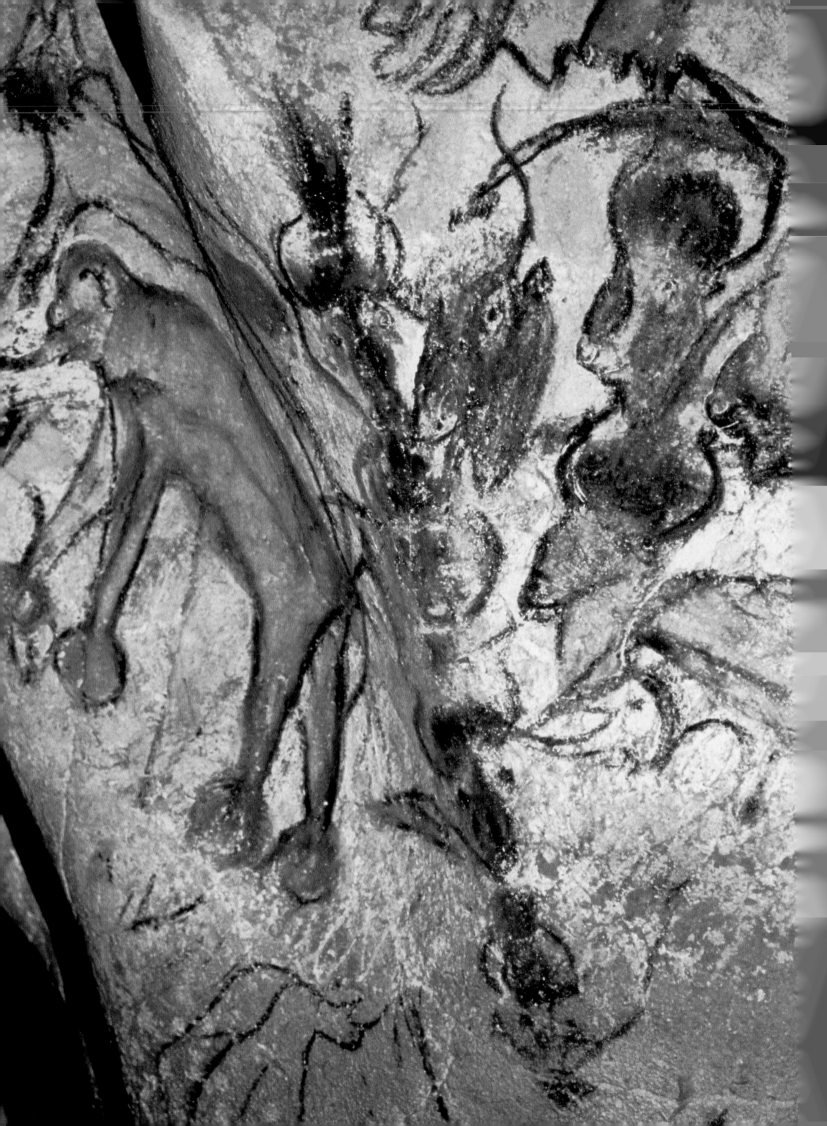

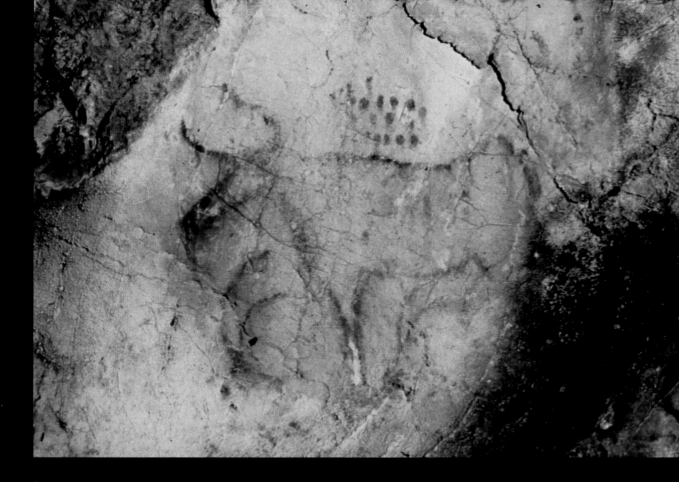

Getting the dates right

The ocher images on the wall of the Tête du Lion ("Lion's Head") Cave at Bidon (Ardèche, France) were discovered in 1963.

The main composition includes an 50 cm high aurochs—a now extinct wild ox—, the heads and forequarters of two ibex with large horns, and a rectangle made of red spots set above the aurochs' back. Facing the aurochs from the lower left is a painted deer, again reduced to head and forequarters. How old are these paintings? Being of mineral origin, the ocher cannot be dated; however, excavations carried out in 1972 turned up fallen drops of paint—scientific analysis has shown it to be the same as in the images—sealed into the sandy clay of the floor. This enabled carbon dating using fragments of Scotch pine branches used by the artists for lighting the cave and found in the same level.

Age: 21,650 ± 200 years D. P.

Frontal perspective

On the far left of the Lion Panel in the rear chamber of the Chauvet Cave, the bison pursued by big cats are shown in an unusual way: some in half-profile and four of them—set on a projection—frontally. The side-by-side heads give the impression of a galloping herd. This is another example of how changes in the pictorial surface can play a part in determining the type and form of the images. On the left a young mammoth—still with neither tusks nor hair—is painted in gray, with a darker outline. This scumbled effect has been obtained by using the fingertip to crush the charcoal into the moist surface of the limestone.

32,000 – 30,000 B. P.

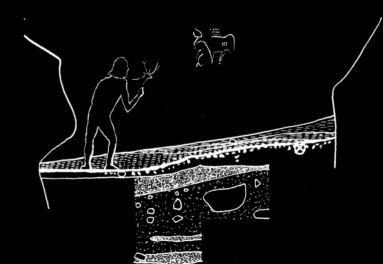

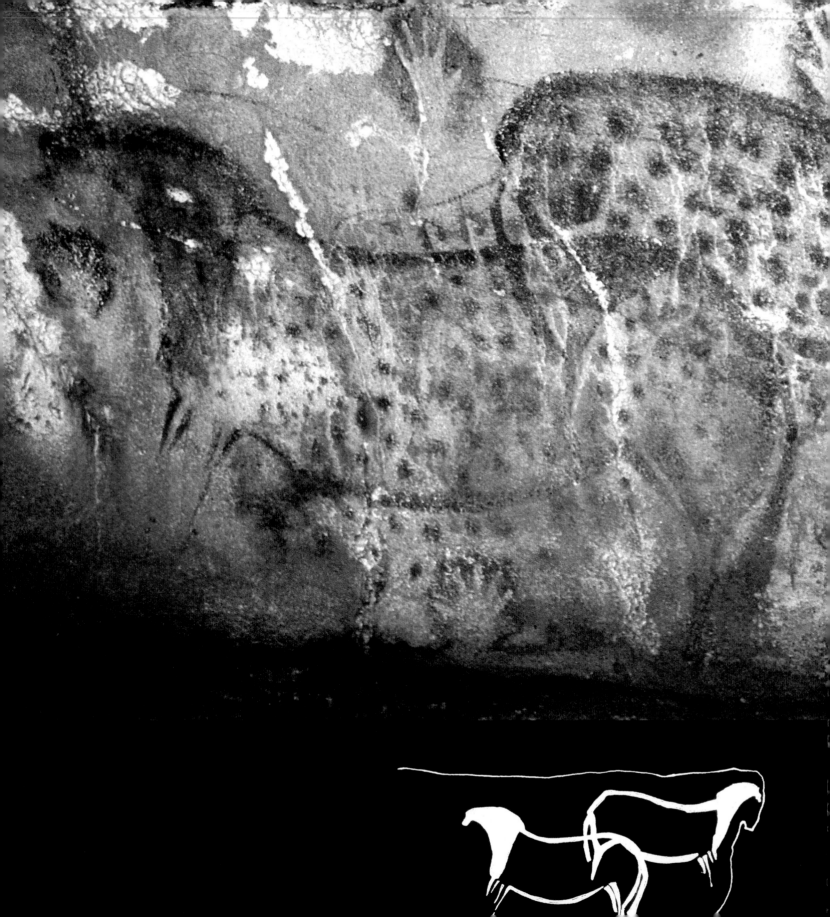

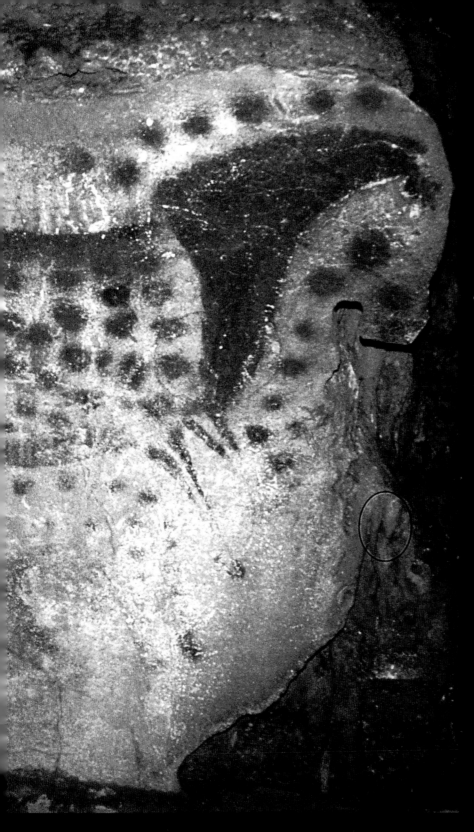

The dappled horse panel

This famous composition from the Pech Merle Cave at Cabreret (Lot, France) shows two near life-size horses (160 cm) that fit very well, especially the head of the horse on the right, with the surface of the stone they are painted on. Specialist Michel Lorblanchet has identified 4 different, complementary phases within the final composition. The first (*see* the drawing, p. 66) is of the same date as the 2 horses; the one on the right has been carbon dated to 24 640 ± 390 years B. P. The second phase is that of the 6 negative-stenciled hands surrounding the horses. The third is that of the black spots, 212 in all, dotted around the horses. The fourth (*see* the drawing below) covers the 29 red spots, the 7 stenciled hands with thumb folded back and the large fish, a pike, set on the neck of the horse on the right. There appears to be no logical development within the panel; we can only say that it is composite in character and its core element is the pair of horses.

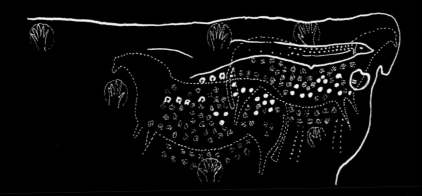

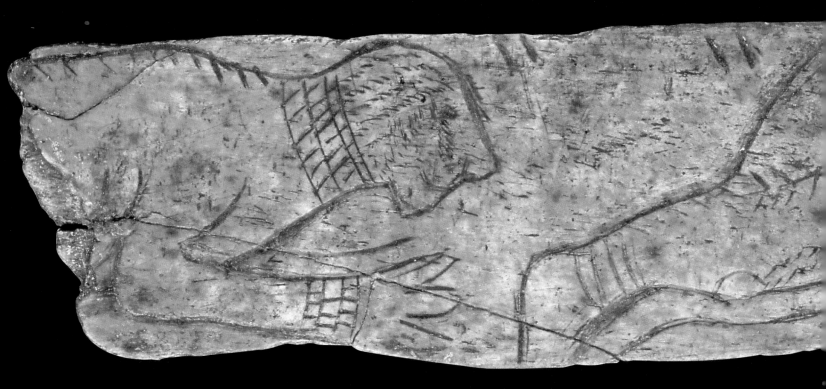

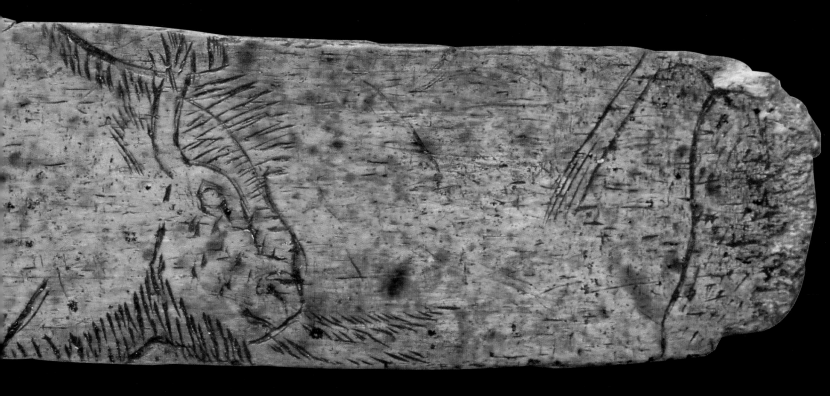

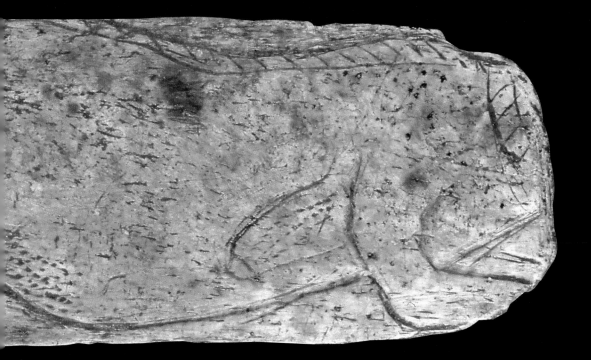

Bison and women

André Leroi-Gourhan has often
remarked on the importance
of this coupling: for him the
2 images complement each other
as the evocation of two sexual
principles. This 10 cm bone blade
from the Isturitz Cave in the
French Pyrenees is decorated
on one side with a snorting bison
whose breath is represented by
the incised hatching emerging
from his nostrils and mouth.
A second bison—only the
hindquarters are visible—is
followed by another animal that
has been wounded by two arrows.
On the other side of the blade is
a series of 3 women wearing
bracelets, necklaces and foot
hoops; the one on the right has
been struck in the thigh by
an arrow. 18,000 – 11,000 B. P.

Musée des Antiquités nationales,
Saint-Germain-en-Laye, France

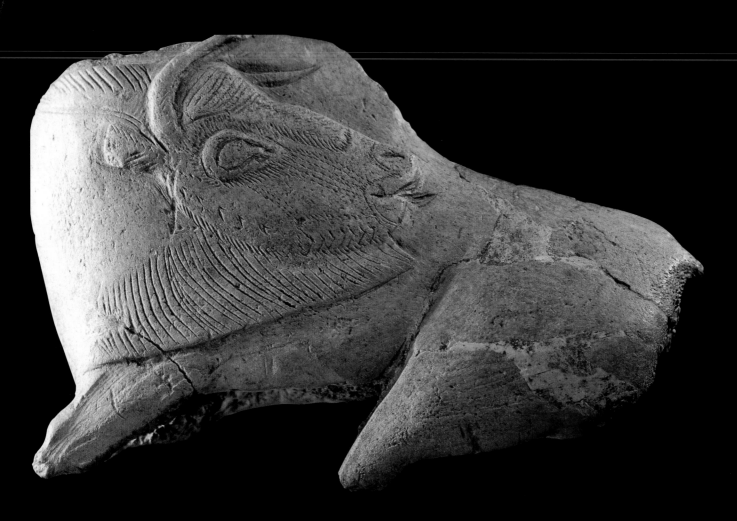

The fascinating bison

Close observation of bison allowed artists of the Magdalenian (18,000 – 11,000 B. P.) to produce splendid reindeer-antler sculptures. Using highly evocative stylization they give a clear idea of natural behavior. Below, for example, the bison licking itself in the La Madeleine Cave at Tursac (Dordogne, France) is 10 cm long: although his head is sparely indicated, we see him turn towards his left flank in a pose that is magnificently incised right down to the pointed tongue. The other bison head carved on a reindeer-antler cylinder is 5 cm high and shows the outline of the horn, forehead, muzzle and beard. It comes from the Isturitz Cave in the French Pyrenees.

Musée des Antiquités nationales, Saint-Germain-en-Laye, France

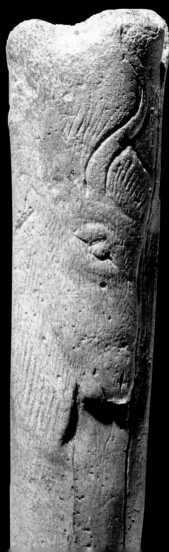

Birth of the little man

Few of the engraved stone plaquettes from the La Marche Cave at Lussac-les-Châteaux (Vienne, France) are as readily intelligible as this one, showing a man's head with an upturned nose and a "scarred" face. According to the interpretation of J. Airvaux, another, less "readable" plaquette portrays a newborn baby with a big, old man's head, atrophied arms and the umbilical cord; overlapping the image is that of a corpulent naked woman, doubtless the mother. This overlapping is probably intended to indicate a close relationship, as here between mother and baby. This "birth of the little man" is certainly one of the earliest examples of its kind, 14,000 years ago.

Musée des Antiquités nationales, Saint-Germain-en-Laye, France

Musée de l'Homme, Paris, France

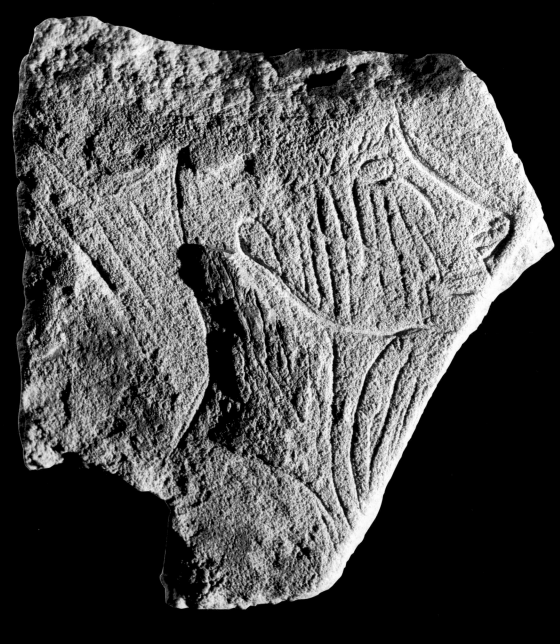

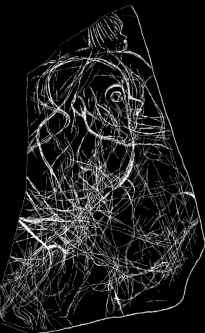

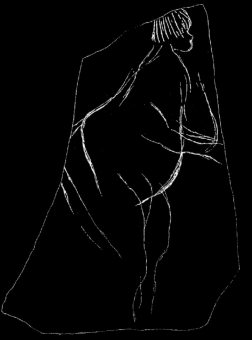

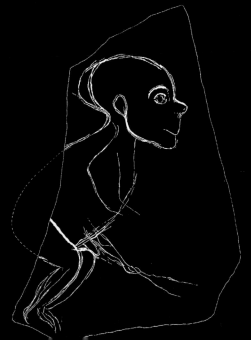

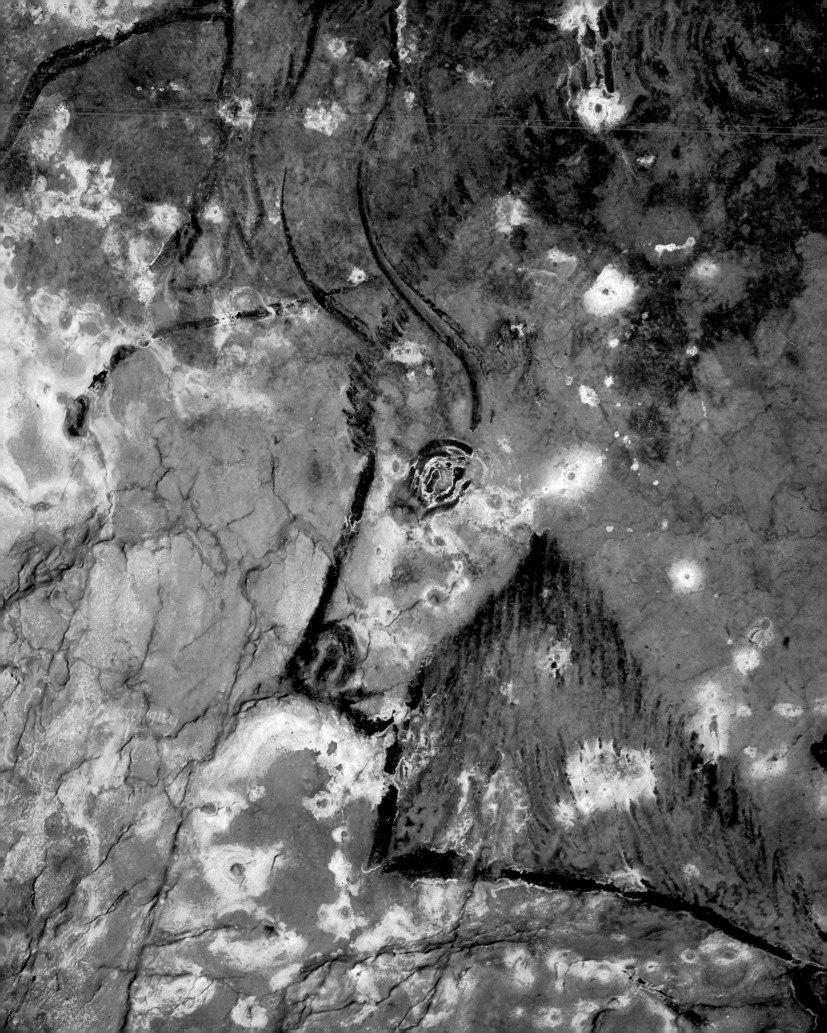

The Salon Noir bison at Niaux (Ariège, France) and especially the one on the left, are among the most majestic of the entire Magdalenian period. The animals on the right are part of the same panel. The one furthest to the right and lower down (the head is shown in the box below) has been struck in the flank by two arrows. It has been dated, using a minute sample of charcoal, to 12,890 ± 160 B. P. Measuring 300 cm long, this would seem to be a female sniffing her calf; just below the latter is a young ibex wounded by javelins. The large bison a little higher up has also been struck by a javelin. In the upper part of the painting another ibex mingles with a herd of bison, as do the miniature horse and male ibex; this bestiary appears to have been created all of a piece, but the arrows and javelins may be later additions. This cave also contains many other marks.

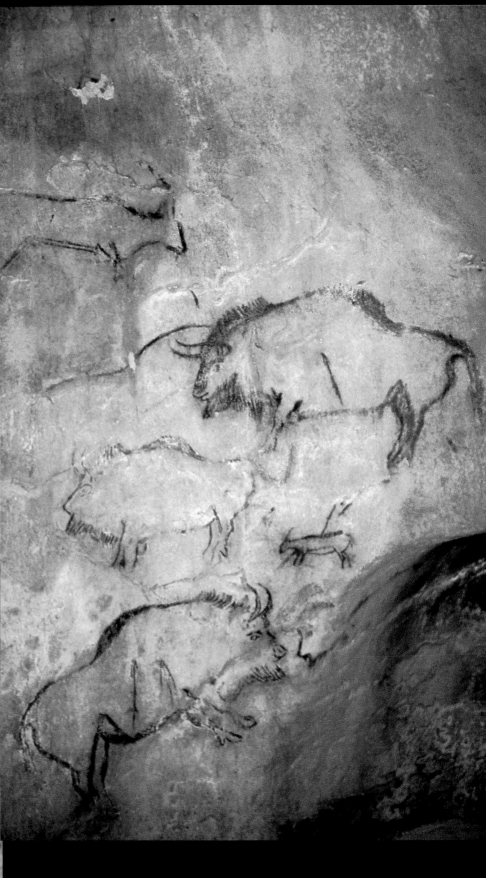

A pair of bison

This is a clay model from the
Tuc-d'Audoubert Cave at Le Volp
(Ariège, France). This tricky
technique is well mastered here:
set to the upper left, the male
measures 63 cm and the female,
in the foreground, 61 cm. The clay
was worked with the fingers
and smoothed: the beard, eye,
nostril and mouth were probably
drawn in with a bone spatula.
A small bison measuring 12 cm
was found not far from the female.
The cave has been dated to
the late Magdalenian, c. 13,000 –
11,000 B. P.

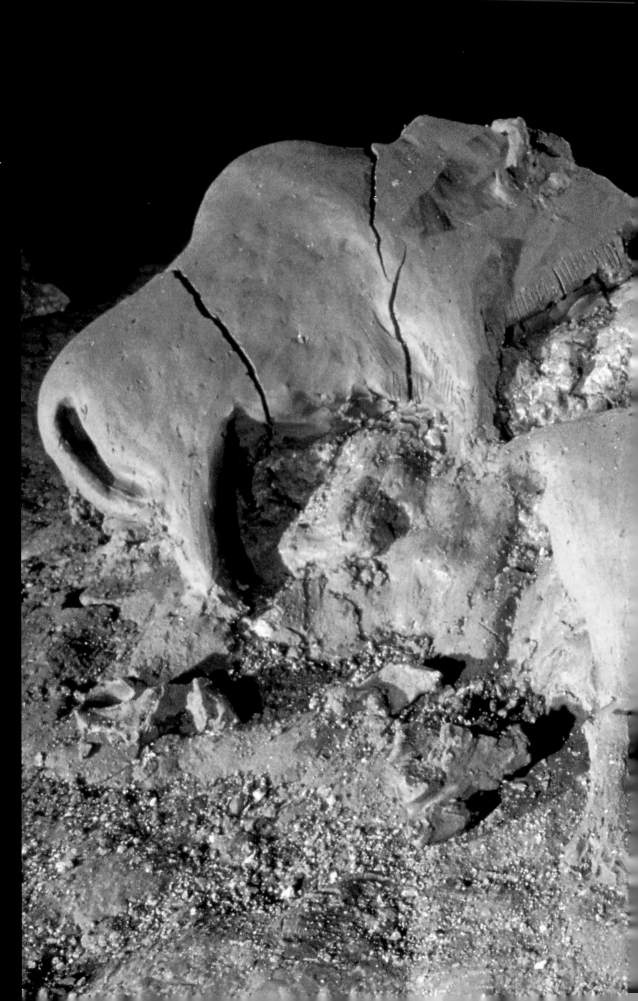

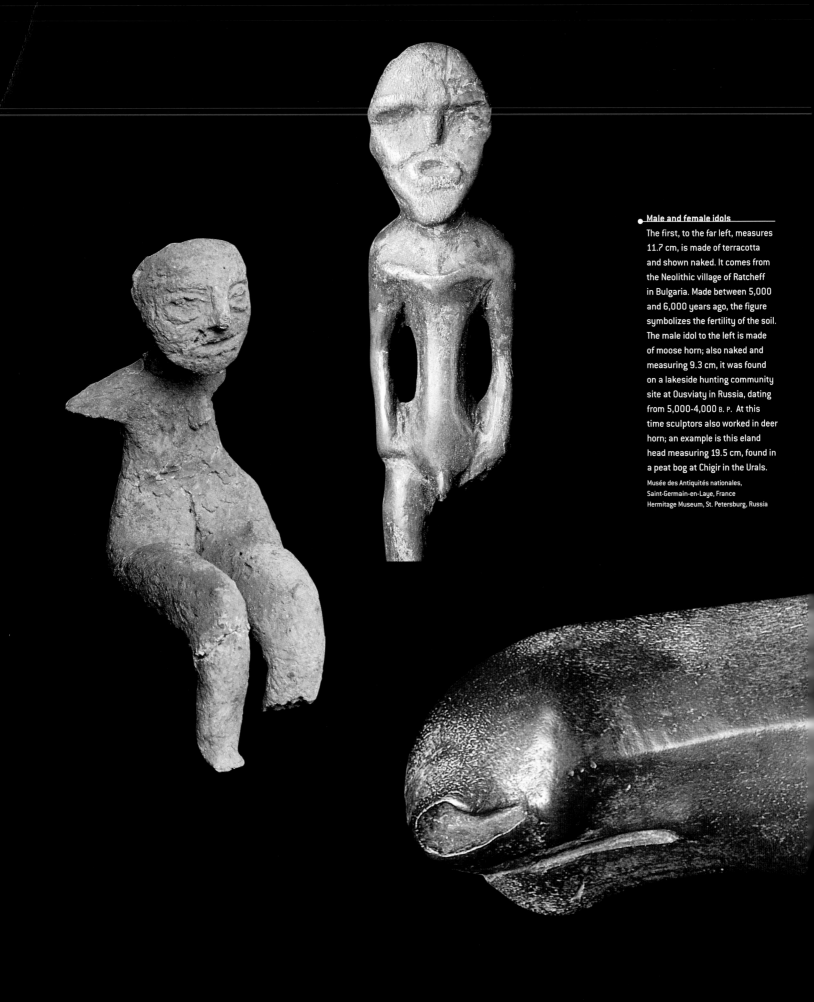

The first, to the far left, measures
11.7 cm, is made of terracotta
and shown naked. It comes from
the Neolithic village of Ratcheff
in Bulgaria. Made between 5,000
and 6,000 years ago, the figure
symbolizes the fertility of the soil.
The male idol to the left is made
of moose horn; also naked and
measuring 9.3 cm, it was found
on a lakeside hunting community
site at Ousviaty in Russia, dating
from 5,000-4,000 B. P. At this
time sculptors also worked in deer
horn; an example is this eland
head measuring 19.5 cm, found in
a peat bog at Chigir in the Urals.

Musée des Antiquités nationales,
Saint-Germain-en-Laye, France
Hermitage Museum, St. Petersburg, Russia

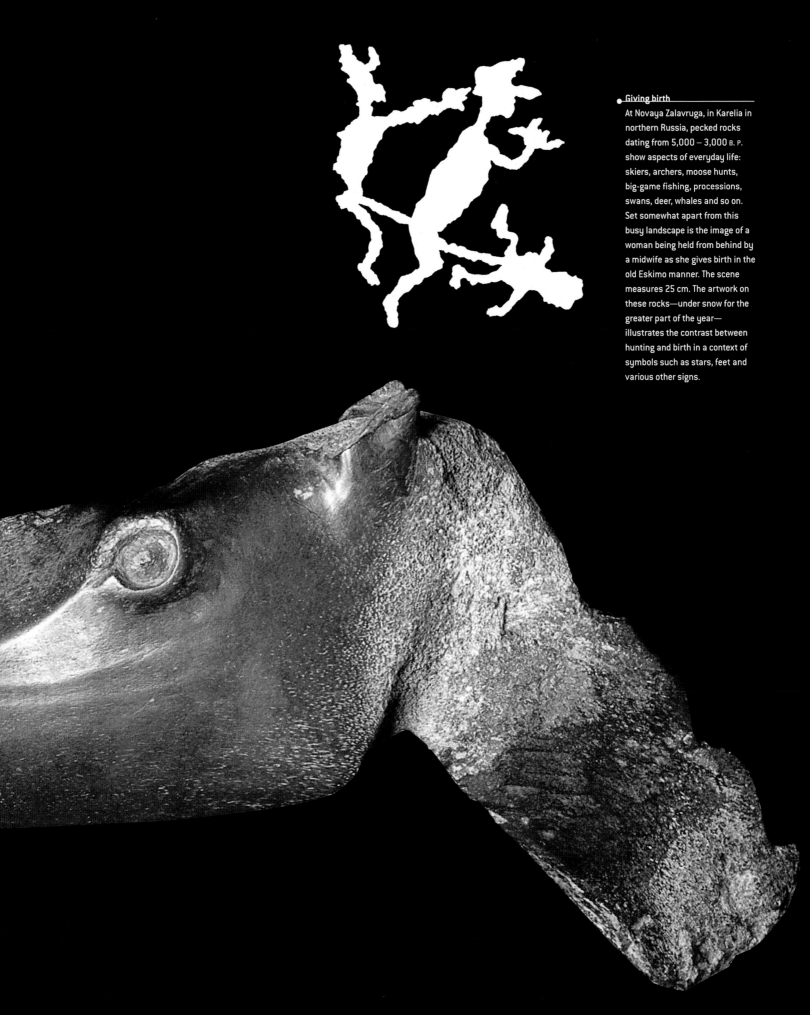

Giving birth

At Novaya Zalavruga, in Karelia in northern Russia, pecked rocks dating from 5,000 – 3,000 B. P. show aspects of everyday life: skiers, archers, moose hunts, big-game fishing, processions, swans, deer, whales and so on. Set somewhat apart from this busy landscape is the image of a woman being held from behind by a midwife as she gives birth in the old Eskimo manner. The scene measures 25 cm. The artwork on these rocks—under snow for the greater part of the year— illustrates the contrast between hunting and birth in a context of symbols such as stars, feet and various other signs.

The Mont-Bégo Sorcerer

A rocky outcrop on the slopes of Mont-Bégo, at Tende in the French Alps, offers us the strange, humanlike figure known as the "Sorcerer". 29 cm high, he seems to be made up of a quadrangular base with 2 antennae or horns ending in hands with spread fingers. The basic motif is that of the "horned man" common in the Mont-Bégo area and here associated with 2 triangular blades, doubtless copper daggers of a type made 5,000 – 4,000 years ago. The local herding rites may have included sacrifices —this would explain the daggers— and only took place in late spring or summer, when these alpine pastures, 2,000 m above sea level, were free of snow.

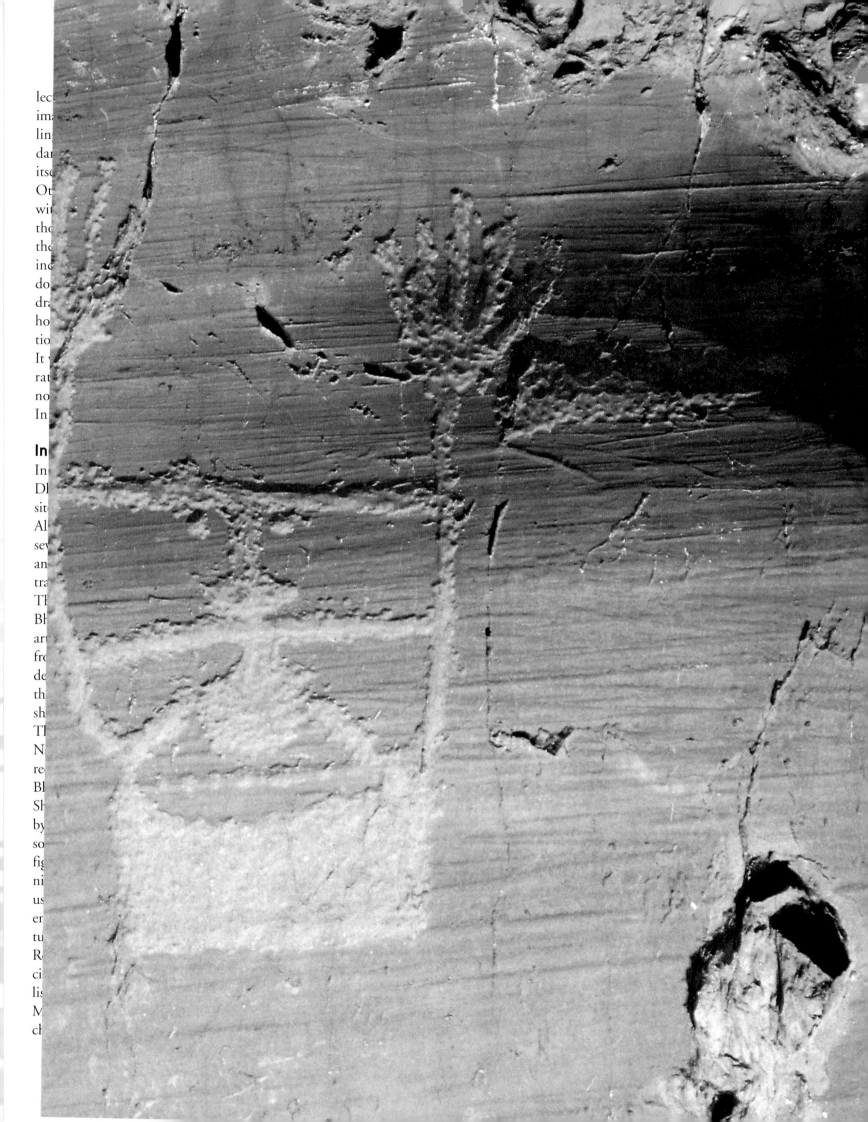

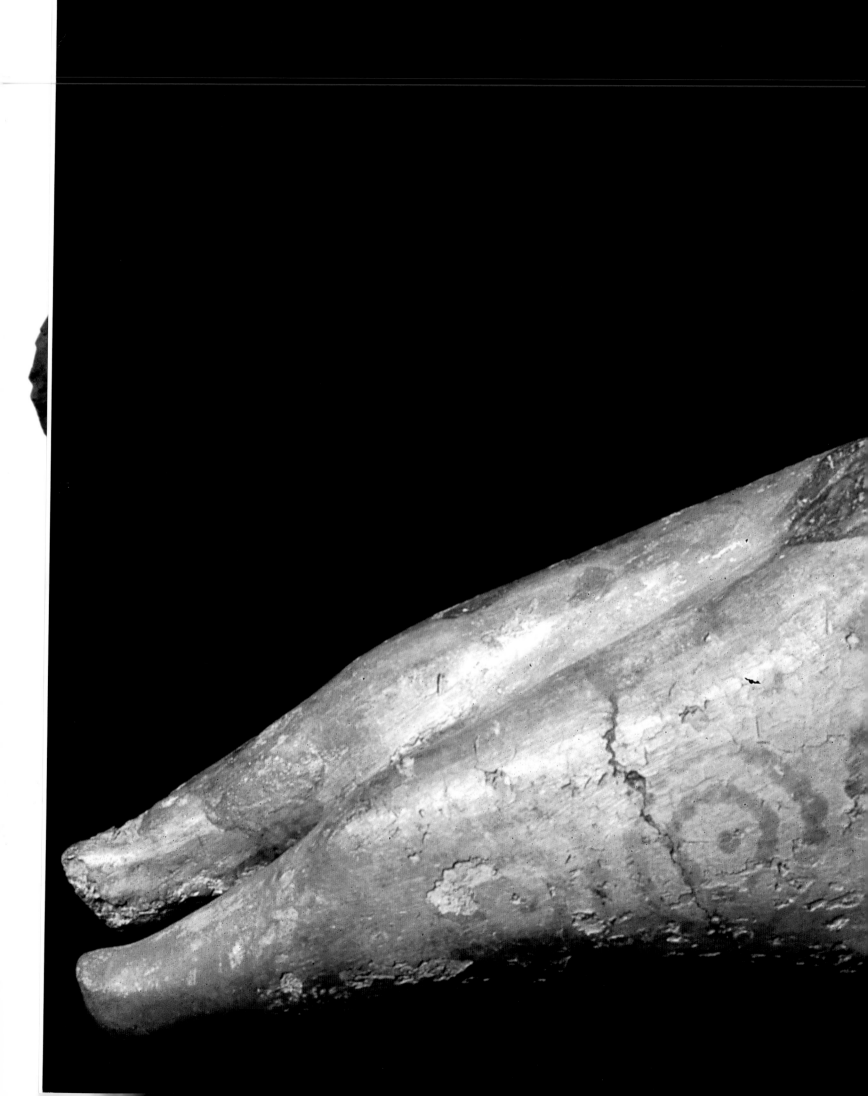

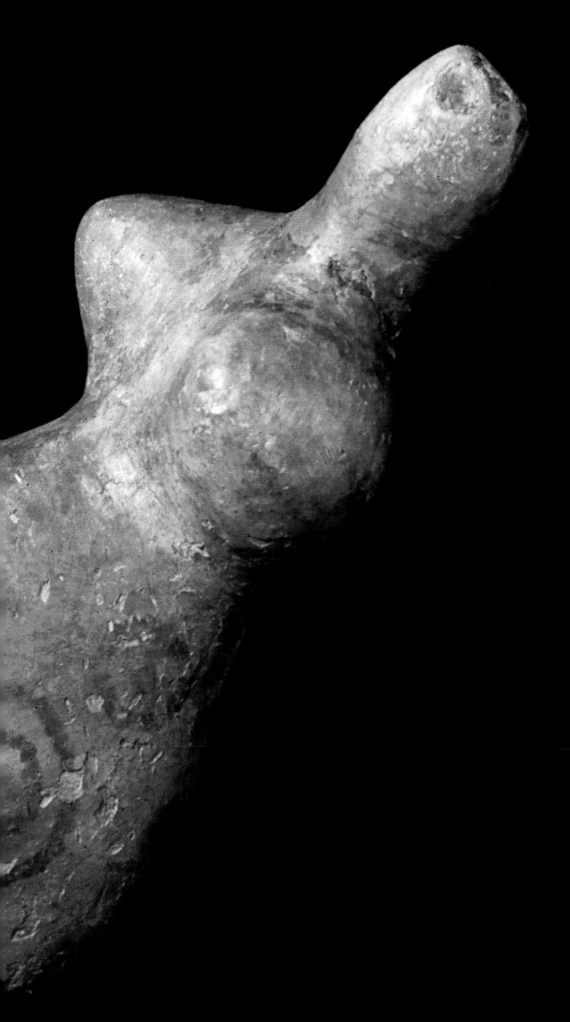

A mother-goddess

Modeled in clay then fired and painted with red ocher, this 27 cm figurine of a seated female comes from Yalangach-Dépé in Turkmenistan, a farming village dating back 5,000 – 6,000 years. The head, with only the eyes indicated, appears to be turned towards the sky. The bosom comprises 2 large, conical breasts and there are no arms. The massive thighs are decorated with circles painted in black, as is the clearly visible pubic triangle. Female figurines were very common in early farming communities in the Near and Middle East and may be related to a mother-goddess cult.

Hermitage Museum, St. Petersburg, Russia

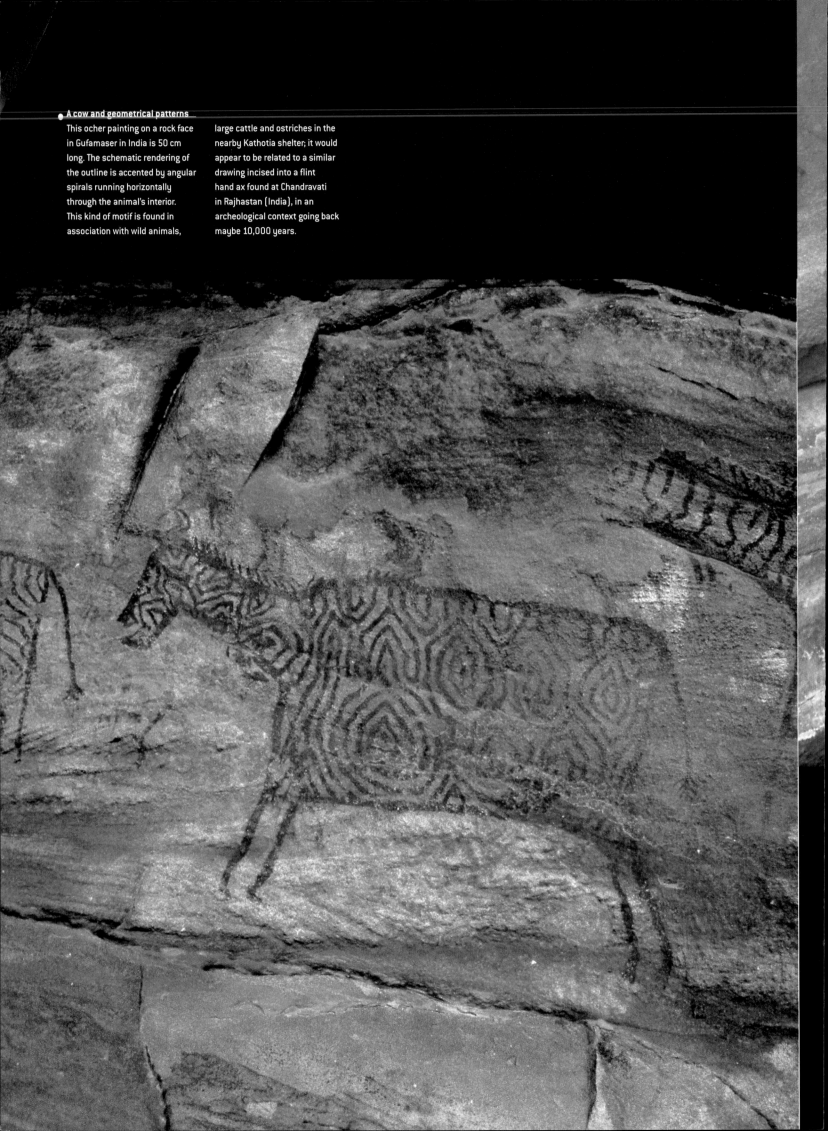

A cow and geometrical patterns

This ocher painting on a rock face in Gufamaser in India is 50 cm long. The schematic rendering of the outline is accented by angular spirals running horizontally through the animal's interior. This kind of motif is found in association with wild animals, large cattle and ostriches in the nearby Kathotia shelter; it would appear to be related to a similar drawing incised into a flint hand ax found at Chandravati in Rajhastan (India), in an archeological context going back maybe 10,000 years.

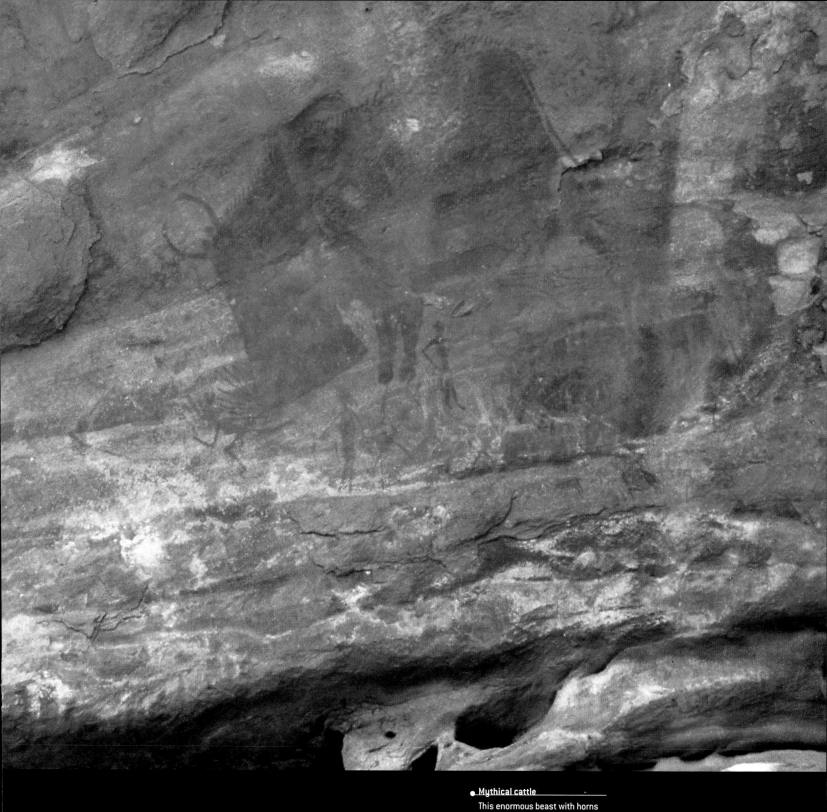

● <u>Mythical cattle</u>
This enormous beast with horns
and an outsized head is charging
a small figure who is running
off in fear. Other human and
quadruped silhouettes of different
sizes, some of them miniature,
surround the maddened animal.
The 140 cm wide ocher-painted
scene is to be found in a shelter
in Bhimbetka, in India. One of
the richest sites in the region,
Bhimbetka offers thousands
of motifs dating from between

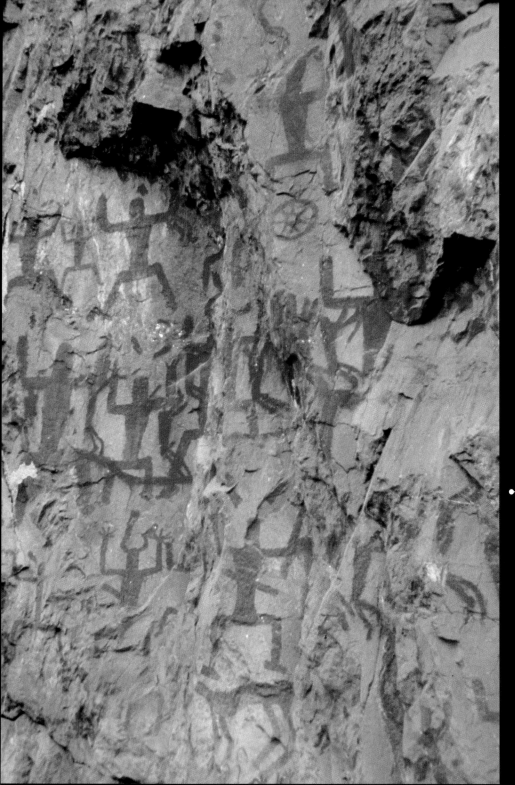

The paintings at Huashan, in Guangxi province in southern China, mainly portray figures with their arms raised and legs spread in the posture of someone paying tribute to a god. There are also animals that may be horses, but the other most striking feature is circular signs and stars surrounded by a circle. The local people held ritual meetings at the base of this imposing painted mountain; carbon 14 analysis of the calcite layer that has formed over the images indicates that the painters were at work here between 2,370 and 2,115 years ago.

The legend of Mongka, the hero

In 1950 came the discovery at Huashan, in Guangxi province in southern China, of a vertical rock face 40 m high and 200 m long overlooking the Zuojiang river; on it 1,800 figures were painted in red. The legend has it that Mongka, a hero who devoted his unlimited physical strength to truth and justice, rebelled against his king, who hated the poor. As Mongka had no army, he painted soldiers and their horses on the rock face; they were then transformed into a heavenly army that crushed the royal troops. The local people pay tribute to their hero by continuing to produce rock paintings from 30 to 300 cm high.

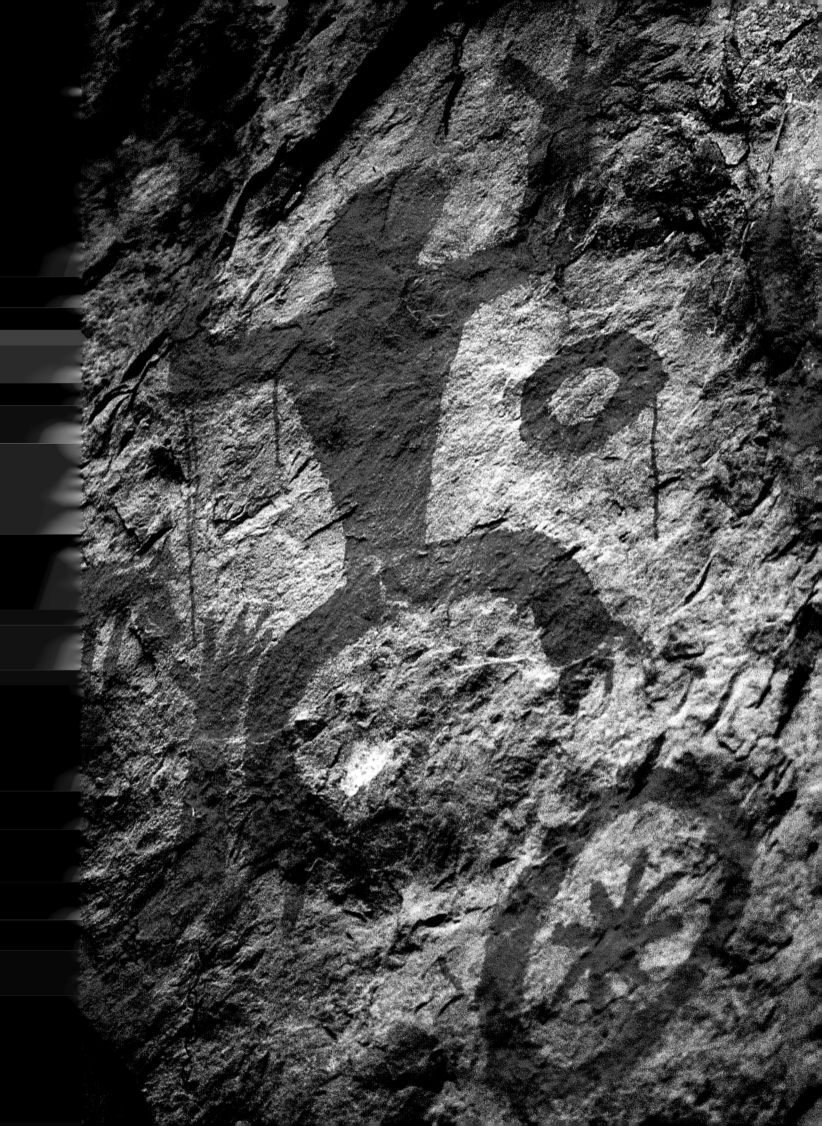

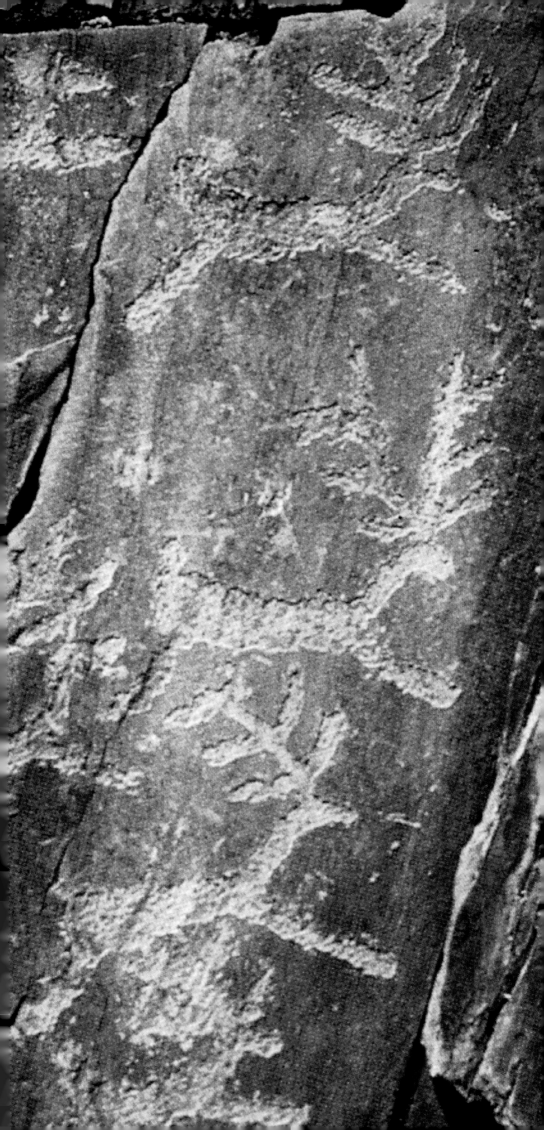

INDONESIA AND AUSTRALIA: RECONCILIATION WITH THE PEOPLE OF THE DREAMTIME

The discovery in 1997 of the stenciled hands of the Gua Mardua Cave in Borneo triggered acknowledgement of Indonesian prehistoric art whose existence had seemed likely in the light of the centers long known to exist in Australia. It is now accepted that the earliest sites in Greater Australia now date from the period 60,000-40,000 years ago. It would seem that humans of the archaic *Homo sapiens sapiens fossilis* group, found in the burial sites at Lake Mungo, took advantage of the drop in sea levels to leave New Guinea and cross some 70 kilometers of ocean to inhabit the new continent. A 40,000-year-old site on the east coast of New Guinea matches another not far from Sydney on the east coast of Australia.

In Arnhem Land the presence of humans using stone tools such as hand axes and scrapers, is attested in association with fragments of red colorant in the deep levels of the two neighboring shelters of Malakunanja II and Nauwalabila, dated to between 60,000 and 53,000 B. P. Since the earliest times the use of ocher has gone hand in hand with the decorative coloring of the human body or of rock faces, as in the collapsed shelter at Carpenter's Gap in the Kimberley, dated to 39,000 years ago.

The first great rock art period is the pre-estuarine, so called because it is contemporaneous with the period of low sea levels that lasted until 6,000 B. C. It includes notably the Paranamitee style, named after an open-air site containing 20,000 engravings and situated 350 kilometers north of Adelaide. The technique is that of relatively deep polished pecking, with two thirds of the petroglyphs—rock drawings—being accounted for by animal footprints making up lines. Among the rest are found representations of kangaroos, wallabies, emu and, on the Cleeland Hill site, a few human figures and faces with eyes made up of concentric circles. Reminiscent of the Karake Cave style, also from southern Australia, circles of 20-30 centimeters in diameter are numerous on some sites, together with cup shapes and long straight lines. The schematic Paranamitee style can be found over several thousand kilometers, not only in the southern and eastern halves of the country, but in Tasmania as well.

The Paranamitee tradition is so familiar to today's Aboriginal people that they can read the signs on the rocks as if they constituted a form of writing. A circle stands for a group of people, a circle filled with dots is a group of people in search of food or hunting an animal; the tonsil shape is a group of people moving in the direction indicated by its point; the crescent is the half-moon two weeks old; a trident is an emu footprint and the equivalent of a woman;

a line with two double barbs is the symbol of an initiated male (P. Beeh, 1993). In Arnhem Land, in northern Australia, there are shelters containing pictographs dating back more than 20,000 years. These are colored imprints of hands and various objects such as cabled sticks and large plants—kinds of vertical lianas—or of animal tracks as in the first style, but painted. This technique of infilled imprints and stencils is also a feature of the art found at Laura, in Queensland, which also includes Paranamitee-style engravings, numerous stenciled hands, boomerangs (*Djawumbu-Madjawarrnja* in Arnhem Land) and even animals such as lizards. A similar technique is to be found on the nearby Koolburra Plateau, where the dominant figures are Quinkans, evil spirits with staring eyes, a kind of helmet or long ears, twisted limbs and knobbed male sex organs.

While rock art began very early in Australia and prospered over an extremely long period, portable art is limited to a few pierced shells like those found in the Mandu Mandu Shelter in Western Australia and dated to 32,000 years ago. The second major style of the first period covers what Australian rock art specialist George Chaloupka (1997) calls "the great naturalistic figures complex" in Arnhem Land. The complex comprises large-scale representations of animals and humans outlined in dark red ocher on rock faces and superimposed in a way that provides a breakdown of their postures, as in the case of the macropods at Inagurdurwil. The Maddjurnai site is dominated by a python 2,6 meters long, painted over earlier images of macropods, while the Dangurrung Shelter is clearly dedicated to the crocodile where one of the three images is 3,4-meter long. Certain animals belong to species that no longer exist in the area, like this enormous crocodile or the thylacine or "Tasmanian tiger", a doglike carnivorous marsupial also depicted at Dangurrung. The site at Golbon offers a recognizable echidna of a species that has been extinct for 15,000 years. The spectacular shelter at Wongewongen is home to a marsupial tapir with its young, representatives of a species that died out 18,000 years ago; they are drawn in red, with spotted bodies. For the Aboriginal people the images of these vanished animals from the Dreamtime preserves the creatures' magic power. This ancient style would also seem to be present in the thousands of gigantic pecked and polished sandstone petroglyphs at the mouth of the Hawkesbury river, north of Sydney: human figures more than 10-meter tall and gigantic animals including a whale some 30 meters long.

While relatively rare in Arnhem Land, the human figures found there are varied; the commonest conventional form, as at Bonorlod, shows a naked man lying horizontally with arms spread and legs slightly bent, as if he were floating in the air. The most detailed treatment is given to the hands and feet. The female figures, also shown with arms spread, may have a more hieratic function, while an image of a couple accords the same graphic treatment to both the man and the woman.

The earliest period of Australian rock art already includes a feature that was to become an enduring tradition: the so-called X-ray technique, used only in monochrome form in ancient times. At Liverpool River a man is portrayed in this way, in profile and with indications of his internal organs; the same technique is applied to animals, one example being an echidna at Maddjurnai.

In the same general category as the great naturalistic figures is the "dynamic" style, but rather than paintings, the works in question are dark outline drawings. At Dangurrung, for example, a long-haired hunter runs while

concealing himself behind a bunch of foliage held in his right hand; with his left hand he has thrown a spear whose trajectory is indicated by a line of dots, the spear itself having struck an emu that has come to a halt and is coughing blood through its open beak. The movement of the skinny hunter is rendered as a "flying gallop". In the shelter at Djuwarr another equally skinny, disjointed-looking hunter some 120-centimeter tall brandishes a boomerang and spears. The dynamic style is an evolving one, figures at Maddjurnai and Dangurrung being reduced to no more than a line and a globular head, while others, at Bokull and Maddjurnai have larger bodies treated in a more naturalistic way. In their conveying of movement and the delicate curves of their human profiles, some scenes attain a striking degree of elegance, as in the case of the "Mountford" figures: the hunters portrayed at Garrkkanj and the women dancers at Inyalak.

The second great period is that of a new naturalistic style known as "the figurative complex". This takes us back to the "estuarine" period of 8,000 to 1,500 years ago, when global warming led to the partial melting of the polar ice caps and a rise in sea level. The major centers of rock art in terms of the dominant style of this period are to be found in the Dampier region in Queensland, where engraving dominates. Other important centers exist in northern Australia, in Arnhem Land, and as far east as Sydney, where the emphasis is on painting. The painted style is either bichrome or polychrome and the subjects are large and given to spectacular movements. The ceiling of one of the shelters making up the Ubirr complex is painted and over-painted with ocher and white images of different sea fish, chosen by hunter-artists who also leave imprints of their hands. Most of the fish (mullet and catfish) are painted using the X-ray technique, with bones and internal organs on display. Examples of painting with beeswax are found at Gunbilngmurrung and Ginga Wardelirrhmeng, where two animal-headed male figures are portrayed, one of them copulating with a woman. The subjects are painted in outline and the areas thus defined are entirely filled with geometrical patterns.

Contact with Europeans dating from the late eighteenth century resulted in a number of new motifs in painting, among them boats and men smoking pipes, carrying guns or riding horses. However, the ancestral tradition clearly lived on as the witchcraft paintings of Daberrik and Amarrkanangka testify, with images of human beings with heads and limbs twisted out of position. Human sexuality is expressed by caresses between couples or scenes of copulation, as at Gruwunggayai and Wulirak. Ceremonial scenes are also included: circumcision and dancing at Djawumbu-Madjawarrnja, and funerary rites at Djarng. Another scene shows men confronting each other around a hedge or tree at Ginga Wardelirrhmeng. Shown in human form, the mythic ancestors known as Wandjinas can reach 5 meters high; dying, they left their images in the shelters where they became the creators and protectors of the tribes. They are portrayed without mouths and their heads are circled with a red band on a white background. The "Lightning Brothers" found in paintings in the shelters of the Kimberley are also foundation myth heroes, figures of the Dreamtime whose magic powers influence the rains and fertility. The Mimi paintings and the lightning figures represented as human silhouettes

at Malangunnger, Nangaloar and Nourlandjie refer to myths that are still very much part of current beliefs among Aboriginal people in Arnhem Land. Some of the mythic ancestral heroes can be identified by name: Warramurrunggundji, for example, is the name attributed to the pictograph at Inyalak of a woman with fifteen sacks hung around her neck. At Djuwarr the serpent Almudj appears entwined around two young men, but in female form, with one arm, breasts and two legs. At Yirrwalatj the serpent takes on the form of an undulating crocodile. At Bornorlod the myth of Badmardi Almudj is portrayed via a rainbow serpent with two young men inside its body. This serpent, often accompanied by two thylacines or "Tasmanian tigers" carrying sacks, lives in the waterfall gorges of Mirbolol, the female principle whose husband is called Gorrogorro. At Djuwarr Mirbolol and Gorrogorro are rendered as slender, humanlike beings.

At Dangarrung a branchlike creature can be seen among the handprints: this is a Dreamtime being known as Nadjurlum, related to the destroying wind. Yak is a macruran, a quadruped with the head of a kangaroo and an over-sized penis who once took part in the activities of the Dreamtime creatures; in the painting discovered in the Namarrgon complex, he is shown carrying a sack on his back. In the painting at Bardugban, the ancestors appear as the ghostly silhouette of Morkul-kau-luan, while at Madjana and Anbanghbang they take the form of the butterfly spirit, with twin antennae.

Howitt, quoted by Cartailhac and Breuil (1906), reports that for an initiation ceremony an old man modeled on the ground the outline of a life-size naked man in a dance posture, the mythic figure Daramulun. A little further from the site he modeled the hero's ax, then two emu footprints and lastly the bird killed by Daramulun. The 1895 description by R. H. Matthews of a sacred camp set up for initiation ceremonies by the Wiradthuri tribe is markedly similar: 160 meters from the center of the camp there began drawings cut into the soil and the trees, beginning with the image of an emu 2 meters long drawn on the ground; then came gigantic emu and human footprints, followed by the outline of a man, 7 meters long and modeled with earth brought from elsewhere. The arms were spread and nearby was an enormous hand, four times life-size: the hand of Baiama, the tribe's mythical ancestor. Further away were images of the moon, of Wahwee, a serpent 20 meters long and of one of Baiama's sons. The trees were marked with representations of yams, fish, serpents, turtles, the moon and the sun. This area was surrounded with a brush hedge, to preserve the sacred character of the ceremony. The overlap between the different techniques for marking out a sacred site—defined by allusions to the heavenly bodies and mythic animals and heroes—is highly instructive regarding this open-air cosmology.

The above references to beliefs in mythical beings point to hallucinatory revelations as the source of such unearthly creatures as the half-man half-woman at Anbadjawuminj, painted with a protuberance on its belly, the head of a kangaroo emerging from the right side of its pelvis and a plant sprouting from its right knee. Drawn from the depths of the collective Aboriginal imagination, these references constitute their society's foundation myths.

Prehistoric painting •
discovered in Borneo
Investigations in 1997 and 1998
led to the discovery of a group
of decorated caves in Borneo,
including the one at Gua Mardua.
Surprisingly, the artwork included
6 negative-stenciled hands
outlined with "spit-painted" dark
brown or red ocher; this motif
and technique are found on all
continents, but this does not
signify a connection between the
painters, who lived at different
periods and doubtless had their
own reasons for working as
they did. There is no doubt that
this is the work of *Homo Sapiens*,
but it represents a form of
communication that developed in
many centers around the world.

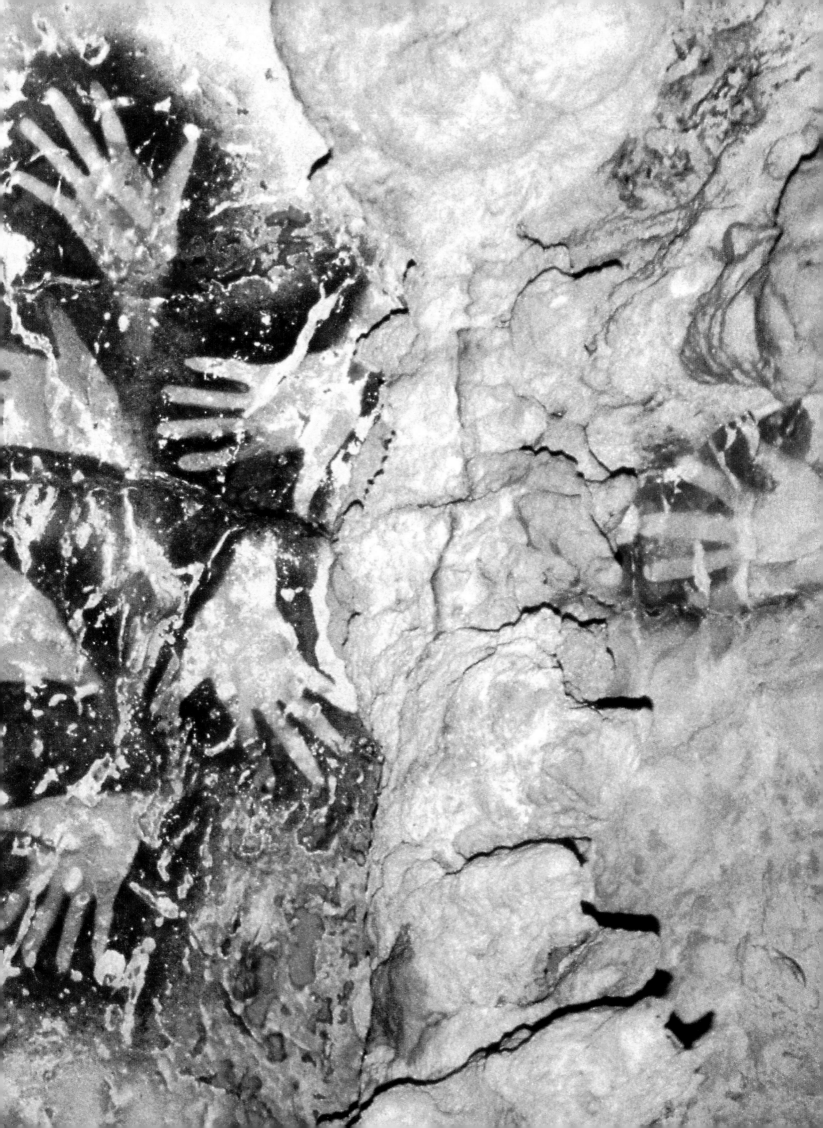

Footprints and signs

One of the most ancient of the Australian styles is the Paranamitee, found in the south of the continent. The number of pecked motifs found on horizontal rocks has been estimated at 20,000; they doubtless date from the millennia preceding the "Estuarine" period 8,000 years ago, when the sea level rose and Australia became less accessible. The images visible in the upper part of the photo are some 10 cm long: the footprint of an emu, representing woman; 2 arcs, considered as crescent moons; and beneath them, a third crescent modified to form a rough circle, sign of a group of people. The lower images are 2 kangaroo paws, representing the most prized game. All these rocks also bear numerous cup marks with a ritual significance.

Next page

Animals of the dreamtime

Animals are a recurring theme in the rock art of Arnhem Land in northern Australia. The "naturalistic" style portrays animals of the dreamtime, that is to say animal spirits, intangible and omnipresent. This explains the impressive size—around 300 cm—of this swimming crocodile and an unidentified quadruped. The 2 animals walking one behind the other on the right are probably thylacines, a kind of marsupial wolf that became extinct 2,000 years ago. For Aboriginal people the disappearance of the species heightens the importance of its dreamtime equivalent.

Geometry and abstraction

In Australian prehistoric painting are found all sorts of superimposed geometrical motifs —concentric circles and spirals in sequence or individually, unidentifiable lines, branchlike forms, hatched rectangles and other ill-defined surface modifications—which are at once similar to and different from those of the Paranamitee style and defy our attempts at analysis. The abstract, intellectual character of these paintings should not be ignored: it denotes a perception running counter to the "art for art's sake" interpretation that has sometimes been suggested.

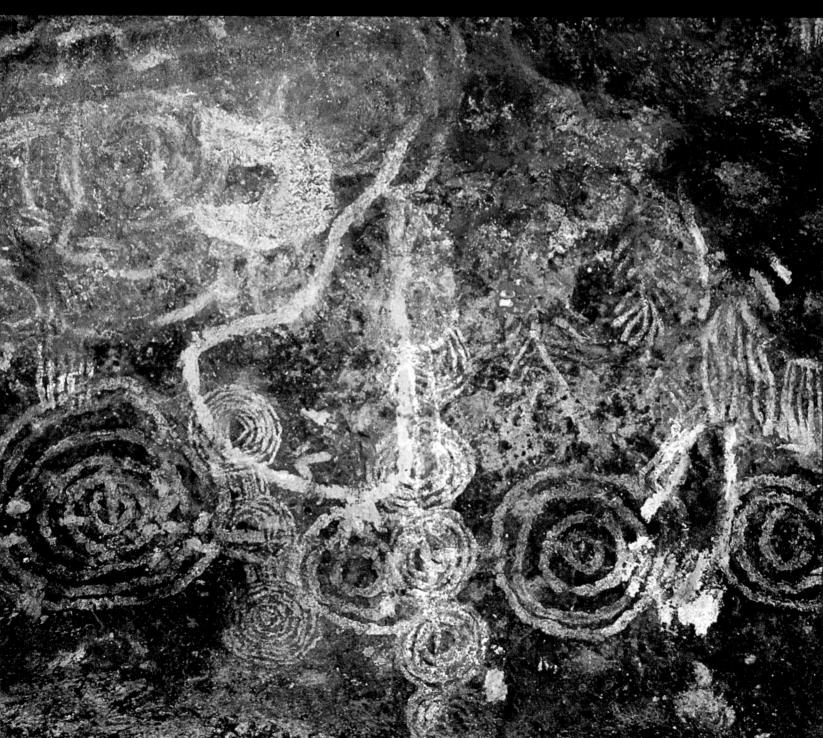

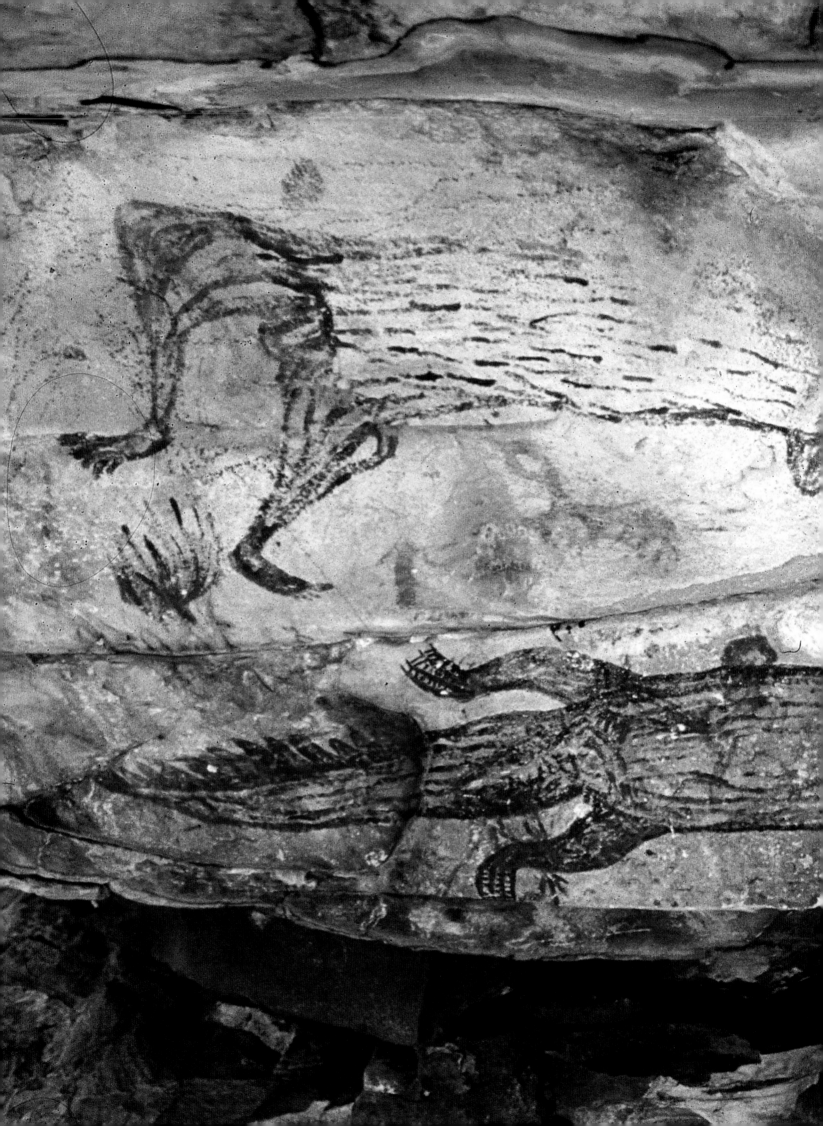

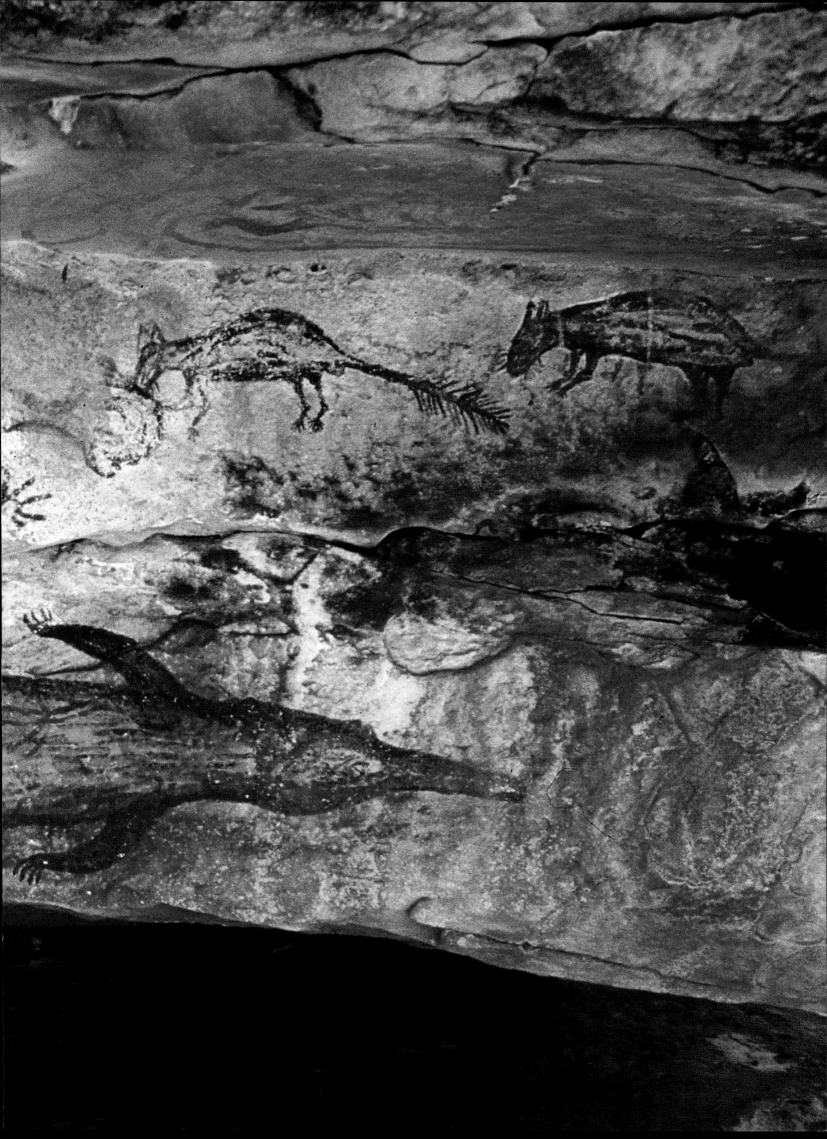

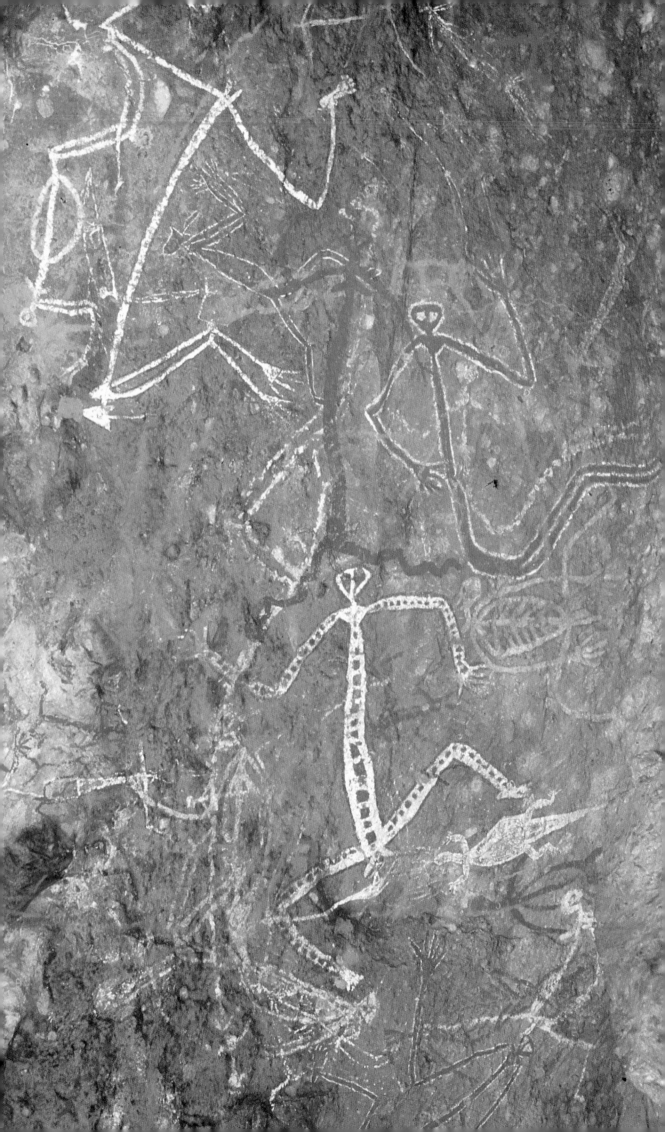

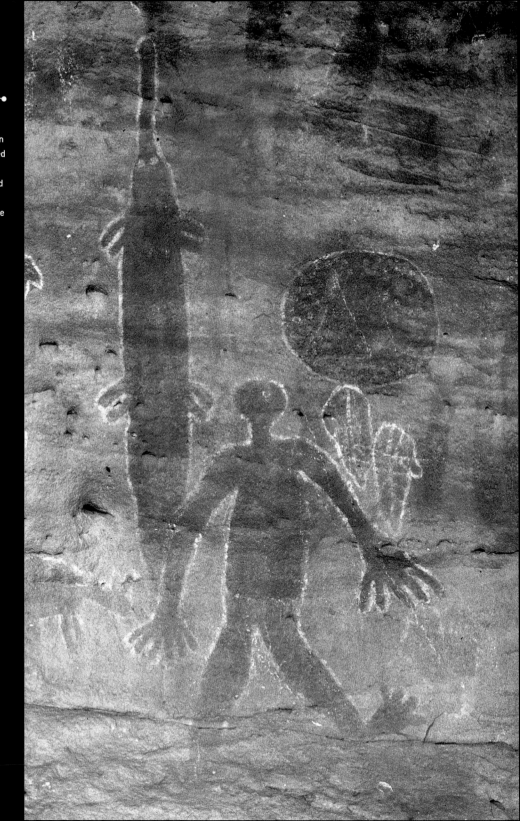

Unified bodies

Naturalistic human figures like this one seem to illustrate the unity of the reconstructed human body, as opposed to the disjointed dynamic figures. Here the brown man is surrounded and contained by a white outline; the head is impersonal; the spread arms have oversized hands with detailed fingers; the legs are also spread, with only the left foot and its detailed toes emerging from the ground or an area of water. The fish in the background indicate that this is the Estuarine period, lasting from 8,000 to 1,500 B. P.

Dynamic figurines

The Australian style of "post-dynamic" figures, a long tradition that survived until relatively recently, is very marked in Arnhem Land. Its spindly figures painted in white or red are disjointed and portrayed in all sorts of postures, as if they were gravity-free. This is because

Ancestors

This representation of human beings in the presence of a male and a female spirit, painted in white and flanking the central male figure, is the work of Nayombolmi, executed during the 1963-64 rainy season in the Anbangbang Shelter at Nourlaugie Rock, in Arnhem Land, Australia. Surveyed by what may be a man-ancestor in the upper part of the image, 2 groups of men and women are separated by a fissure in the rock, suggesting a difference between 2 families or groups that is vital to the marriage procedure. The style draws on the "X-ray" approach, notably for the 2 spirits, who thus take on a supernatural appearance.

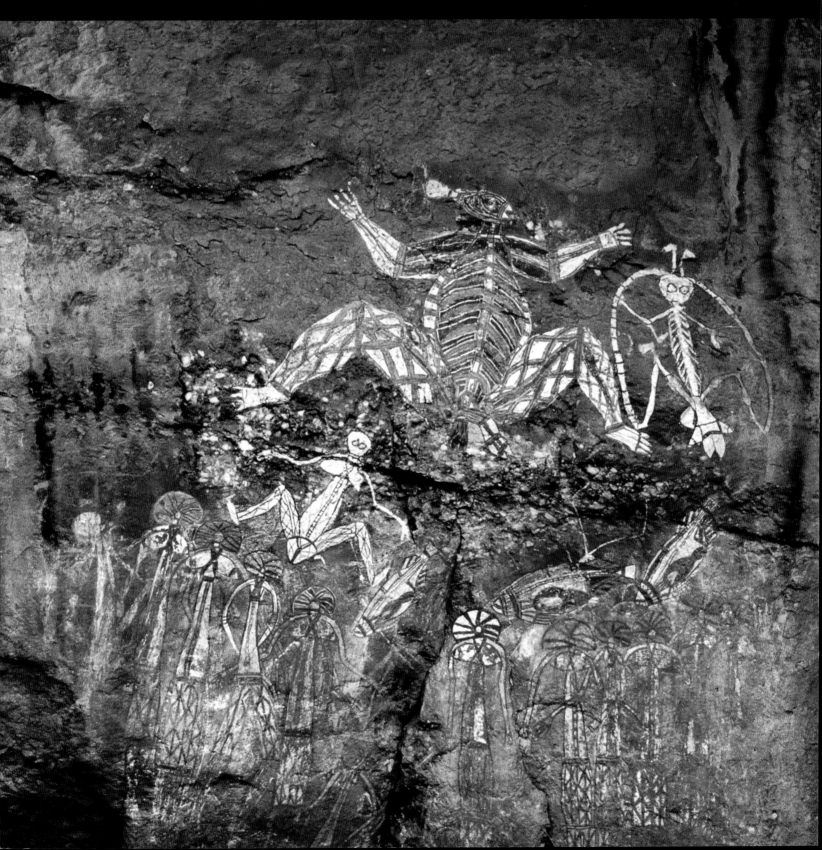

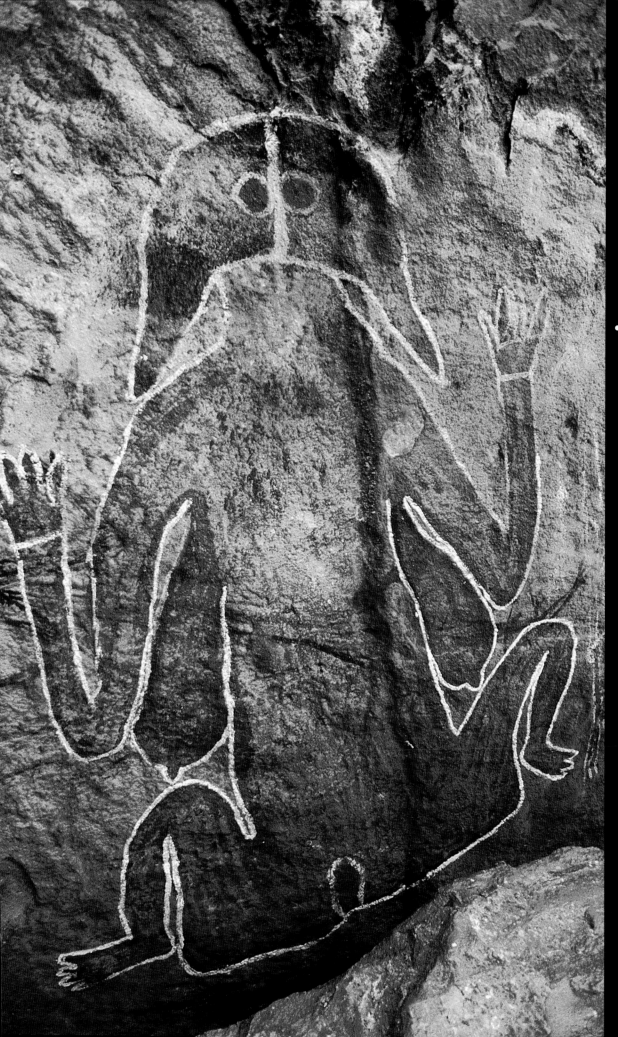

AMERICA AND THE MYTHS OF THE OTHER WORLD

The American continent was peopled between 50,000 and 30,000 years ago when, according to the classical theory, the Bering Strait separating eastern Siberia from North America could readily be crossed. The oldest remains of human bones all come from the species *Homo sapiens sapiens*, like those dug up in the painted shelter of Lapa Vermelha in Minas Gerais, Brazil. In one of the decorated caves in northern Brazil—Toca do Boquierão da Pedra Furada, in Piaui state—a fragment of ocher-covered rock wall was found in a level dated to between 26,000 and 22,000 B. P. This very early dating is under dispute with an estimate of 17,000 years for the first rock art on this site is currently finding wider acceptance; however, datings of 12,000-10,000 B. P. for the upper levels are doubtless correct, as they correspond with those for other collections at Monte Alegre in the Amazon region and Toca do Baixao do Perna in Piaui state. It seems likely that the shelters in Patagonia —Cañadon de las Pinturas, Cueva de las Manos Pintadas and Rio de las Pinturas—with thousands of stenciled hands and other geometric designs, are the work of the same early hunters thought to have carved dozens of vulvas and a number of penises at Muleje in the Sierra di San Gorjita, in Baja California. 6,700 years ago the Mazama Ash site in southern Oregon was used by hunters who engraved simple geometric designs and polished cup marks, or cupules. At Mud Portage in Ontario, Canada, images of quadrupeds and humans were pecked into large slabs 9,000 years ago. The hunting tradition continued until recent times with the Amerindian peoples, whose ancient mythologies throw interesting light on certain rock art representations: for the Algonquin, for instance, a turtle surrounded by cupules stands for clan fertility, the eagle symbolizes lightning and absolute power, and quadruped footprints suggest that which cannot be seen. In Alaska and later in California, a concern with fishing appears, notably via the image of the manta ray. The supernatural is present too, as indicated by the incised monsters and dragons at Nanimo on Vancouver Island in British Columbia; in a similar vein are an antelope-horned serpent 3,5 meters long and another 1,5 meters long with deer's antlers, painted on the rocks at Cueva de la Serpiente in the Sierra de San Francisco, Baja California. The latter site also offers some sixty profiles of humans with animals' heads or headdresses with large ears; these have

been seen as attributes of shamans, but the many Indian myths studied by Claude Lévi-Strauss (1979) via polychrome wooden masks of the last few centuries refer directly to mythical beings rather than the priests who invoke them. Among the Tlingit, for example, the bear takes the form of a monstrous creature with a broad sculpted or painted face; like the salmon, he is one of the mythical beings who gave rise to human societies. Stylistic similarities would seem to indicate a relationship between these sculpted wooden masks and the masks painted on rocks in British Columbia.

The Seminole Canyon site in Texas offers a remarkable collection of majestically large, otherworldly praying figures without faces. At Panther Cave, one of these supernatural beings is outlined in red: 3-meter tall, it spreads arms in the form of cacti and its head has an animal look about it. Not far away another, equally tall figure is painted red all over, with long lines branching out from its spread arms in a way that may suggest plants or feathers. The same notion is implied by a third red figure 2,5 meters high; faceless and framed by two appendages, it has a feathered, birdlike tail. A similar, much smaller silhouette in red and black is from a later period.

C. Grant (1967) lists the most frequently occurring subjects here as hands, bear tracks, plumed or horned snakes, lightning-birds and various animals that appear to be game, especially bighorn sheep. In Delgadito Canyon in New Mexico are paintings showing figures identified as divinities. The *yeis* of the Navaho are supernatural beings similar to the *kachinas* of the Pueblo. Among these divinities is Ganaskidi, the hunchbacked god of harvests, plenty and fog; he is also the protector of the bighorn sheep whose horns he wears. Ganaskidi holds a digging stick, with seed-grain kept inside his hump. Nearby is a figure wearing a pointed hat, called Dsahadoldza, still honored and represented in their sand paintings by the Navaho today. The next, rectangular-headed divinity is portrayed in a style resembling that of the kachina dolls, which allows for his identification.

In South America, the Amazon, the West Indies, Paraguay and Bolivia we find a host of geometrical signs and three-toed rhea footprints. Human footprints are not uncommon, a further intentional signaling of the presence of human beings or, in a more indirect sense, of the creation of humankind. Members of the camel family are portrayed in Chile and in the Andes in general, while various kinds of deer are to be found in the Perdida Shelter at Jaciara, in the Mato Grosso in Brazil. Vegetal subjects, fairly rare in rock art, are evident in the Tocada Extrema Shelter in the Brazilian state of Piaui, where we see twelve figures with erect penises rushing with open arms towards a two-branched plant. In the Santa Elena Shelter in the Mato Grosso highly schematic humans mingle with frogs, toads, lizards and crocodiles seen from above. They are accompanied by more realistic and perhaps earlier images of tapirs, deer and big cats. Elsewhere in Brazil, pumas and jaguars also feature at Lagoa Santa (Minas Gerais state), São Raimundo Nonato (Piaui state) and Rondonopilis (Mato Grosso). The puma makes frequent appearances in Andean rock art sites: these deified animals played a major role in pre-Columbian religions, but here they would seem to date from prehistoric periods preceding the rise of the classical civilizations. The big cats are also guardians of megalithic burial sites in the Rio Magdalena valley in the San Augustin region of Colombia, where the monuments began to be erected in the sixth century B. C. and the iconography of the sculptures suggests an Olmec origin.

At Nazca in southern Peru, gigantic lines and drawings kilometers long cut into the ground portray hummingbirds and plants; their creation dates from 200 B. C. to A. D. 700 and their scale is such that their meaning only became clear when they were observed from the air. Two other large American examples worthy of note are the figure at Blyke in California and the famous Serpent Mound in northern Adams County, Ohio. The latter is a 300-meter long earthwork showing an uncoiling snake swallowing a circle that doubtless symbolizes the sun or an egg.

With regard to the Arctic regions, Fitzhugh and Crowelle (1988) mention bone and ivory statuettes, decorated tools and weapons, jewelry and petroglyphs dating back several thousand years in some cases.

Among the abundant traces left by still-anonymous prehistoric societies, the following example, while only 200 years old, is well enough documented to indicate that collective worship of a parietal painting can be the result of a purely personal initiative. Interpretation of the Agawa site as an image of the god Michipichu painted in red on a cliff overlooking the northwest part of Lake Superior, was made possible by an account transcribed onto birch bark in 1851. Michipichu is the Great Lynx of Algonquin Indian mythology, the spirit of the underworld, complete with horns and a spiked back. The painting was executed in 1812 by the chief of the Ojibe warriors, who had crossed the lake in four days at the time of the American War of Independence. Michipichu had aided him in this feat and so had to be honored. Various pictographs provide the details of the miraculous achievement: the canoe, the chief himself and a simplified representation of the lakeshore. The story itself has been forgotten by the local Indians, who nonetheless recognize Michipichu and come to pay homage to him.

A host of hands

With their white, red or black halos, the negative, positive and sometimes overlapping hands at La Cueva de las Manos in Los Toldos, Patagonia, create the effect of a festive crowd. This is a totally different context from that of the hand at Gargas (Ariège, France), isolated and dramatically framed in a clearly visible niche, with all fingers except the thumb folded under (*see* the first illustration in this book).
The hands of La Cueva de las Manos are more recent than those of Gargas (27,000 B. P.), having been dated to 11,000 – 9,500 B. P.. Thus there can be no direct link between the sites, in spite of an interesting technical and visual convergence.

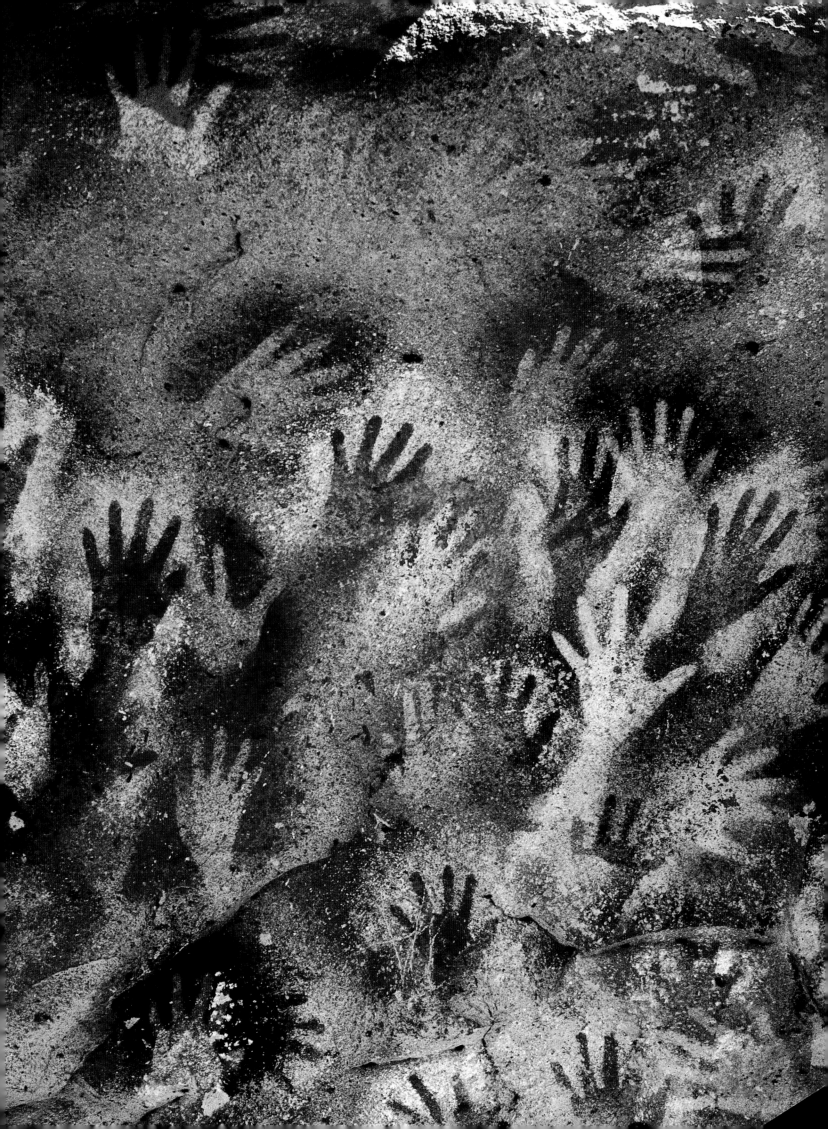

A large plantlike figure

On the rock art site of Panther
Cave overlooking the Pecos river
in Seminole Canyon, Texas,
this large (250 cm) red painting
presents a "tree-man" in praying
posture and decorated with
leaves, branches and lianas.
The small head seems to turn to
the left, towards another white,
mythical being decorated with
plant motifs and having the head
of an animal. A smaller figure
painted dark brown appears
on the right. This site is thought
to be over 1,000 years old.

Totem spirits?

Also in the Panther Cave Shelter
in Seminole Canyon, Texas, a set
of paintings side-by-side uses
white, yellow, red, brown, gray
and black pigments. It is
dominated by a strange main
figure, a tree-person 250 cm high
with short legs and short arms
held out horizontally in line with
a head that is in fact no more
than a head-covering. The figure
is painted white, with a central
green area. A second totem-spirit
of similar appearance, but entirely
green and wearing a red head
covering, is associated with

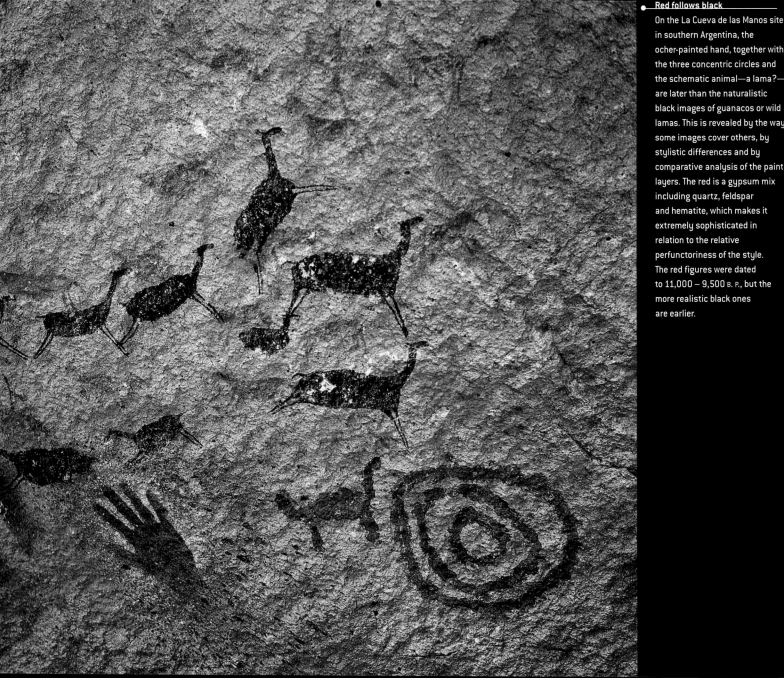

On the La Cueva de las Manos site in southern Argentina, the ocher-painted hand, together with the three concentric circles and the schematic animal—a lama?— are later than the naturalistic black images of guanacos or wild lamas. This is revealed by the way some images cover others, by stylistic differences and by comparative analysis of the paint layers. The red is a gypsum mix including quartz, feldspar and hematite, which makes it extremely sophisticated in relation to the relative perfunctoriness of the style. The red figures were dated to 11,000 – 9,500 B. P., but the more realistic black ones are earlier.

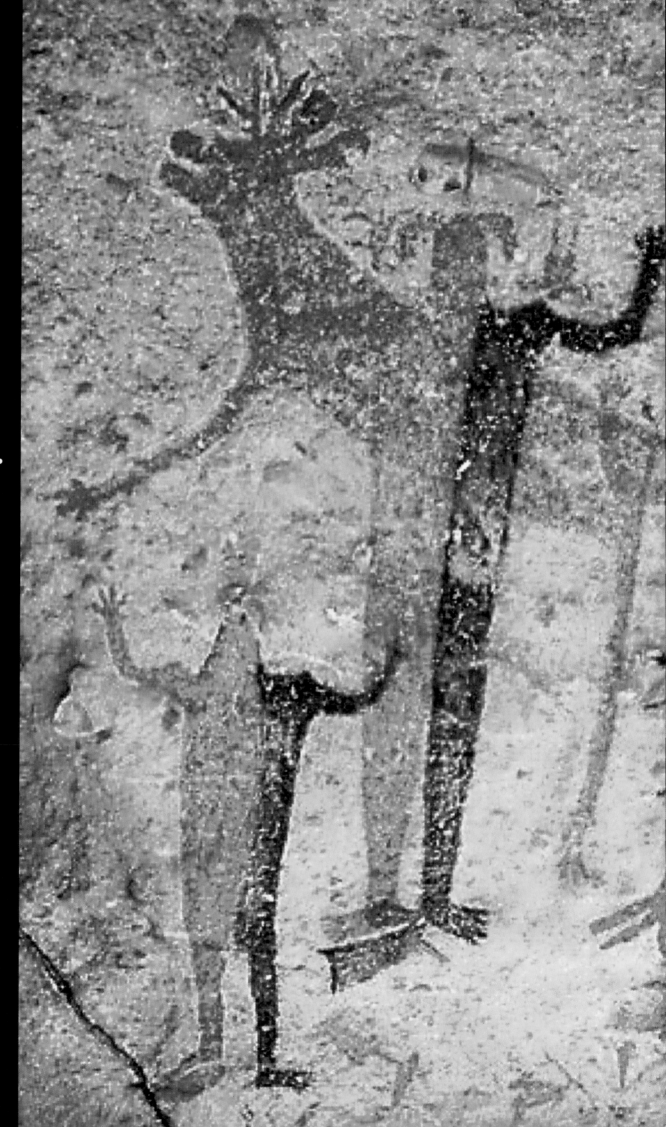

Praying figures with horns

In the period between 4,000 and 2,000 years ago the mountains of Baja California in Mexico were dominated by a significant style: it was characterized by praying figures 2 m high of 2 colors—one side black, the other red— with arms spread and hands reaching out, and wearing a headdress topped with horns or plants. The scene shown here—praying figures and a deer with open mouth and prolific horns—is from La Cueva Flechas in Baja California. A similar one is to be found not far away on a site overlooking the San Nicolas river in the Sierra de San Francisco. These bichrome praying figures also occur in La Cueva Pintada and La Cueva dei Serpenti, also in Mexico. In the latter shelter the figures seem to have been added close to 2 very long snakes, doubtless a vital part of a mythical narrative.

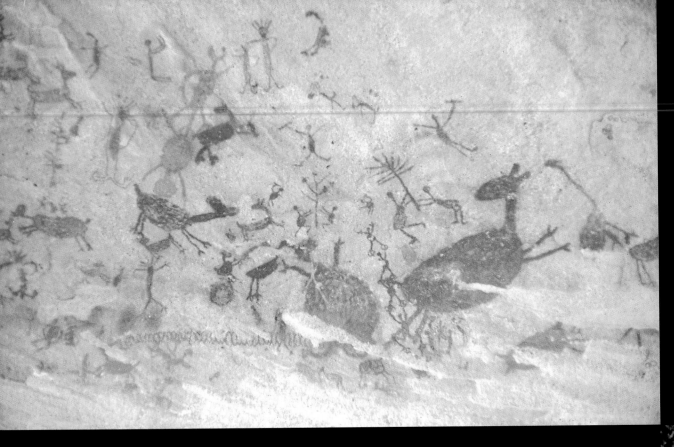

Types of myths and rituals

This 150 cm panel in the Entrada do Pajau in Brazil is composed of tall, rearing stags with their heads turned to the left, other leaping animals and a host of human figures. 2 of the figures wear distinctive headdresses, others approach a tree in groups of 2, still others—very small, at the bottom of the image—form a procession. In the middle, some of them form a chain. Some of the lower, more faded paintings belong to an earlier phase. These panels were in fact created over a period of several centuries, perhaps 6,000 years ago.

This part of the rock face at
Entrada do Pajau in Brazil seethes
with paintings, patterns and
signs; among them we can
identify a majestic red deer, to the
right, and a number of enigmatic
signs on the left. In the center a
doe with curved legs is partially
effaced. Lower right we see a
small deer that may be a fawn.
The rock face is packed with
images whose creation was in
fact spread over several centuries
and may date from the era of
portraits of large game animals.
The suggested date of 6,000 B. P.
seems likely.

These are up to dozens of meters long and date from the period 2,350 – 350 B. P.

Left: this hummingbird was created by digging a ditch that exposed the white rock beneath the black soil on a plain overlooking the valley of the Rio El Ingenio.

Below: this monkey with its fingers spread and tail curled is also white and was drawn in the same way.

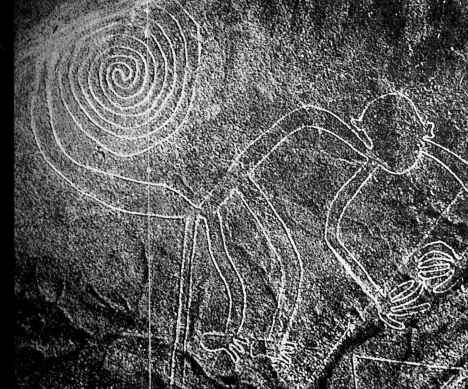

These giant animals (llamas?)
traced on the desert floor at
Nazca may have been part of
an astronomical calendar
serving as a guide to the

OCEANIA

The islands making up Oceania were the last landmasses to be taken over by human beings; their discoverers were peoples of Asian origin who first set out from Indonesia some 2,000 years B. C. Some islands in eastern Polynesia remained uninhabited until around A. D. 800.

The Easter Island Birdman religion

Easter Island is home to many drawings of fish and birds engraved on slabs and blocks of basalt. The single site of Orongo has five hundred petroglyphs portraying the "Birdman" and the god Make Make. From the site, and more specifically from the spot named Mata Na Rau, which has the highest concentration of images, the islets of Motu Nui and Motu Iri can be seen. The greatest of all religious celebrations on Easter Island was that held in honor of Tangata Manu, the Birdman, at the beginning of the southern spring. It coincided with the arrival of the terns, which came to nest on Moto Nui, the larger of the islets. Here it was that Make Make, the supreme and tutelary deity of Rapa Nui—the local name for Easter Island—took refuge, bringing the birds with him. Make Make, who emerged from the primal egg, is portrayed with a bird's head. Each year a competition was held, with divers setting out in search of the newly laid eggs. The first to find one uttered the cry of a tern and returned with the egg attached to his head; having thus earned the title of "Birdman", he returned to the village amidst great acclamation. The Birdman petroglyphs on Rapa Nui are a fine example of symbols of a foundation myth that had to be renewed each year: during the ceremonies new images were carved to maintain the spiritual existence of the community.

Myth and reality in Vanuatu

The excavations carried out on this Polynesian island by J. Garanger in the 1960s demonstrated the authenticity of the mythical founding of Vanuatu society by Roy Mata. On the islet of Rotoka, Garanger rediscovered the collective grave in which the hero was buried, dating from A. D. 1,265 and on the island of Efate he succeeded in locating the decorated cave where the king had meditated before his death. The painting in the cave had become the focal point of a foundation doctrine that had been handed down through the centuries.

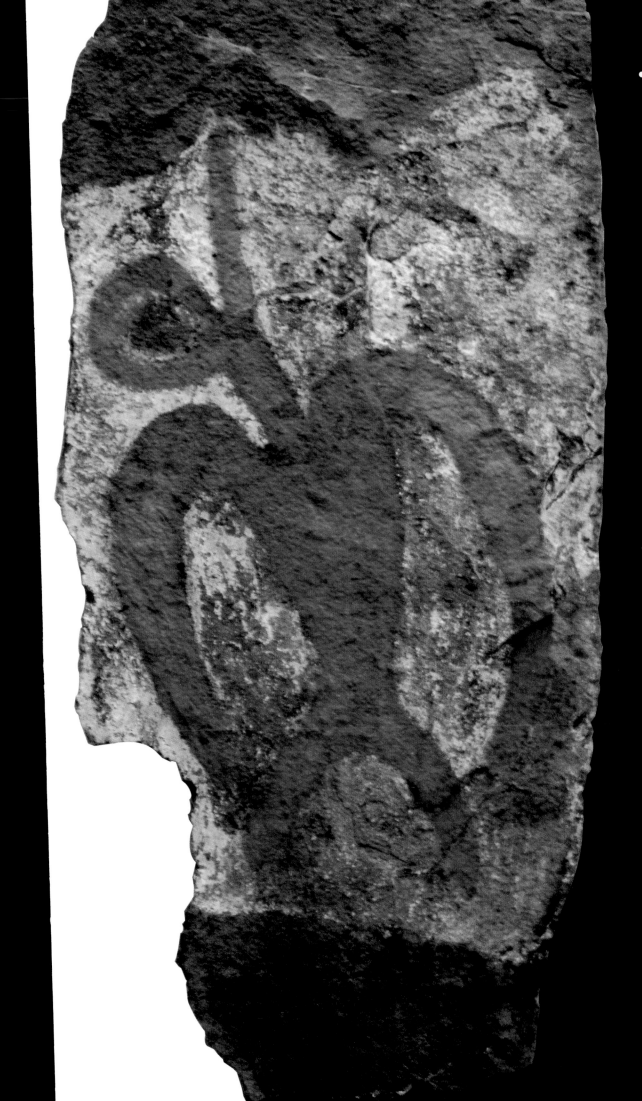

According to the beliefs of the
Easter Islanders, the god
Make-Make emerged from the
primal egg. A competition is
organized for the annual
regeneration of this sacred
foundation event: men swim to
the nearby islet of Motu Nui in
search of the first tern's
egg of the year. The winner
is given the title of "Bird-Man".
On Rapa Nui—Easter Island—
there are numerous images of
birds incised or carved in the
basalt. There is also a bird
painting on the vaulted ceiling
of the Ana Kai Tangata Cave,
as well as on a stele kept in the
Rapa Nui museum: it has human
characteristics that make its
symbolic function readily
identifiable. These painted
images are at least
300 years old.

Topography
and Rites
of the Imagination

4

The arts of prehistory cannot be considered simply as another, classical form of graphic expression, for they spring from ceremonial acts producing varied esthetic outcomes; the aim here is certainly not mere representation, but the creation of a living image and perhaps even the generating of a specific reaction. Rock art is the highest form of prehistoric expression and its variants are to be found throughout the world. This pre-eminence is perhaps no more than the result of a process of natural selection that has destroyed more perishable materials and, of course, left no place for such intangibles as accompanying songs and dances. Whatever the case, rock art seems to be part of a specific form of behavior vital to the survival of the societies that practiced it.

THE CAVERN AND THE REVELATION OF FORM

Decorated deep caverns are a characteristic of the Paleolithic period in Europe. There are some three hundred of them in all, one hundred fifty in France, one hundred twenty-eight on the Iberian peninsula, but other examples from the Ice Age have been found in Italy, where there are fifteen caves, in Central Europe and as far afield as the Kapova site in the Urals. A handful of such caverns has been recently discovered in Indonesia and Australia.

The closed world of the cavern

At the first turning along the entry corridor the light of the cave opening disappears and the visitor is plunged into the darkness of a cavern whose unpredictable surfaces make it far from easy to negotiate. Damp walls, curtains of stalactites and column-like stalagmites gleam in the light of hesitantly-advancing torches and animal-fat lamps. The sound of dripping water may alternate with deep silence or strange noises. Suddenly the eye falls on a painting or engraving and at a single stroke the already striking natural setting is transformed from a cavern into a sanctuary inhabited by numberless spirits. With its unpredictably jagged or broken walls, its patches of half-light, its cast shadows that dissolve then reform, the cave lends itself to these imaginary encounters.

For the prehistoric peoples exploring these caves, the search for animal and human forms in their erratic natural contours presupposed that such beings had truly existed there before becoming recognizable. The "Great Bison" in the Bernifal Cave in the Dordogne possesses an entirely readymade outline: only an ear and the patches on the chest have been added, as signs of human awareness of the natural forms giving birth to the animal.

Similarly, a deerlike animal in the Las Chimenas cave in Cantabria, Spain, has a painted spine; but the rest of the creature is simply suggested by the irregular surface of the rock wall. In the El Castillo cave a bison is created out of a wavy fissure standing for its spine; the profile is completed by a continuous painted line.

It could be said of these three examples—and there are many more—that the animals conjured up spring physically from the rock face, just as the heads of the famous dappled horses surge out of darkness at Pech Merle, in southwestern France. Other animals, by contrast, disappear into darkness,

Precedent page
The vulva: a cave symbol
One of the vulvas modeled in clay from the Bédeilhac Cave (Ariège, France) is 15 cm high and dates from at least 12,000 years ago. The vulva is a very common subject in prehistoric art, especially in caves and shelters. It is likely that, in the same way as Socrates called his teaching a birthing process, prehistoric people saw the initiation provided by the rituals of the decorated cave as the equivalent of a birth. The metaphor of the cave and the vulva from which life emerges is made explicit by the baby emerging from a vulva in the Guy Martin network of caves at Lussac-les-Châteaux (Vienne, France, see pp. 190-191).

A face emerging from darkness
In the Altamira Cave in Spain, the artist who painted in the right eye some 15,000 – 14,000 years ago revealed his discovery of the natural form of the rock transformed into a face. The encounter between the imagination and the vagaries of nature gives rise to the concept: the image of life.

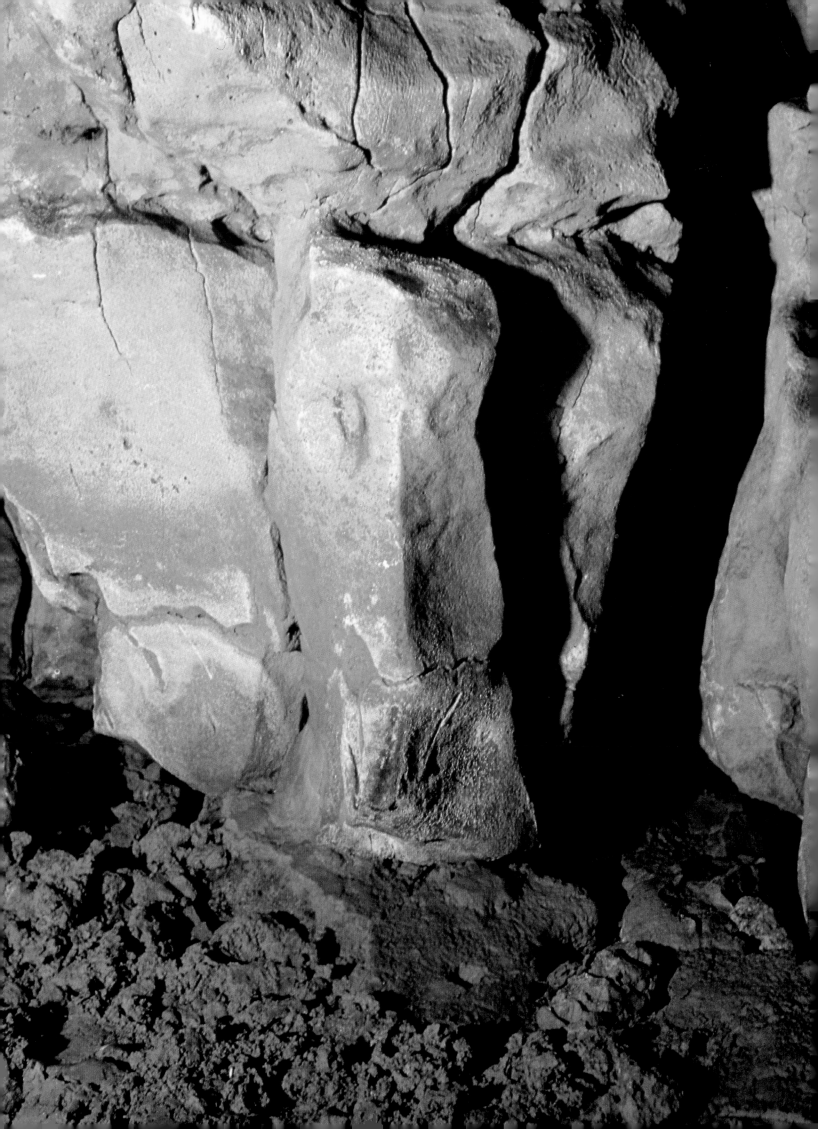

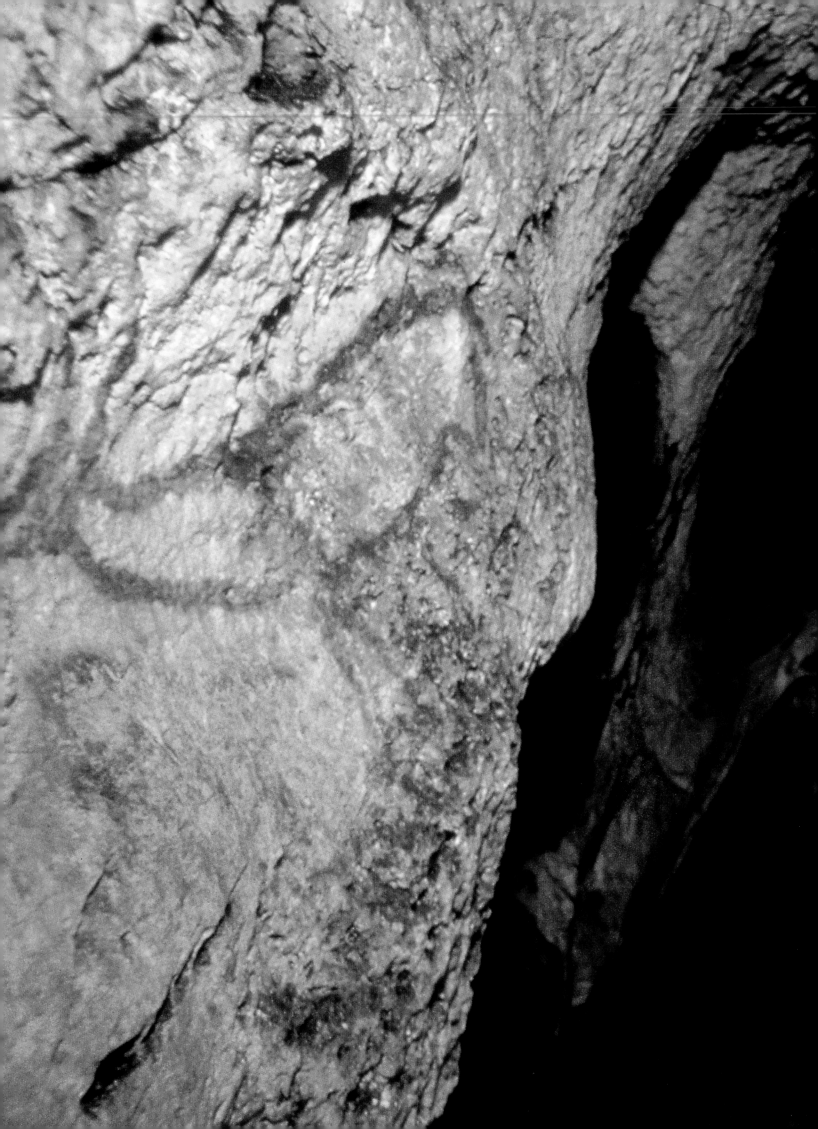

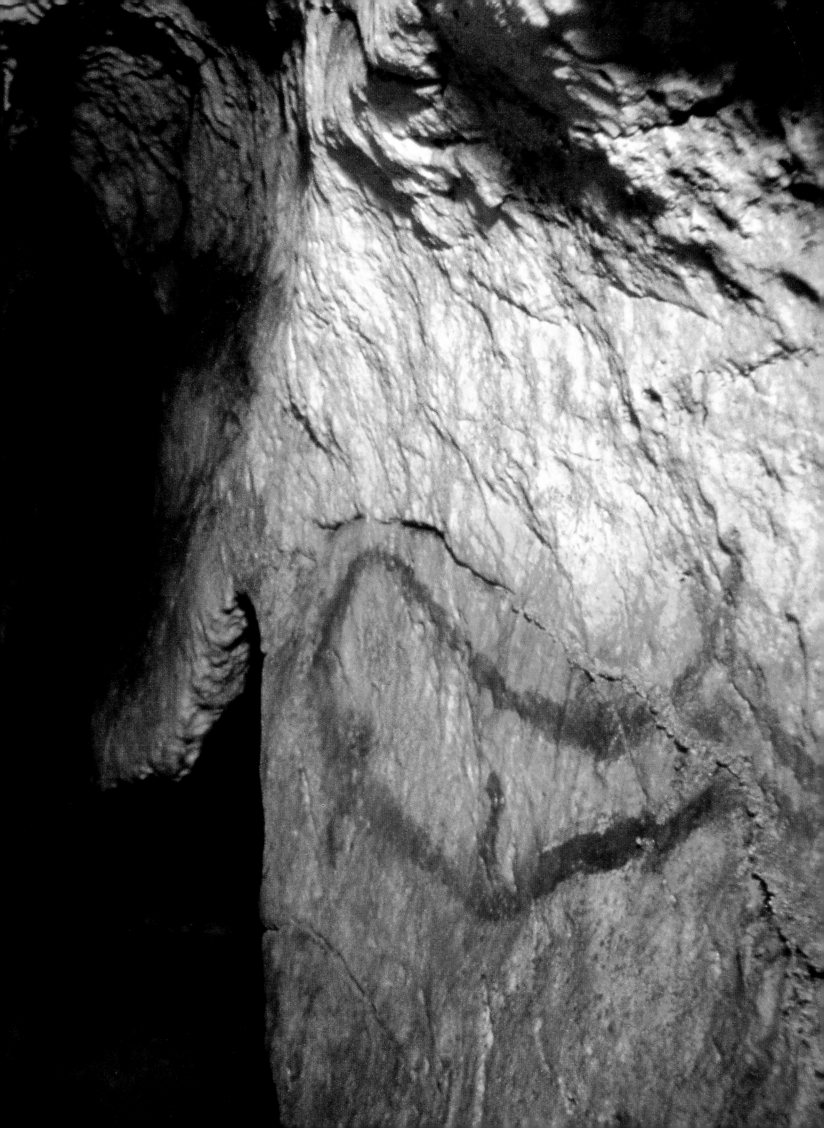

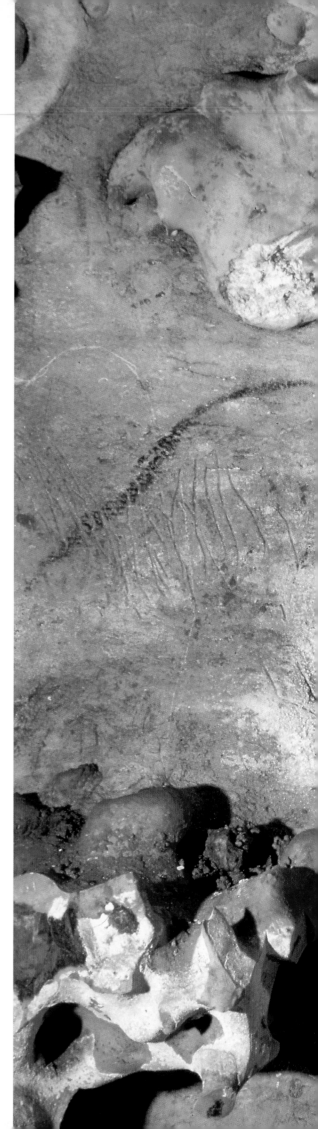

like the reindeer at the Gabillou site, bounding towards the stygian depths of a narrow underground passage. The movement of the animal combines with its presentation to emphasize the impression of life passing, emerging only to vanish again.

Thus the characteristics of the rock and the half-light create the specific context of the being in question. At Las Monedas in Cantabria, in northern Spain, a little black horse takes on a special aura from being framed by the cavity it is set in. Likewise, a niche in Bernifal Cave contains the drawing of the head and forequarters of an ibex, while another, close by, is occupied by a mammoth. At Gargas, in southwestern France, a hollow in the rock has been decorated with a black handprint whose deliberately chosen context immediately sets it apart from all the other handprints in the cave. Thus, in a setting in which the eye is ceaselessly drawn this way and that, one particular cavity attracts special attention and establishes a more accessible, more identifiable landmark.

The Magdalenian period (16,000-10,000 B. P.) provides example after example of animals apparently following changes in ground level that are in fact dictated by a rock ledge, a natural entablature or a fissure. At Font de Gaume in the Dordogne, for instance, a succession of polychrome bison advance along a line created by an uneven patch in the rock face, while at Las Monedas two reindeer and a horse make their way up an ascending rock ledge.

However, it does not seem that the natural context of the cave with its bumps, projections, cracks and crevices, is intended to replace the ground, rivers, plants and stars of the external landscape; there is quite simply no indication of their existence. This lack of realistic representation of the living environment and its replacement by a mineral abstraction can be seen as support for the hypothesis that world of the prehistoric cave, whether figurative or merely suggested, is primarily an unreal, fictive creation born of rock and shadow.

Precedent page
Female deer emerging from
the depths of the Covalanas
Cave in Spain some 18,000
to 12,000 years ago.

Presentation of two mammoths
in the Rouffignac Cave
(Dordogne, France), 14,000 years
ago. The 2 lines of flint nodules
indicate the ground and a sky full
of clouds. The animals, each
100 cm long, are painted on the
smooth limestone and shown face
to face in a way that generates
a dramatically intense
relationship. There can be no
doubt here that this was
intentional: the image was
intended to convey a message.
In all, the cave contains
150 mammoths. Thus this
imposing beast enjoyed pride
of place at Rouffignac, at a time
when nearby decorated caves
were more focused on
the aurochs, as at Lascaux
or the bison, at Altamira.

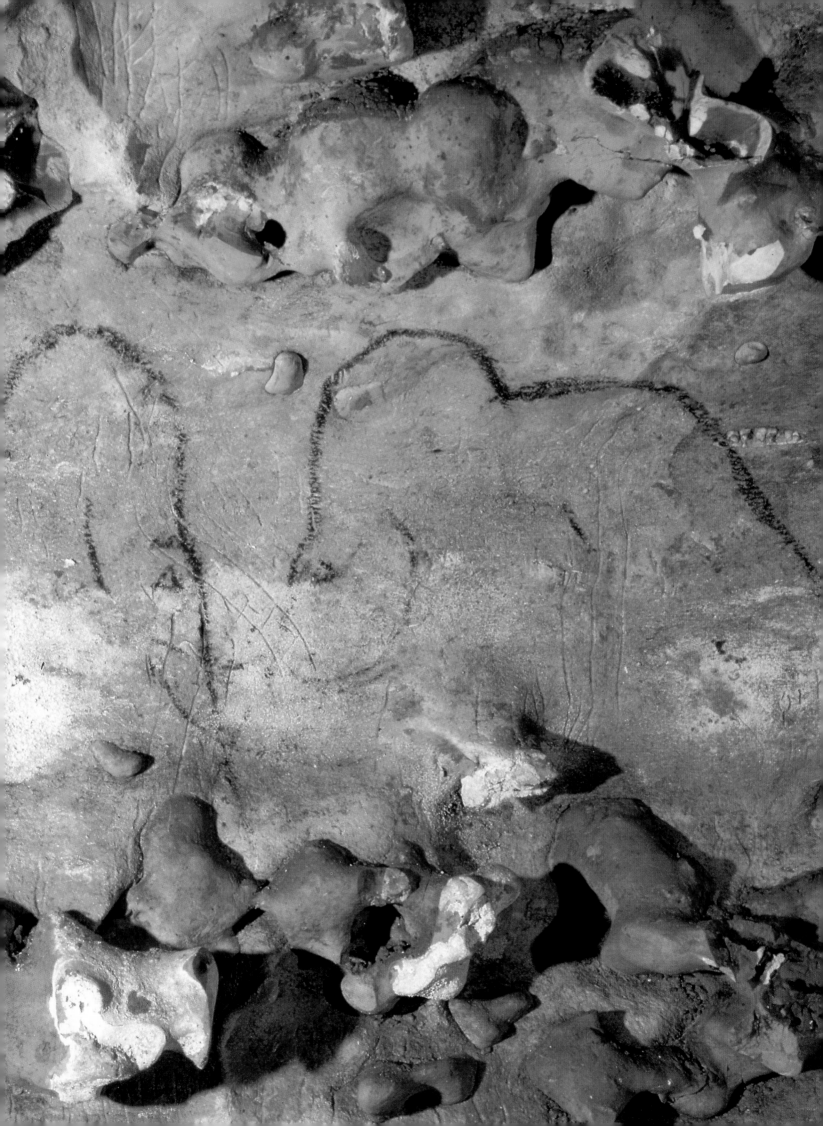

This interpretation of the cave as a virtual world bounded by the rocky surfaces so attractive to the hunter-artist imagination is strengthened by the fact that sometimes the entire available surface bears traces, marks, figures and signs: not only the rock face the visitor finds at eye-height as he explores the subterranean network, but also the ceiling, the floor and even crevices that are all but inaccessible. Recent discoveries in the Placard and Montespan caves in southwestern France have revealed the incised treasures to be found on stalagmite-covered floors. In the Bédeilhac Cave in the same area the image of a cud-chewing animal is deeply incised into the rock underfoot. Clay sculptures and areas set aside for offerings—sometimes outlined with stones—are proof that the cave floor was not simply a pathway: it was an integral part of a total environment of signs and images. Those who entered the underground complex were knowingly setting foot in a specific, living emotional universe in which no tiny area was visually neutral and no moment without significance.

Painters and sculptors: that special knack

Prehistoric peoples had different ways of creating their artistic world. Sometimes they settled for giving meaning to a pre-existing natural form, adding a line, patch of color, engraving or peck-mark to emphasize a profile or a silhouette; this is the case of the eyes, nostrils and mouths of the four masks at Altamira, or the painted eye on the "natural" face seen in profile at Mas-d'Azil. Specialists see the same technique in the ocher spread over the fold of a vulva-like stalactite in the Font de Gaume Cave. This kind of addition made it possible to give increased focus to a diffuse imaginative vision and use an ambiguous natural form to communicate it. It made visible something previously unseen but at least potentially existent. The shift from invisible to visible was also a conscious highlighting of something more or less lost in shadow; the mere presence of a mark tells us that people went into caves in search of ghostly beings whom they brought to life by a deliberate act of recognition. Such marks are not proof of some primitive phase of figurative art; in the prehistoric caves of all periods they are evidence of creative vitality at work.

Imprints left by human beings make up a specific expressive category in decorated caves. Apart from footprints such as those in the caves of Niaux and Chauvet, which are involuntary and raise the issue of visits by children walking barefoot, we find two types of prints deliberately intended to play a part in the ordering of a decorated cave. The first is that created by stroking the soft clay of the wall with one or more fingers and creating "spaghetti" patterns, most of which—as at Gargas, Rouffignac and Ekain—portray nothing in particular. Others, as at Altamira or Las Chimenas, outline bison, mammoths and so on, while humanlike profiles have been identified at Pech Merle. In still other, less frequent cases, these finger traces partially efface a pre-existent painted design, as for some of the hands in the Cosquer Cave on the south coast of France. A further category covers the many positive and negative handprints to be found on cave walls and ceilings. In fact positive handprints, obtained by application of a hand covered with red paint, are relatively rare, occurring on only eight sites in Italy, France and Spain. In the same three countries the negative version, of which there are five hundred examples in all, is found in twenty-six caves. In this latter technique, finely ground pigment is mixed with filler and a water or fat-based binder, then

Palm prints and finger tracing
Close examination of the red patches in groups and sometimes in lines in the Chauvet Cave (Ardèche, France) has revealed the characteristic imprint of a small human palm, in some cases with the lower parts of the fingers. It has been suggested that this is the palm of a woman or a teenager. Here the red palm print is not only a pointer, but also a composition that transforms the sign into a figure 1 m high, suggesting a bison or rhinoceros silhouette with the head on the right. It was dated to 32,000 – 30,000 years ago. Finger tracing is another direct way of turning a simple imprint into an image: here, in the Pech Merle Cave at Cabreret (Lot, France), there emerge outlines of mammoths and, on the left, women drawn between 25,120 and 19,500 years ago.

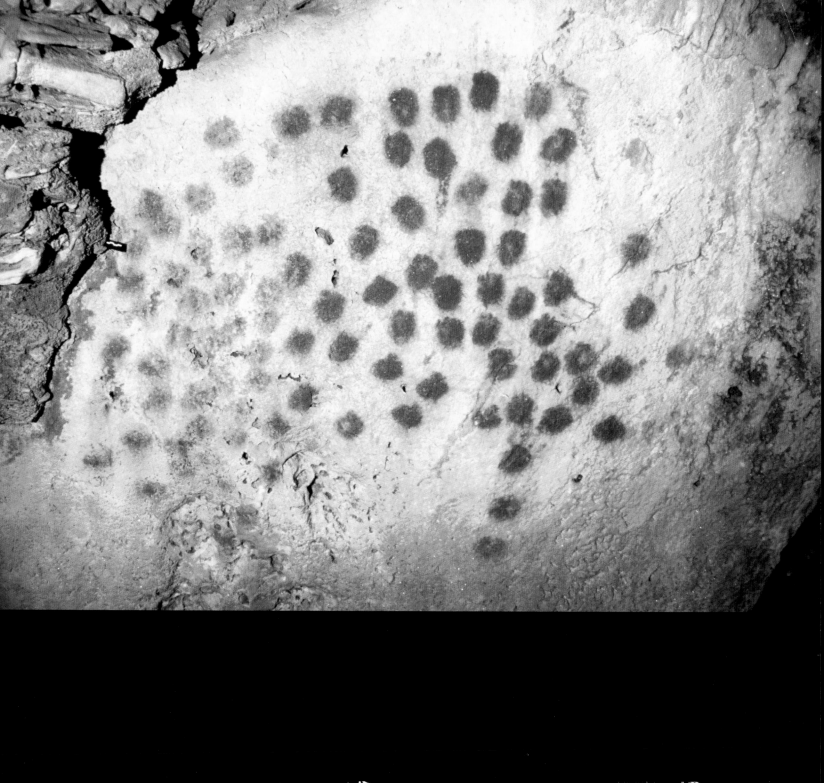

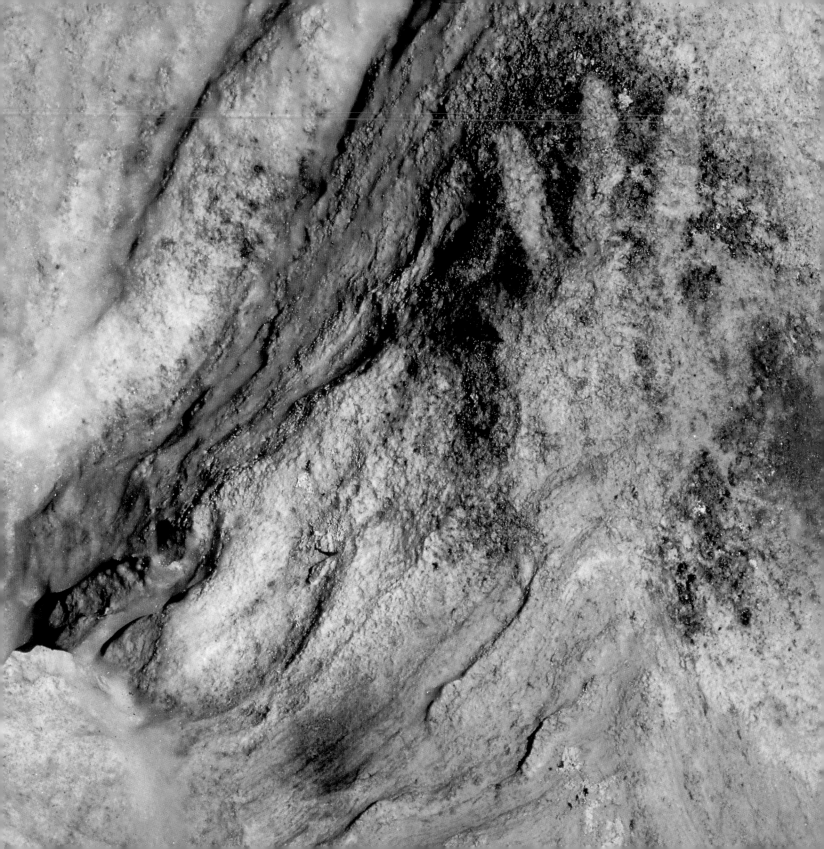

dabbed, sprayed or spat around the fingers and the palm. Four sites (Gargas, Tibiran, Cosquer and Fuente del Trucho) contain hands with several fingers missing. Some prehistorians have interpreted these as evidence of amputations due to frostbite or Raynaud's disease (a form of gangrene), while others see them as ritual mutilations. For André Leroi-Gourhan, these are hands with fingers bent according to a special hunting code. Some, in the Cosquer cave, for example, have been partly effaced by scratching. Had they lost their original significance? If so, here they would simply seem to be canceled out, rather than replaced.

From handprints to pictographs

In the Chauvet Cave in France's Ardèche region, ninety ocher handprints combine to form the image of a bison on the rock face. This coalescence is significant in two ways, signaling a dynamics linking man to artistic expression and a vital relationship between man and animal.

Reading imprints was a matter of habit for Paleolithic hunters. In 1985 B. and G. Delluc demonstrated the striking similarities between certain "signs" in prehistoric art and the tracks of such creatures as bears, horses, hares and birds.

The figurative outline

The figurative outline is created using a variety of techniques, usually highly developed and requiring a complex learning process. The line may be incised or painted. The rock engraver or the sculptor of portable art objects begins working on the stone with a flint tool, most often a "burin" or "graver", beveled widthwise.

The great majority of the pigments used in decorated cave paintings are shades of red and black. The reds, or ochers come from clay rich in iron oxide or hematite, which is crystallized iron oxide. Goethite, a more yellow iron ore, was heated and artificially transformed into hematite to provide darker, richer reds. Black was obtained by grinding up manganese oxide or charcoal. The basic pigments were mixed with a filler made up of quartz, fine clay or biotite and blended with a water or fat-based binder, as at Fontanet, Enlène and Trois Frères. The resulting paint was extremely durable, but its use required great skill. Preparation of the subject matter was meticulous and required specific "recipes", identification of which has made it clear that the hands found in the caves of Gargas and Tibiran are the work of several different people painting at different times. This unexpected creative pluralism of course represents a challenge to the long-accepted notion that these imprints expressed a single, definite intention on the part of a single individual. Quartz, mica and amber were added as filler for the black and red pigments used at Altamira. At Niaux, in France's Ariège département, the painters of the cave used biotite, or black mica; this substance is also found in the paint applied to the bone and reindeer antler objects discovered in the nearby La Vache Cave, probably frequented by the same group of hunters (Menu, Walter, 1996).

The figurative outlines were executed with the same elaborate care and on closer observation we find a combination of technical exigency and stylistic freedom. At Lascaux, Cougnac and Santillana, for example, there are figurative works associating drawn and painted elements that complement each other. At Portel, Lascaux and Altamira, profiles in red or black have been emphasized by an incised line. Monochrome and bichrome images are common,

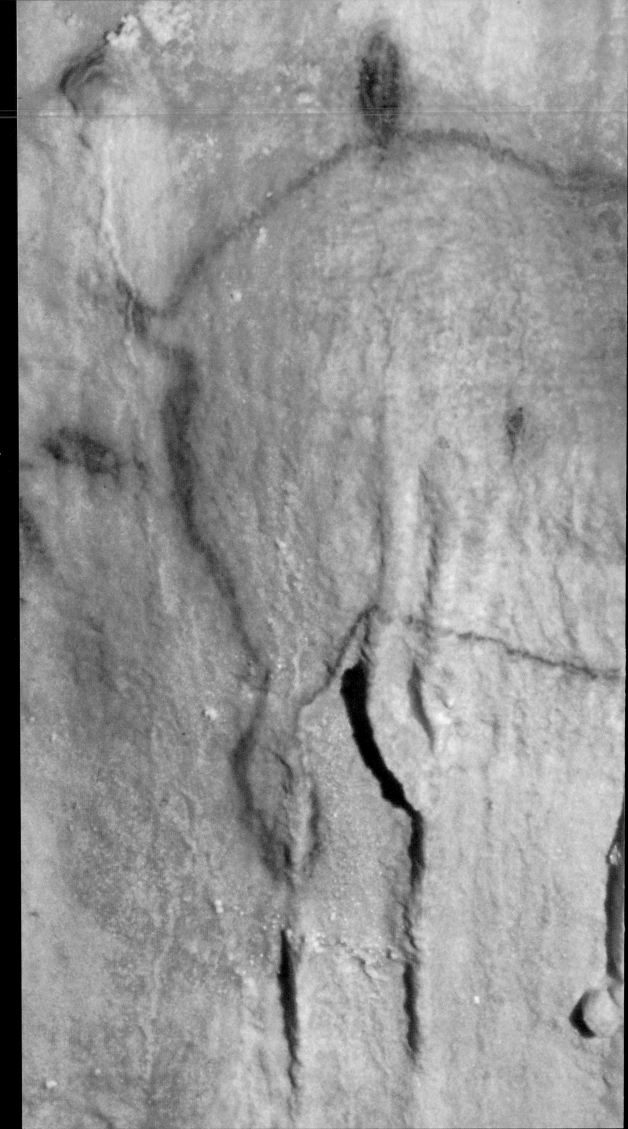

Ibex in relief

The large (80 cm) ibex in the cave of Cougnac at Payrignac (Lot, France) was painted 14,000 years ago on a wall coated with irregular concretions of calcite. This raised surface conveyed both the visual feel and the idea of the hanging wool of an ibex, which the artist then proceeded to make explicit. On the animal's head and around his body are double lines of darker color and a curved line in front of the breast; their meaning is unknown, but always present in such images is the shift from realistic representation to the world of abstract codes. Prehistoric art has always been multi-dimensional, a reuniting of physical and symbolic space.

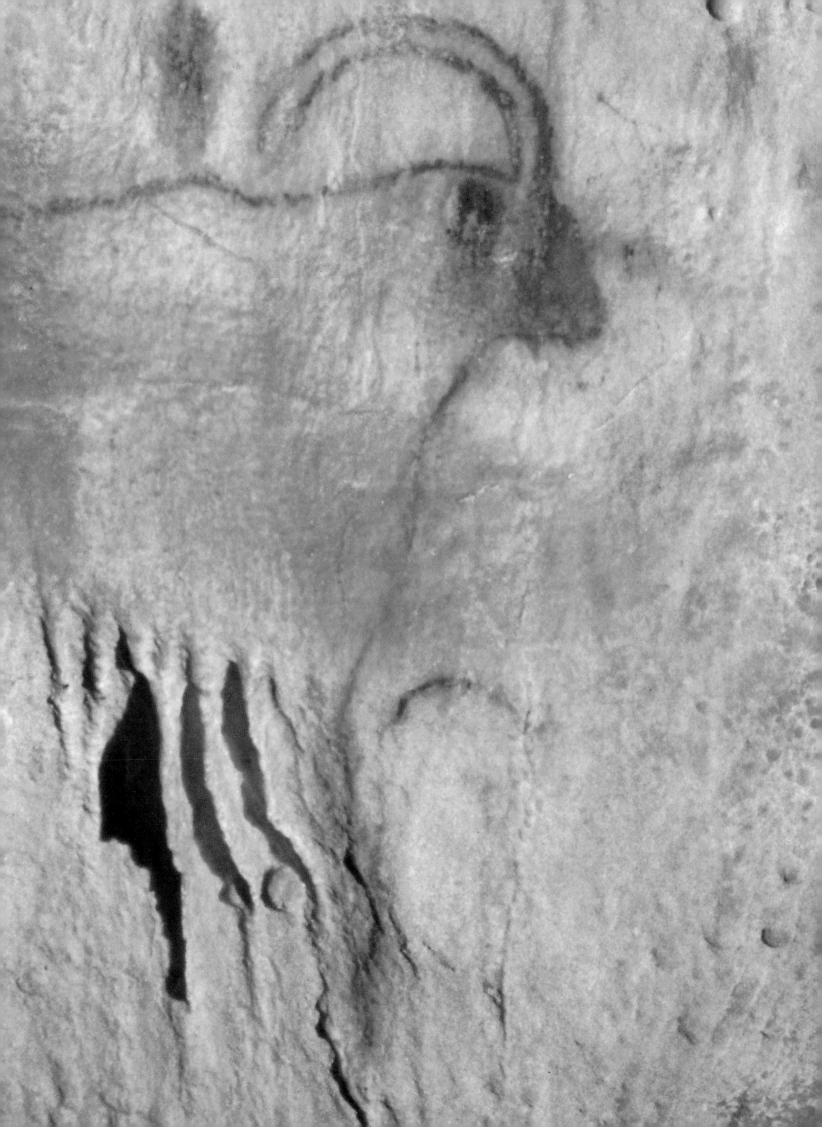

but artists also strove for a more multicolored approach by scraping the walls in search of color variations in the calcite and scratching into the patina or the rock itself. Examples are to be found at Font de Gaume and Labastide in southwestern France, and at Altamira and Tito Bustillo, in northern Spain. The different technical approaches to painting and engraving can also be explained by the business of adapting to the uneven surface of the rock, as in the case of the Rouffignac bison. The painting surface was often prepared by a process of scraping and smoothing, doubtless in the interest of making the work as easy as possible.

Among the various "knacks" used by Paleolithic artists, the following deserve a mention: the use of the stump and, as at Chauvet and Covaciella, of the stencil; silhouetting with a line of colored dots executed with the fingertips, as at Covalanas and Marsoulas; and successive shifts of a reversed hand to define the painted area of the neck of the dappled horses at Pech Merle. Michel Lorblanchet (1995) has reconstructed the technique used for this famous group: spitting the colorant psilomelane (a combination of manganese oxide and barium) onto a rock face, he smoothes it out with his fingertip then intensifies the color with charcoal scumbling. The charcoal line that can be seen on the neck of the right-hand horse at Pech Merle and the mane of the left-hand horse was introduced to heighten the contrast between these zones and the color of the rock itself. At Niaux, in southwestern France, traces of charcoal unrelated to the actual paintings have been interpreted as indicating the execution of a preliminary sketch. Michel Lorblanchet is of the opinion that the black drawings at Pech Merle were done in this way.

Lascaux and the cave of La Vache, at Ussat in France's Ariège region, have yielded various grinding and crushing tools for preparing the finely powdered pigments, together with the flint burins and picks needed for the engravings. Missing from the overall picture, however, are the brushes capable of provid-ing lines of the same or varied thicknesses according to the effects sought. We can only assume that they were made of animal hair or vegetable fibers. Paint runs on the rock face or drips on the ground are rare. To reach the higher parts of the cavern the artists resorted to scaffolding; clear traces of this practice have been found at Lascaux in the Painted Gallery, where archeologists have identified ten holes and three stop screws on the north side and seven holes and three stop screws on the south side. At Rouffignac in the Dordogne, the cave contained traces of trimmed wood used for the scaffolding needed to paint the Great Ceiling where it overarches the pit. Such meticulous technical preparation paid to the idea that these parietal representations were improvised, yet the approach is not at all incompatible with a certain spontaneity of execution.

Sculpture in clay is rare, but when we do find it, its presence seems a necessary part of the cave as a whole. The cave of Tuc-d'Audoubert offers two bison modeled with truly exceptional skill. The "sculpture" of a bear at Montespan was doubtless once covered with fur and, as indicated by the hole at the base of the neck, had a skull held in place with a rod. A horse carved deep into the clay wall of the same cave suggests a particular sculptural technique, for it is pitted with the marks of projectiles. The cave of Erbérua in the Pyrenees offers an example of another original technique, in which horses are sculpted in block of clay, then separated from it and applied to the wall.

Technical exigencies

The depth and subtlety of the painter's eye goes hand in hand with a technical exigency combining simplicity and nuance. In the Altamira Cave in Spain excavations turned up some of the painters' accessories, now dated to between 16,480 ± 200 and 13,130 ± 20 B. P.: little blocks of yellow and red ocher of various shades and charcoal. The pigments could be used directly for drawing, but most often they were prepared as specific mixes with filler and water or animal fat. The knee bones of certain ruminants were sometimes used as paint pots with handles, as were the vertebrae of some animals. Thus the imaginativeness evident in the pictures was also to be found on the technical side.

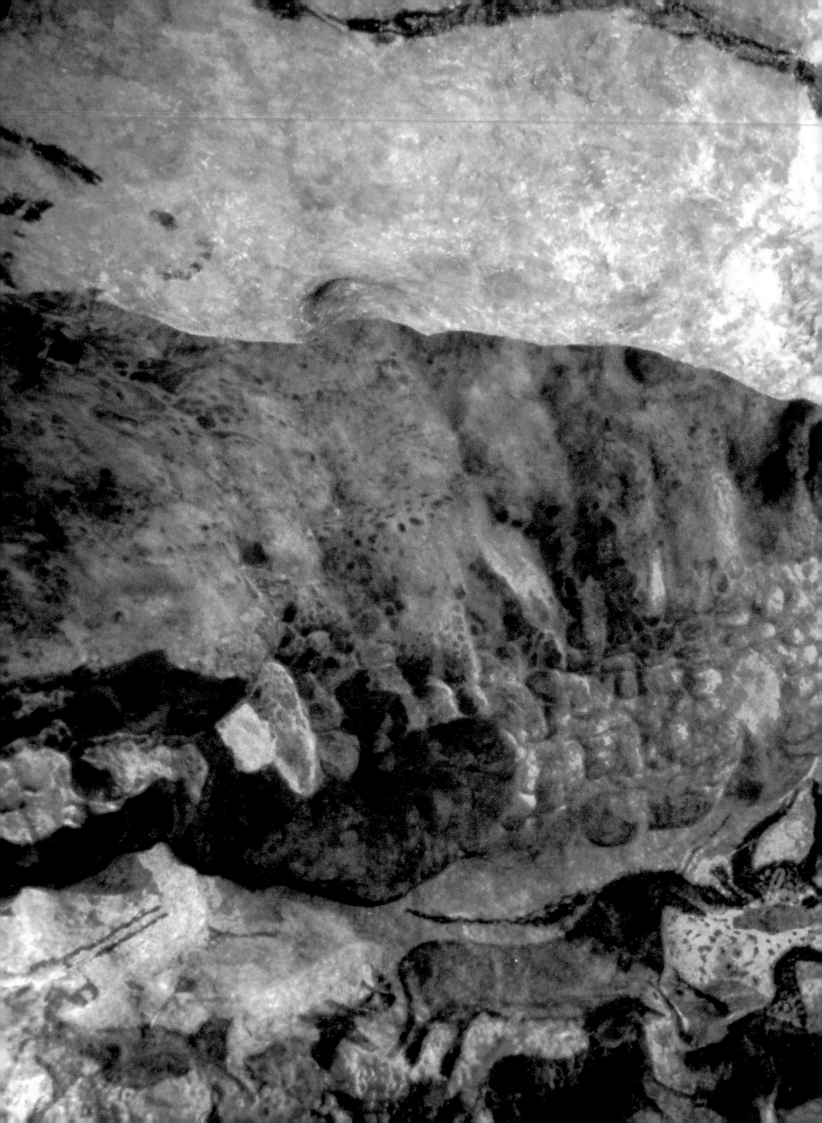

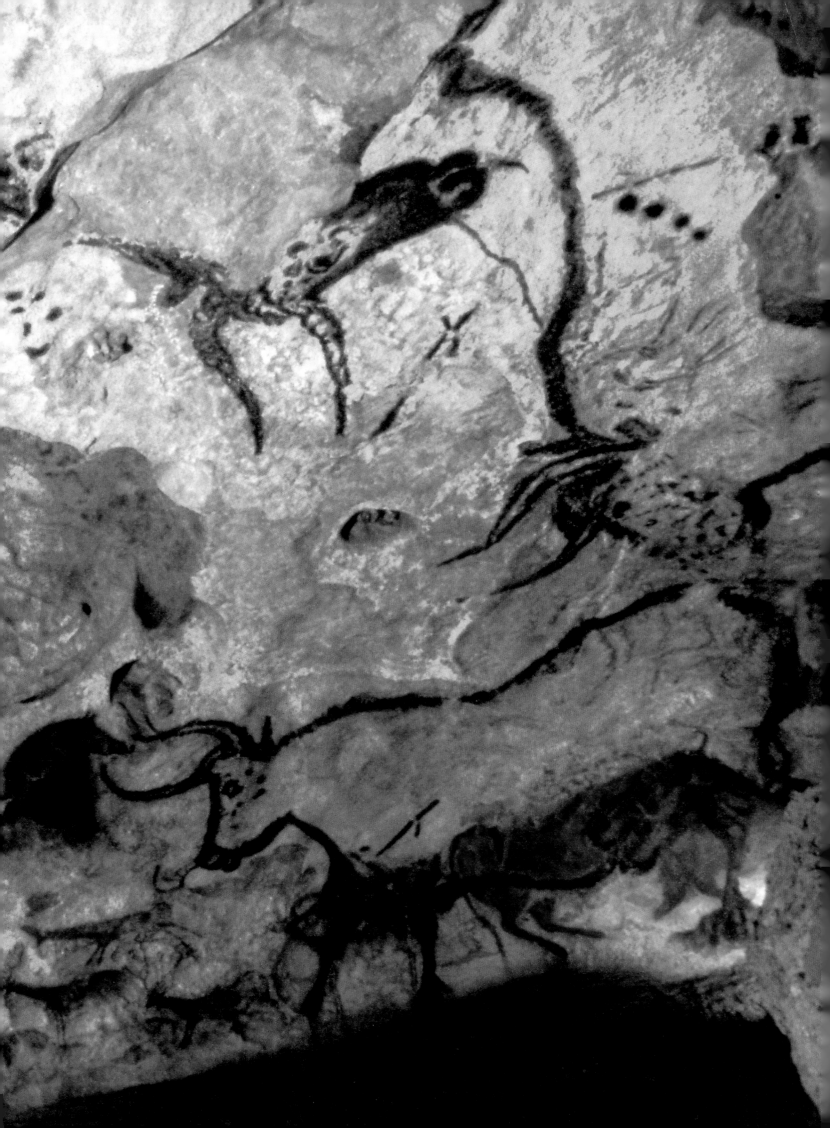

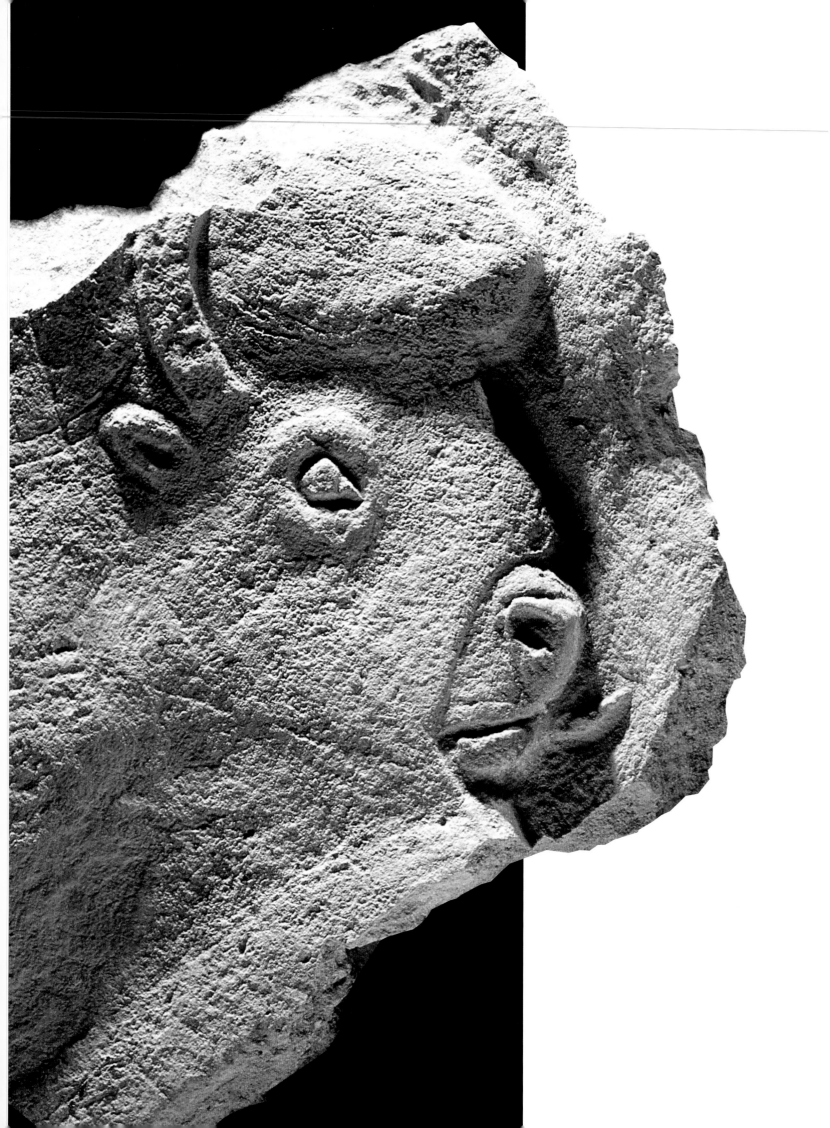

ROCK SHELTER SCULPTURE

Rock shelters differ from caves in that, instead of darkness they enjoy the benefit of daylight. Most prehistoric European rock sculptures are in fact situated either in the depths of such shelters or in cave entries into which light penetrates, which amounts to the same thing. To make the most of the limited light, the sculptors emphasized the depth of contour of the motifs they created. Two interesting and very ancient French examples are the impressive collections of sculpted blocks set in front of the shelter at Laussel (Dordogne) and the Solutrean frieze at Roc-de-Sers (Charente).

At Laussel, the "Venus" holding the horn is sculpted onto a block of several cubic meters, while the other figures occupy blocks some 40 centimeters long and are grouped together 9 meters away. This series of figures includes the "woman with the cross-ruled head", the "Berlin Venus" (destroyed in 1945) and the "playing card", representing a double figure and variously interpreted as a birth or copulation scene.

The Solutrean sculpted frieze (20,000 B. P.) at Roc-de-Sers comprises eight blocks laid out in an arc before the cliff face, on a base of large stones. From right to left the first block shows a wild boar (with a bovine body?) and a horse from which the surrounding stone has been cut away; the second and third are each decorated with a horse; the fourth shows a bull pursuing a fleeing man, two horses and an animal identified as a badger, together with a figure on the far left who may be wearing a mask. Three other blocks on the same site portray a powerfully built ibex, two ibex confronting each other, and a bird.

The 12,6-meter sculpted Magdalenian frieze (14,000 B. P.) in the Roc-aux-Sorciers Cave at Angles-sur-Anglin (Vienne departement, France) explores two closely associated subjects: "Venuses" and bison. The frieze was reworked at some point and a new theme appeared in the form of a number of ibex, some of which are carved over the original images. Women and bison are also found in the La Madeleine sculpted shelter (Tarn, France), as well as horses at Cap Blanc (Dordogne) and La Chaire-à-Calvin (Charente). Thus the distinctive feature of sculpted Paleolithic shelters is a non-supernatural bestiary (horses, ibex, bovines) characterized by less variety than is found in the caves. Here men are seen as in a position of weakness in relation to animals; women, by contrast, are presented majestically, a highly realistic treatment being accorded to the naked body, while the head, arms and legs are abstract or entirely absent. Several traces of ocher at Laussel and Angles-sur-l'Anglin indicate that these sculptures may have originally been painted.

Struck and sculpted materials

The bison's head from Angles-sur-l'Anglin (Vienne, France) belongs to a group carved into the limestone of the Roc-aux-Sorciers Shelter, used 14,000 years ago. The shelter comprises 2 focal points and the carved, broken-off block, which comes from the Taillebourg section, is 35 cm high. It was originally part of the animal frieze found in the neighboring Bourdois section, in which are found representations of several naked women. All the carved images were lit by daylight and the resultant lateral shadows throw them into relief. Traces of different-colored paints prove that the bas-reliefs were originally colored: the bison's poll, for example, was painted black. A man's head from the same site has black hair and beard and a red face.

Mammoth at the cave entry •
The mammoth carved on the left
hand wall 16 m inside
the entry to the Domme Cave
in Dordogne, France, is lit by
daylight. This accomplished
representation—130 cm high and
executed 13,000 years ago—
shows affinities with other
engraved and painted mammoths,
notably those in the nearby
Rouffignac Cave. The limitations
of space in the entry to the cave
seem to have determined the
choice of a technique aimed at
providing a readily recognizable
shape. Sculpture also implies
another, more absolute approach
to control of place and material:
it is intended to be seen vertically,
where possible, and by daylight.

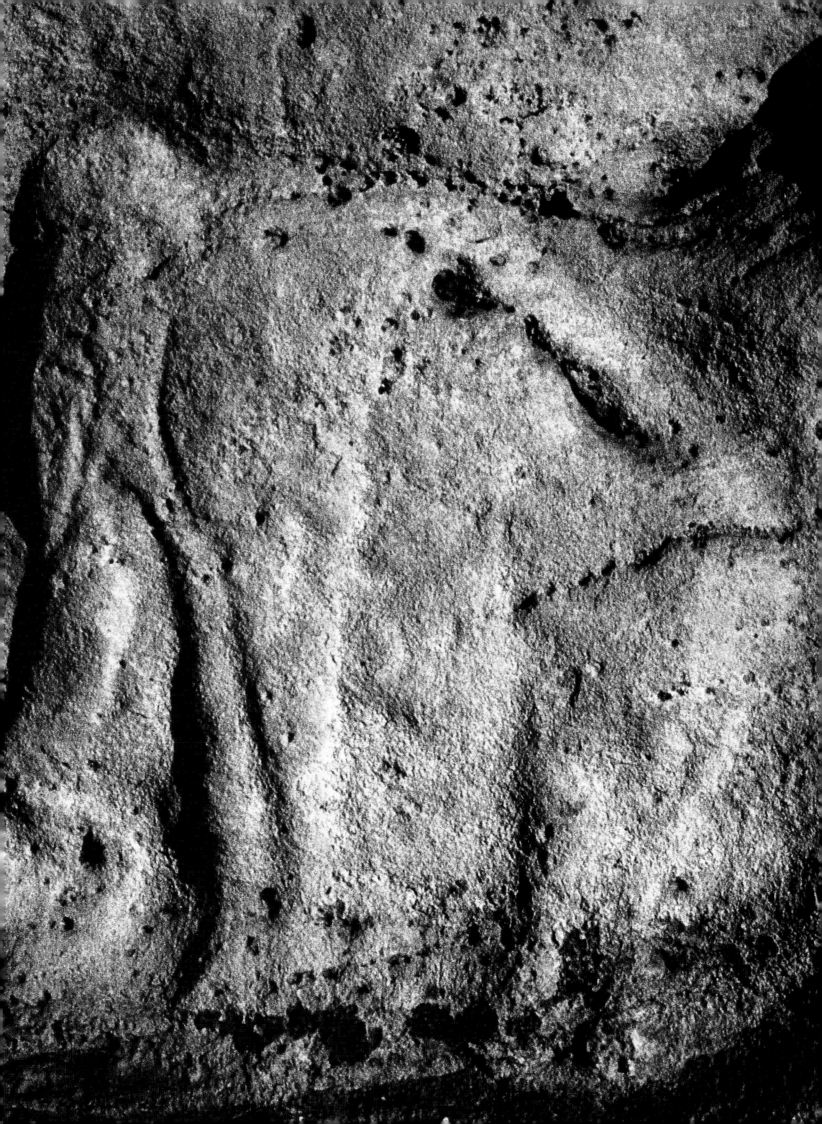

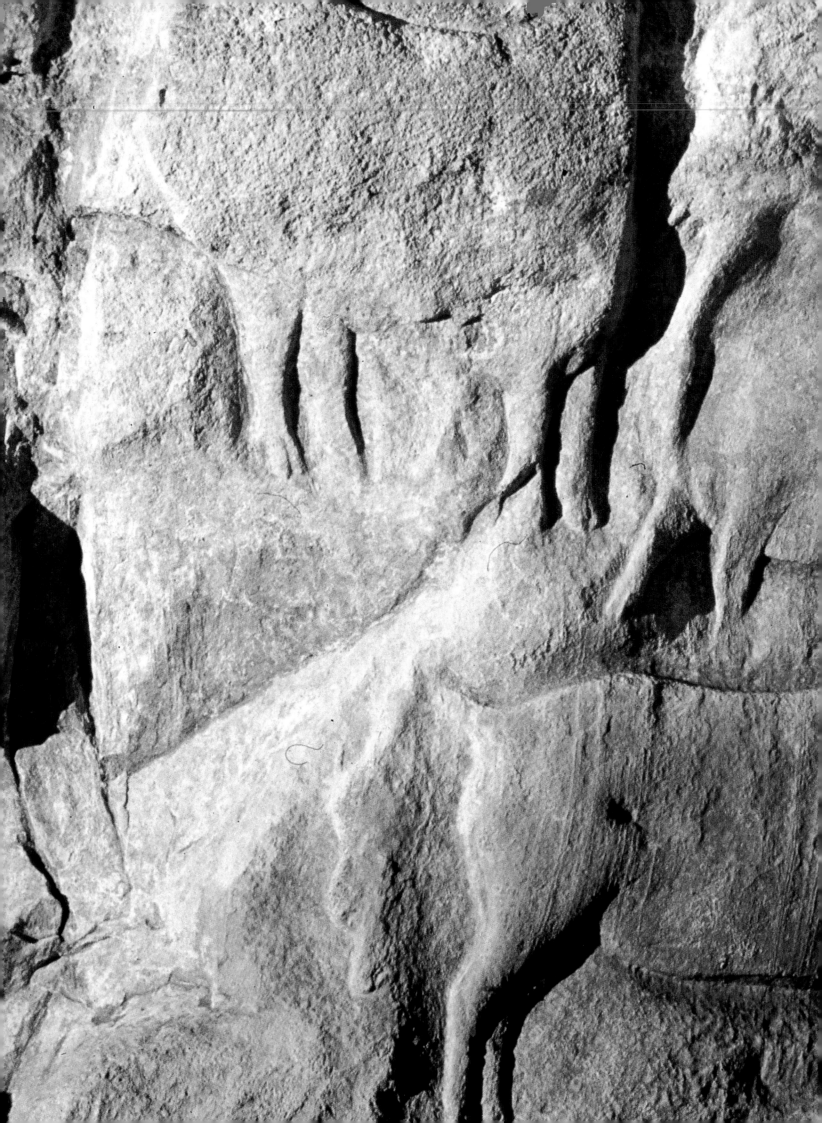

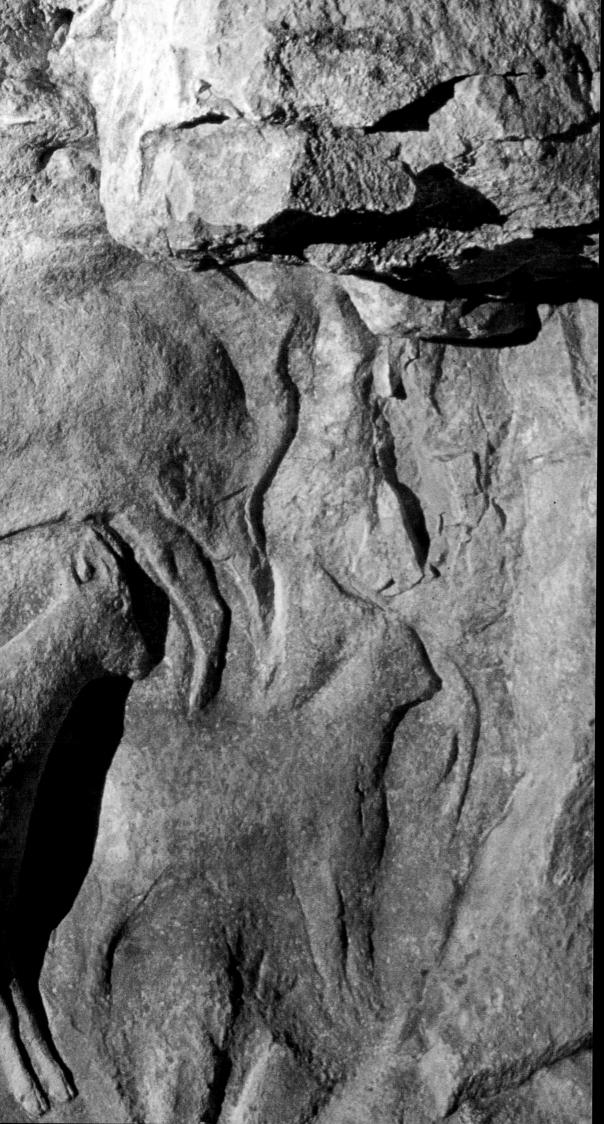

The life of the ibex

Panel IV in the Bourdois section
of the Roc-aux-Sorciers Shelter
at Angles-sur-l'Anglin (Vienne,
France), offers a sculpture of
the life cycle of the ibex, executed
14,000 years ago. In its upper
part 2 males confront each other
during the mating season,
readying themselves to fight
for possession of the females.
Lower down, a female (or a goat)
1 m high is protecting her young.
Sunlight falling on these two
juxtaposed scenes gives rise
to shadows that set off
the volumes and give the sculpted
animals a most lively, natural
look. This is naturalistic theatre
at its best, even though
the images fit with definite
conventions and a fixed style.

OPEN-AIR ROCK ART AND IMAGE REPETITION

Another highly distinctive feature of the arts of prehistory is to be found on the major decorated sites known as "open-air sanctuaries". Unlike the decorated caves, that collection of closed worlds devoted to the emergence of form, and also unlike the rock shelters providing direct confrontation with "iconic" images, the open-air sites offer vast series of incised or pecked rocks bearing figurative or abstract motifs. These are usually executed on flat rocks or on slightly tilted surfaces oriented towards distinctively shaped high points. They would seem to be votive messages repeated many hundreds of times and addressed to the forces of the universe. This process of veneration can extend to entire landscapes, sometimes several dozen hectares in area. The figures and signs are no bigger than in the caves or rock shelters, but in the European groupings at Foz Côa (Portugal), Monte Bego (French Alps), Valcamonica (northern Italy), Tanum (southern Sweden) and Zalavrouga (northern Russia), they occur in hundreds, spread over great distances. This suggests large-scale gatherings of the faithful and a special, specific function for the site. As João Zilhão, one of the discoverers of Foz Côa wrote, "This is not an art linked to the depths of the earth and limited to caves, but a behavior intended to impose symbolic contents on a landscape comprising the entire territory used by Paleolithic hunters."

Open-air sculpture of this kind is in fact much more common than was once thought. These immense sites are found on all five continents, but especially in Australia and America. The animals they feature, in association with more or less fantastic humanlike creatures, are not solely—or not at all—those that were hunted; they seem, rather, to be symbolic references introduced, generation after generation, into an ancestral narrative. Our investigation of this form of prehistoric art will begin with the oldest and interestingly varied sites identified in Europe.

Open-air Paleolithic parietal art received quite a boost with the recent discovery of thousands of engraved drawings at Foz Côa in Portugal, where twelve of the twenty-six groupings are from the Paleolithic period. Engravings in the same style have been found at Fornols-Haut in the French Pyrenees, at Domingo Garcia, Siega Verde and Piedras Blancas in the Meseta in Spain, and still others at Mazonco in the Douro valley in Portugal. So if

Open spaces, slanting light
Engraving and "pecking" of smooth rocks are techniques widely used on open-air sites, where the slanting light of the sun makes the images stand out clearly. This was doubtless much more of a collective venture than work carried out deep inside a cave or in a rock shelter, and decorated open-air sites sometimes cover considerable areas. This ibex from Penascosa in Portugal's Coâ Valley is probably related to archeological remains found nearby and dated to 18,000 B. P. The deep, V-shaped line of the back is notched at regular intervals to induce a contrast between the sunlight striking one side of the groove and the shadow on the other side. This interplay of light and shade can change the viewer's perception of the drawing. This image offers two possible placings of the head.

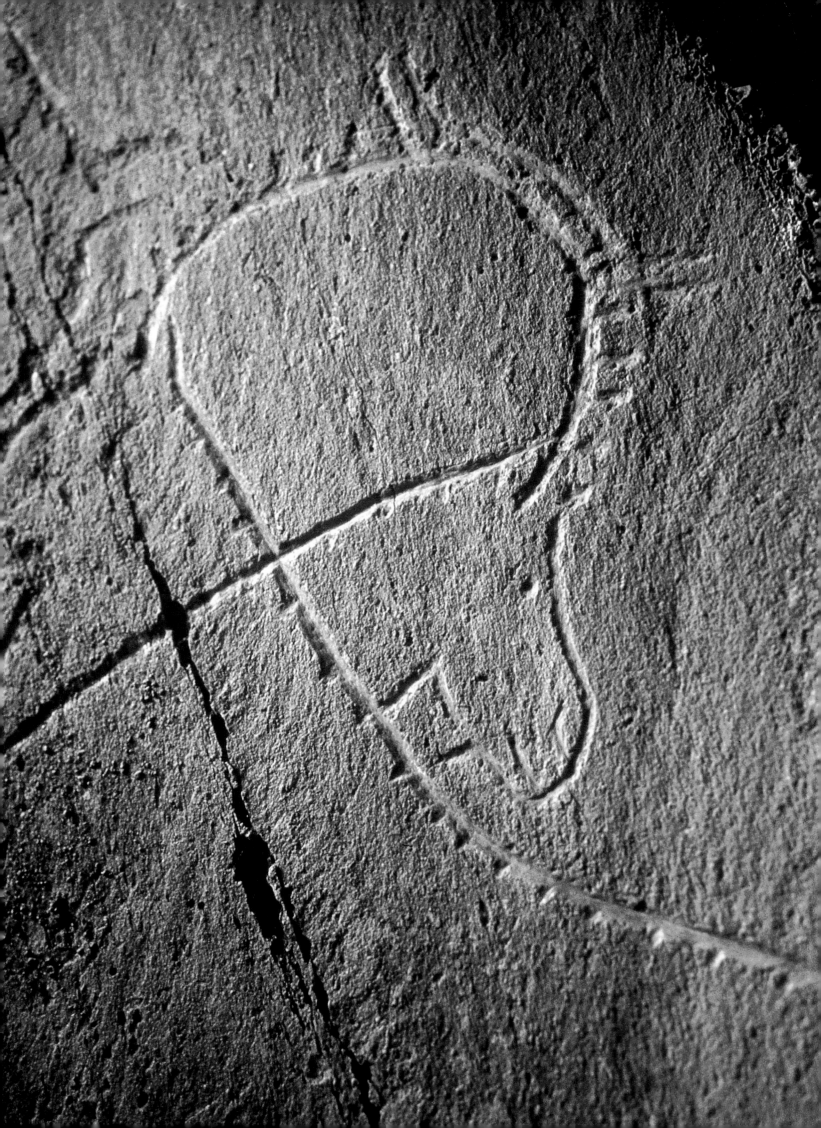

A vigilant horse

This horse, engraved maybe 18,000 years ago on the outdoor rock of Penascosa in Portugal's Coâ Valley, is turning to look behind him, exactly like the ibex on the same site (p. 149). This is the wary stance of an animal that stops feeding because of a noise or an odor, and looks around to see if it should flee. Hunters know this stance: it is the moment when the hunter and the prey cross gazes, when the contract of death is signed. In the caves we find simulated massacres; in their own, different way, these outdoor sites testify to the drama of the hunt and death.

the two horses and the wild bull, all three red-painted, in the Lena valley in Siberia are genuinely Paleolithic, which would seem to be the case, as both species became extinct in the region at the end of the period, we must consider open-air Paleolithic art as being as widespread as the parietal and portable art of the European and Siberian Paleolithic.

In a virtually limitless landscape each rocky surface as defined by natural crevices represents a graphic entity with its own visual makeup and potential for complementing its neighbors. The ready access such sites offer, in contrast with the frequent difficulties posed by decorated caves, may explain why open-air sites from a similar Paleolithic era lack the system of signs so typical of caves and apparently providing a connection between the various figures. A general characteristic of open-air sites is the technique: deep incising and pecking catch indirect sunlight in a way that emphasizes the outline of the drawing. In the protohistoric period the interior of the image may be pecked, as is the case with the daggers at Monte Bego and lyre-players at Tanum. Sculpture on the other hand, while frequent in the rock shelters but less so in the caves, is totally absent from open-air sites. Once again the question arises of whether this reflects the types of site so far discovered or the habits and specific intentions of the artists. The creation of these sites led to regular visits over several centuries; and even if some periods betray greater activity than others in terms of engraving and pecking, these vast natural sanctuaries must have represented a considerable temptation for the addition of purely personal contributions; and all the more so given the simplicity of the basic technique and motifs.

There would seem to be a connection between these immense sacred areas and the passing of the seasons, which would have been a factor in the organization of Paleolithic hunters' search for the herbivores portrayed on the rocks in Portugal. Spring and summer are the only seasons when outdoor protohistoric sites are really accessible, as they are under snow all winter and part of the fall. This is also the case of Monte Bego, high up in the mountains behind Nice, where the ground is snow-free only during the three months of summer. Although lower than Monte Bego, the pecked rocks of Valcamonica, north of Brescia, are very much part of the Alpine zone and under snow in winter. Similarly, several months of snow and ice block access to the open-air sites in Scandinavia and on the shores of the White Sea in northern Russia.

The pecked geometric forms at Monte Bego have been interpreted as local maps. At Valcamonica this notion of space occupied and ordered by human beings is much more explicit, notably on the Bronze Age petroglyphs known as the "Map of Bedolina". The effort expended in these mapping exercises is indicative of an approach to controlling invisible spaces too vast to be taken in by a single glance.

Next page
Images and monuments
When the wide-open spaces were beginning to be turned into farmland some 6,500 years ago, megaliths—monuments of large stones—appeared as landmarks on disputed territories. However, images were also included when these structures served funerary and religious purposes.
The Gavrinis dolmen, built a little more than 6,000 years ago at Larmor Baden in Brittany, France, is an excellent illustration of a determination to express messages visually on these 2-m high stones: clearly visible on the left and in the center are drawings of polished axes with pointed polls, highly prestigious objects of which real-life jadeite examples have come down to us. Other motifs are interpreted as representing sticks, bows, serpents and, on the right, the profile of an idol. This kind of imagery doubtless served to ensure the balance and dynamism of the society that produced it.

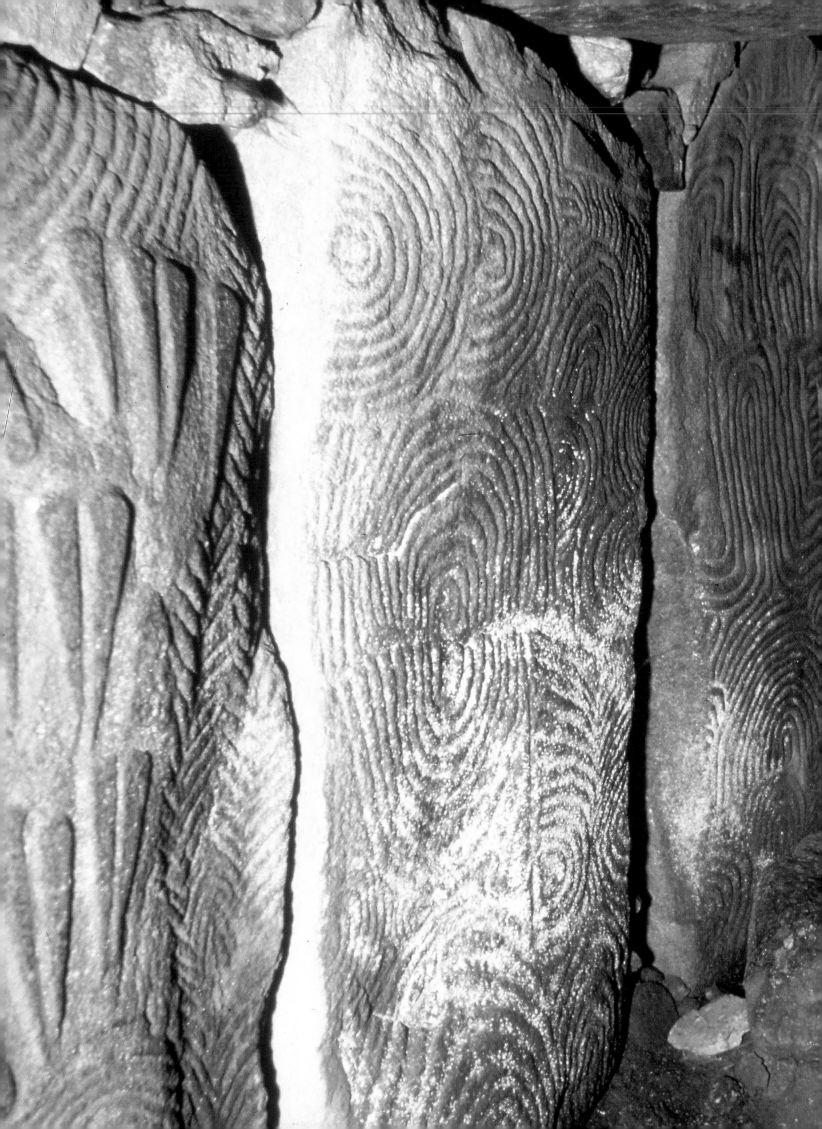

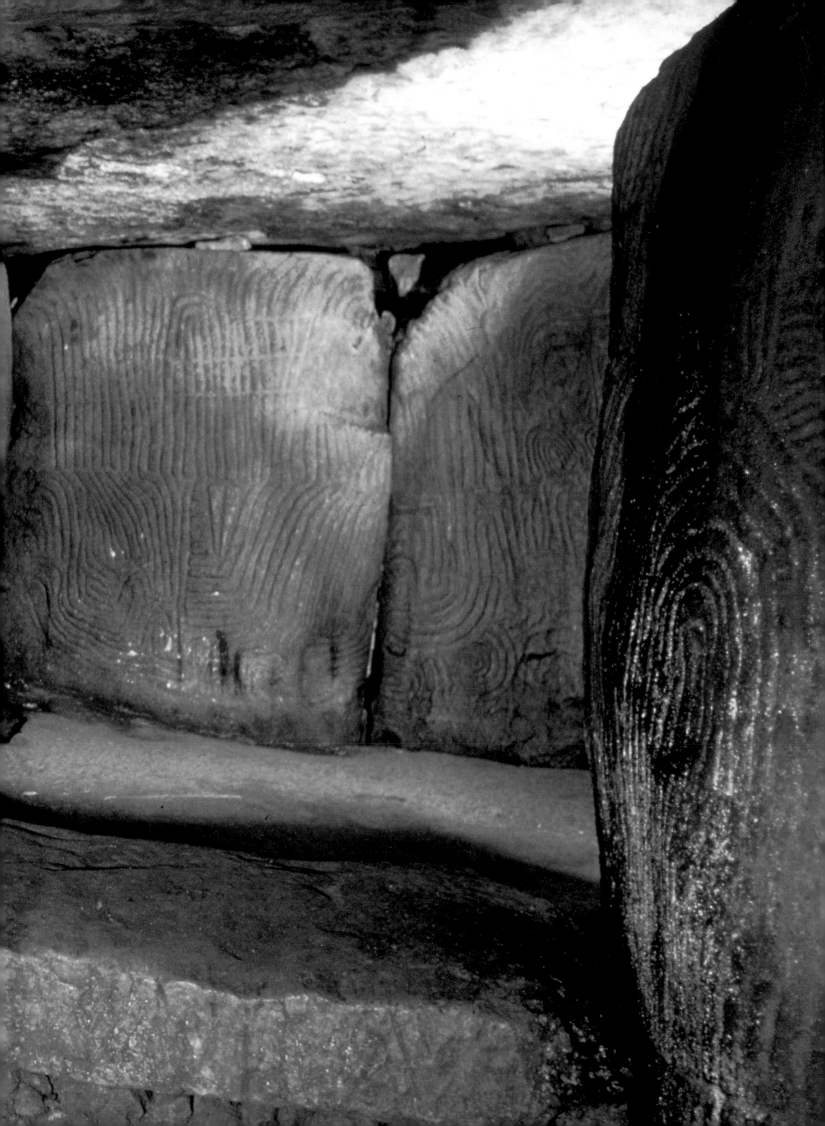

Hidden
Meanings

5

Abstract women

This 60 x 45 cm limestone slab engraved with schematic female images comes from the La Roche Cave at Lalinde (Dordogne, France). Archeological material found in association with it indicates an age for the engravings of 13,000 – 12,000 years. The female body is shown in profile, with emphasis on the buttocks and the curve of the lower back, a visual convention then widespread at this time in Western Europe, where the many known examples include 500 plaquettes from the single site of Gönnersdorf, near Coblenz in Germany. There is no indication of the head, arms or feet, but the breasts do sometimes appear. The drawing thus becomes an ideogram, but the reason for its repetition remains unknown.

Musée national de Préhistoire,
Les Eyzins, France

Some of the best documented prehistoric images and scenes from Africa, Australia and America provide us with a glimpse of supernatural worlds, worlds brought to life by the performance of special rites and at the same time memorized in their role as transmitters of myths. Speaking of the deep vertical incisions made into the rock at the La Viña Shelter in the Spanish Asturias at the Aurignacian period, Michel Lorblanchet (1999) points out that some fifty years ago, near Ingaladdi and Delamere in northern Australia, Aboriginal people were seen cutting into the rock face in the course of rain-making ceremonies. This "cutting" liberated spirits called "scout brothers" shut up in the wall of the shelter; masters of the weather and the climate, these beings could then release the rain. Thus these vertical lines, which for the uninitiated are totally abstract, had a very concrete meaning for their creators; the same Aboriginal groups were also responsible for naturalistic animal motifs in a nearby shelter, using a different style related to another set of myths.

ABSTRACTION AND MOVEMENT

The style and content of prehistoric art are characterized by an abstraction linked to a quest for the expression of movement and life. Abstraction is simultaneously a simplification of a natural world observed as infinitely complex and a concentration of the meaning of observed detail. This dual tendency, abstraction and condensation of meaning, inds expression in more or less developed forms, from the illusory realism of the Magdalenian to post-glacial schematism and the approach to the pictogram widely adopted during the various metal ages.

Do degrees of abstraction in fact correspond to changes in perception? S. Geidion (1962) reminds us that *aphairesis*, the Greek word for abstraction, has two meanings: on the one hand it indicates a way of homing in on essentials, and on the other the process of freeing the imagination. If we look at the first Mousterian (80,000-35,000 B. P.) cup marks, which may have a connection with the deeply etched vulvas and phalluses of the Aurignacian, and if we reflect at the same time on the stenciled hands of the same period at Gargas and Chauvet, it would seem that the earliest prehistoric art displays a highly fragmentary, but strongly explicit grasp of certain themes. By indicating the primary male and female characteristics at the pictographic level of abstraction, the artist emits graphic exclamations that summon up desire and the life force. Everyday realism is dissipated in favor of undulating backbones forcefully applied to the rock as a means to naming the idea of the ibex, the horse, the rhinoceros, the mammoth and so on. The notion of realism and of the geometrical perspective that accompanies it is totally foreign to prehistoric art, even if an intimation of perspective can be felt at Chauvet, with the overlapping of heads and horns and the frontal view of the bison. Renaissance-style linear perspective requires a flat, urban picture surface which is neither that of the rock face nor that of the herd massed on a hillside or on a riverbank. While modern perspective assumes a single individual considering the work from a given point, the space generated by prehistoric art is open to several viewers looking at the subject at the same moment but from different angles. These viewers identify the subject in terms of its essentials, that is to say as an abstraction. In addition to the line of the animal's spine, another constant concern for artists throughout the

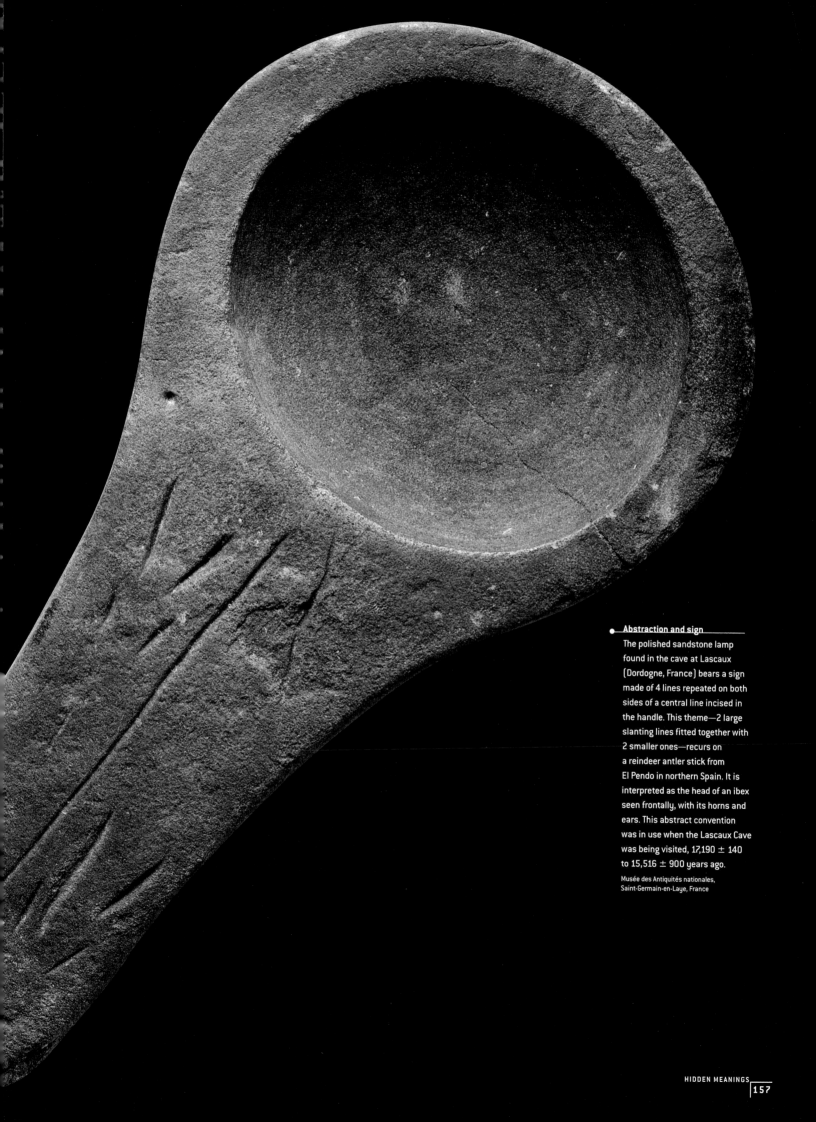

Abstraction and sign

The polished sandstone lamp found in the cave at Lascaux (Dordogne, France) bears a sign made of 4 lines repeated on both sides of a central line incised in the handle. This theme—2 large slanting lines fitted together with 2 smaller ones—recurs on a reindeer antler stick from El Pendo in northern Spain. It is interpreted as the head of an ibex seen frontally, with its horns and ears. This abstract convention was in use when the Lascaux Cave was being visited, 17,190 ± 140 to 15,516 ± 900 years ago.

Musée des Antiquités nationales, Saint-Germain-en-Laye, France

Abstract painting surfaces

A fissured stone some 20 cm high
in the wall of the upper gallery
at Mas-d'Azil in Ariège, France,
became a source of inspiration for
a Magdalenian painter between
14,000 and 12,000 years ago.
Adding a little black paint to
signify the eye and to emphasize
the volume of the nostril, he
provided the gallery with a
guardian who would be seen by
every visitor with a torch or an
animal-fat lamp. Abstraction was
at the root of all illustration in
prehistoric caves.

millennia of prehistory was to structure the portrayal of the subject's legs so as to express that "active", contained, concentrated repose to be found in the bison of Altamira, the noble gait of the bulls of the Lascaux procession or the flying gallop as at Chauvet. Nor are the forms and conventions used to suggest movement to be taken as criteria of realism; they are quite as abstract as the significant details that allow us to recognize the species of animal in question. In its repetition of the same image seen from different angles, the frieze of the deer heads at Lascaux conveys a profoundly convincing impression of the movement of a herd crossing a river. Abstraction uses conventions acknowledged as symbolic: this is the case of such scenes of animal combat as the two rhinoceros at Chauvet and the pair of sculpted ibex at Roc-de-Sers. The simplification of the contours, together with the exaggeration of the horns and the musculature of the forequarters markedly increase the impression of physical impact, generating a magical effect that emanates from the block of stone.

The schematic treatment of reality used for the two ibex heads on the Lascaux lamp pushes our visual understanding to the limits. Seen frontally, each animal is reduced to no more than four slanting lines for the horns and ears set symmetrically around the space that suggests the skull. This kind of abstraction is not far removed from that of the ibex of El Pendo in Spain. As the approach becomes more methodical the abstraction it generates is sometimes conducive to an ambiguity that may in itself be meaningful: the bison at Pech Merle can also be read as female profiles, and thus as pointers to a symbolic relationship between bison and woman. These Magdalenian feminine outlines appear as pictographs on the many incised slabs at Gönnesdorf in Germany and at Eyzies and Lalinde in the Dordogne, in France. Certain signs at Altamira, rods with bulging middles, may be the outcome of one of the most extremely abstract evolutions of the female form, as Leroi-Gourhan suggested in 1964.

Abstraction is not present solely in terms of the profiles of animals and human beings; it may also appear in the way they are filled in. Thus anatomical details such as the eye, nostril, nose, mouth, ear, or coat, together with their variations in tone, are expressed in petroglyphs or paintings in a stylized and even geometrical way. Often, too, the pictorial surface of stone or bone, for instance, includes surface irregularities that may themselves be evocative of hair, skin, the eye, the mouth or the ear. The coat of the Lourdes horse, sculpted in ivory, is represented by parallel series of etched lines, while that of the horses at Pech Merle is indicated by more abstract dots of color. One consequence of becoming accustomed to abstraction is a readiness to accept the transparency of the subjects. This can take two forms, the first being the kind of superimposition that allows for seeing the drawing of a bison or part of a reindeer under the horse actually being looked at. This technique, frequent on the carved walls at Combarelles and Trois Frères, the painted surfaces at Pech Merle and the incised plaquettes from Limeuil (Dordogne) and La Marche (Vienne), is disconcerting for the twenty first century viewer, who tends to interpret them as successive subjects of which the most recent automatically eliminates its predecessor. However, this kind of superimposition can have a more positive meaning: it may be cumulative, for example, if the main concern was to get the image made without thinking in terms of a final composition. Then again, it may be a matter of simple *rapprochement*: the two small human silhouettes transfixed by spears at

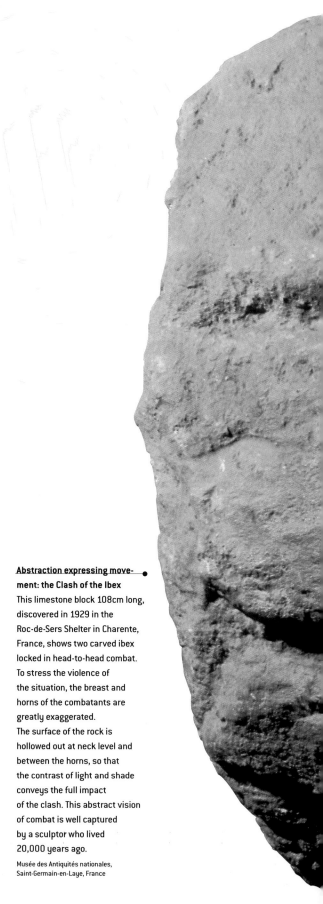

Abstraction expressing movement: the Clash of the Ibex
This limestone block 108cm long, discovered in 1929 in the Roc-de-Sers Shelter in Charente, France, shows two carved ibex locked in head-to-head combat. To stress the violence of the situation, the breast and horns of the combatants are greatly exaggerated.
The surface of the rock is hollowed out at neck level and between the horns, so that the contrast of light and shade conveys the full impact of the clash. This abstract vision of combat is well captured by a sculptor who lived 20,000 years ago.

Musée des Antiquités nationales, Saint-Germain-en-Laye, France

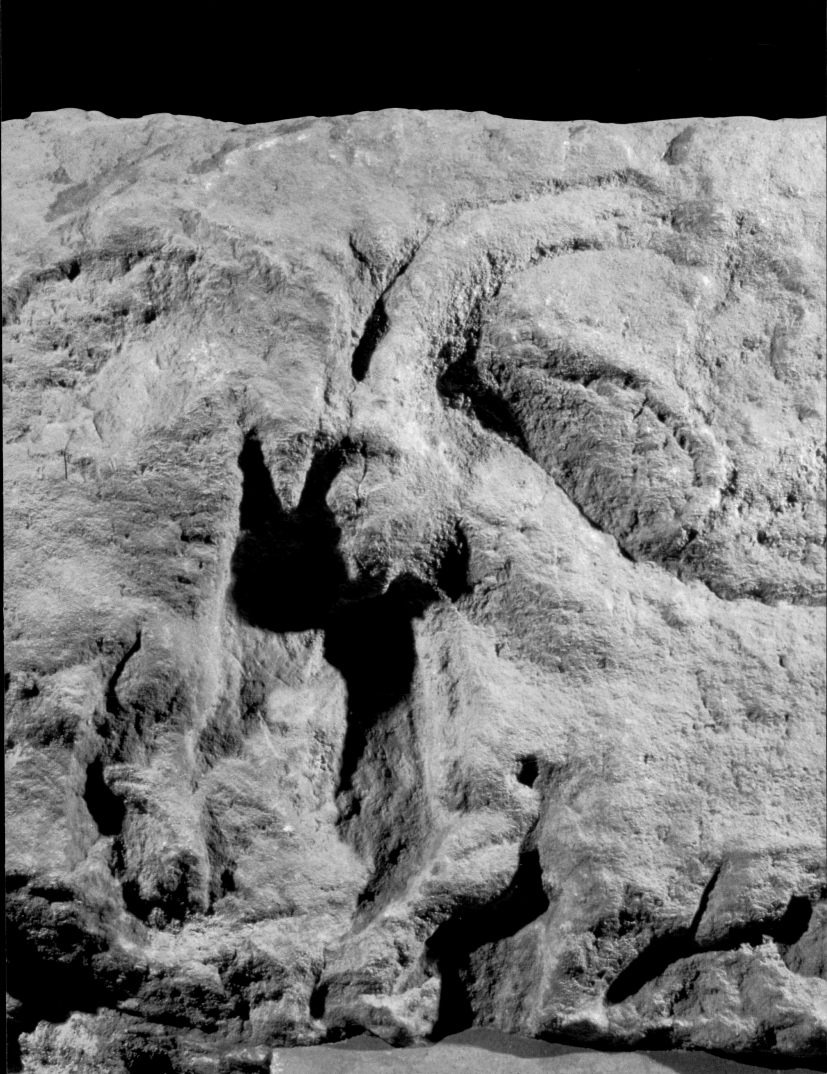

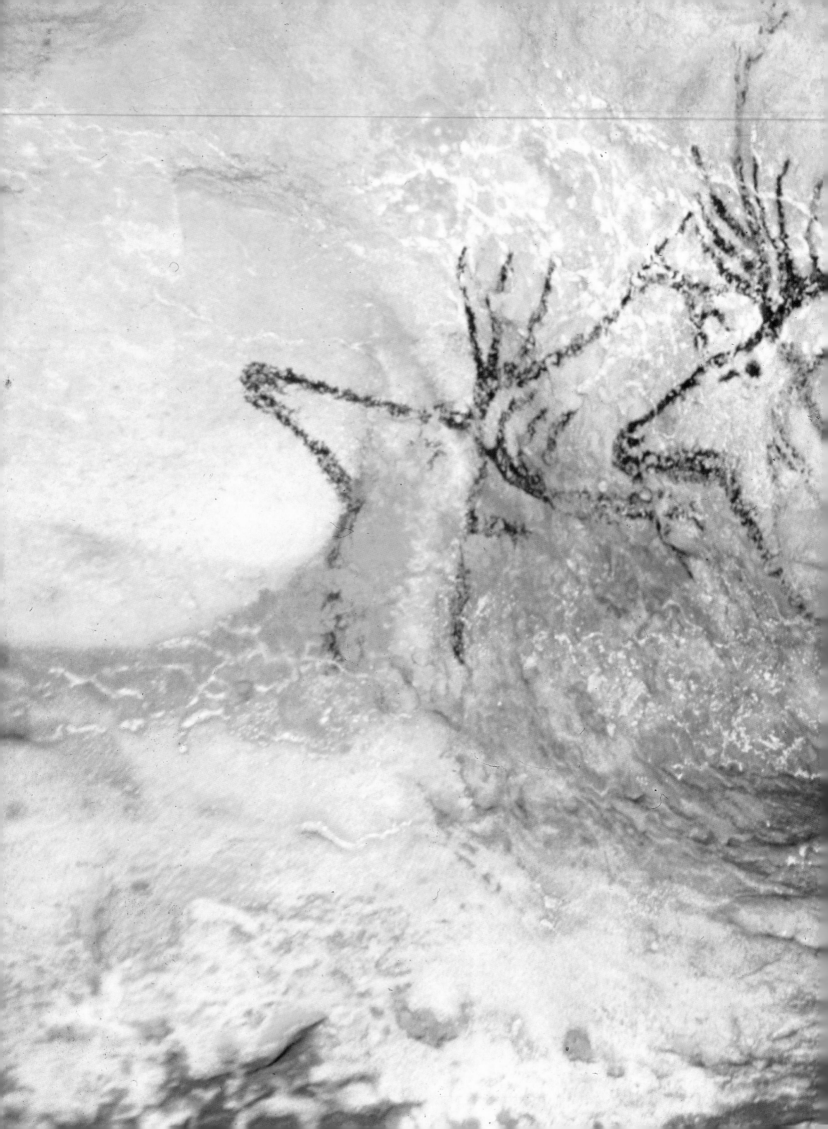

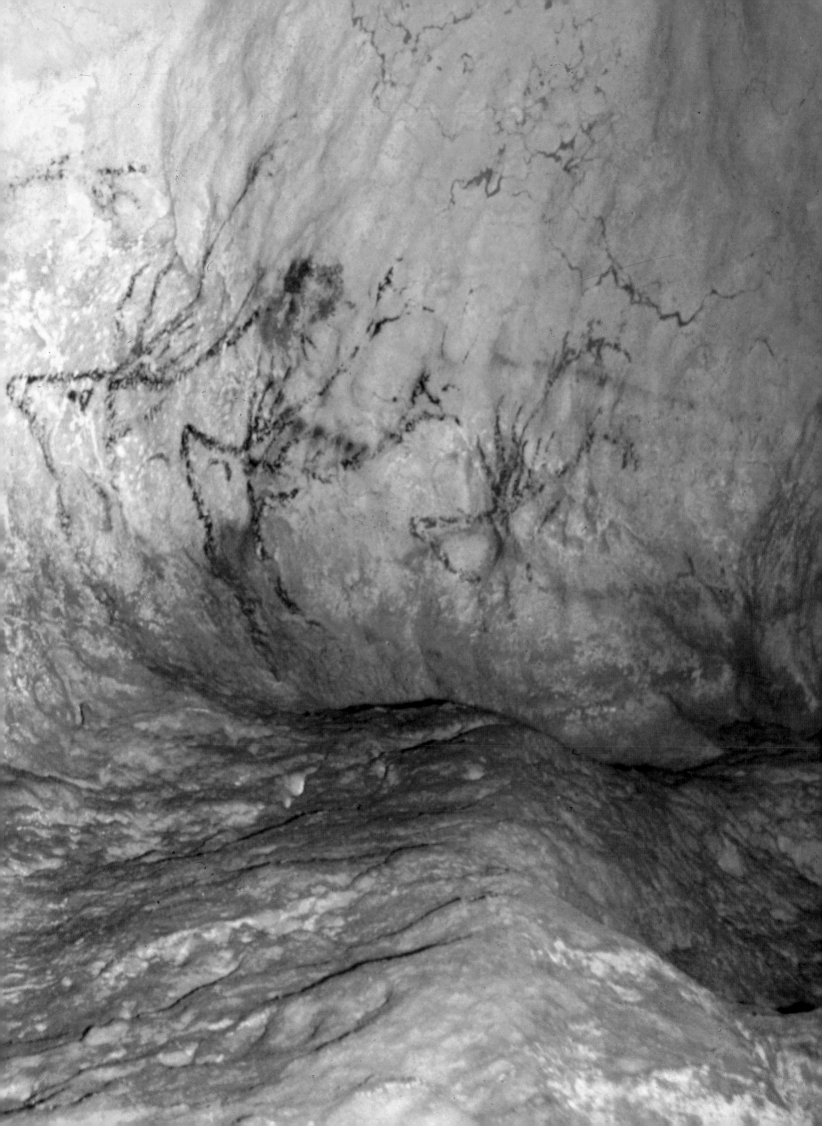

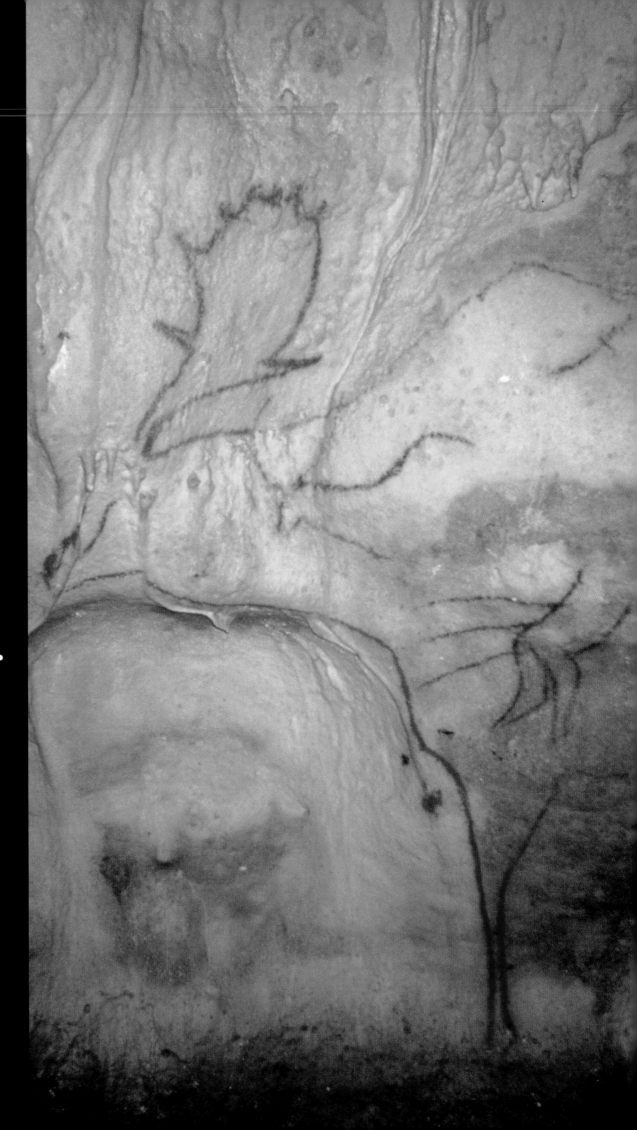

Precedent page
The swimming stags

At Lascaux in Dordogne, France,
these 5 stags' heads with impres-
sive antlers—1 m high in all—
were painted in rich black some
17,190 ± 140 to 15,510 ± 900
years ago. They are all holding
their heads high, as if crossing a
river whose level is indicated by a
natural, wavelike rock ledge. Each
head is seen from
a slightly different angle,
a technique that heightens
the illusion of the movement
of the water and of animals
making their way through it.
Once again the use of abstraction
confers real power on a scene
which, while nothing special
n itself, is characteristic
of the fragility of life faced
with the forces of nature.

The large figure guiding the small

The space enclosed by a drawing
acquires a certain intimacy with
its internal components. What,
then, is the relationship between
the 120 cm high megaloceros,
or Irish elk, whose outline appears
in Cougnac Cave at Payrignac
(Lot, France) and the other
subjects enclosed within that
outline? These include a partially
drawn stag on the megaloceros'
neck and, on the front part of its
abdomen, a running man with no
head or arms and three javelins
projecting from his back. This cave
was being visited from 25,000
to 14,000 B. P. and the paintings
were executed gradually. What
continuity, what inner life and
what narrative might lie behind
these superimposed images, with
their seeming absence of any
coherent connection?

(Ardèche, France) appears on the right-hand wall of the central niche, opposite a big cat. Clearly he is fleeing, as indicated by the open, panting mouth and the fact that he has been given 8 legs, with the addition of perspective effects: the outline is only indicated for the last of the back legs; the second front leg is accentuated by a broader black stroke. Here speed and movement are captured with a vividness worthy of the cinema.

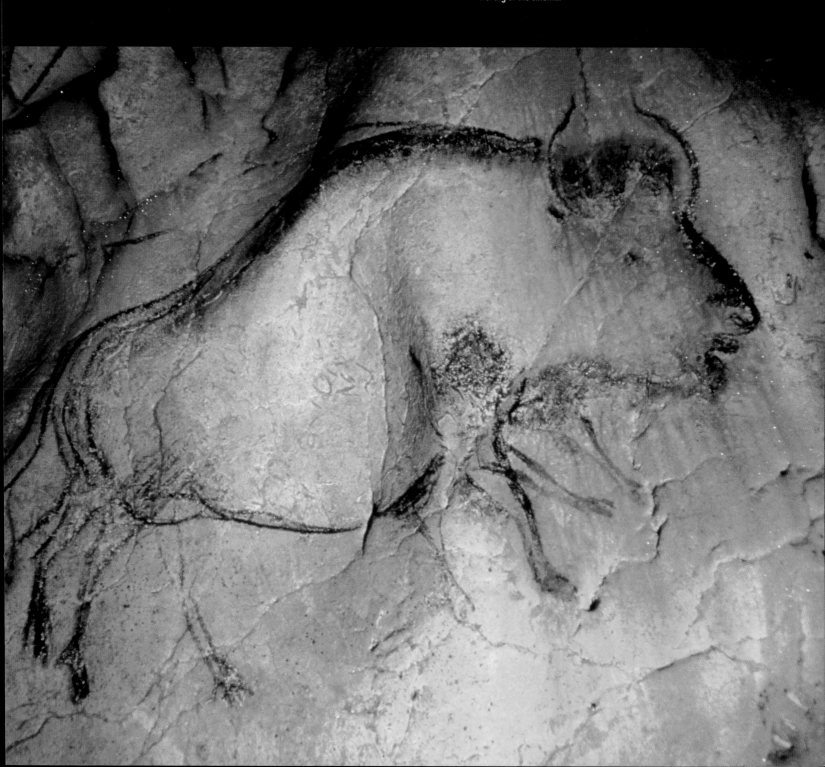

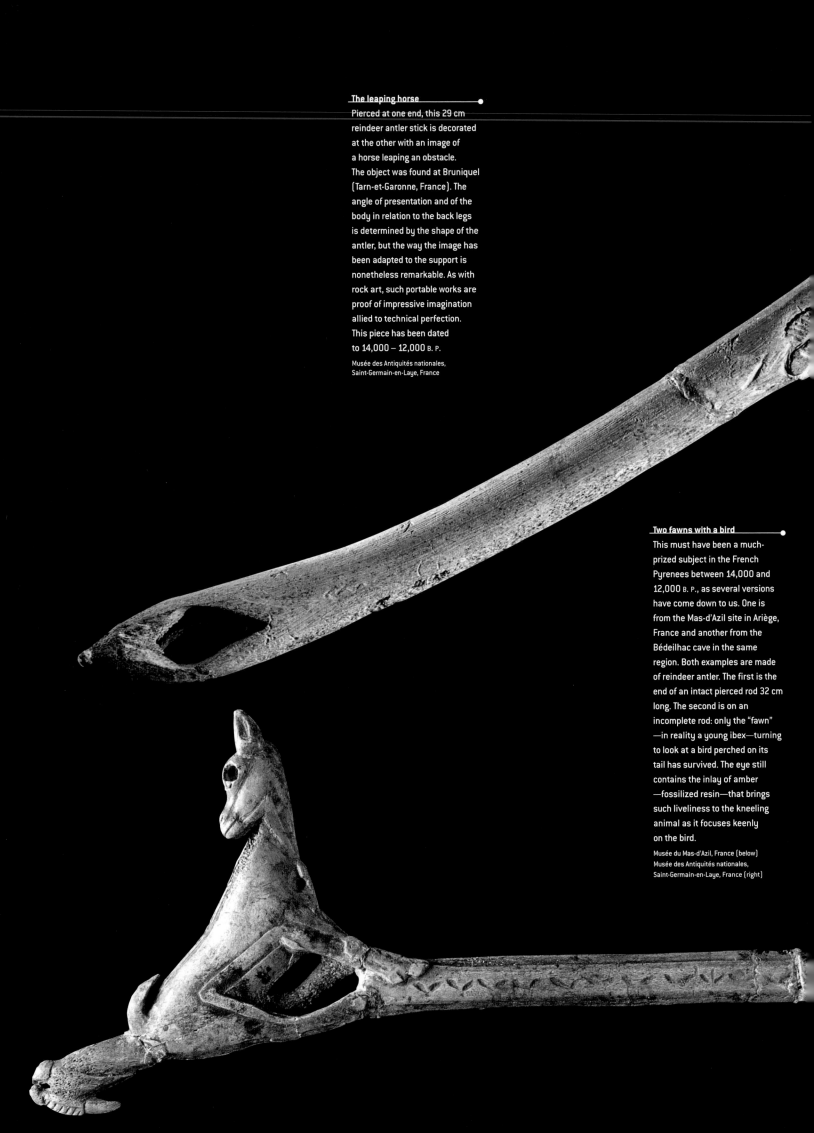

The leaping horse

Pierced at one end, this 29 cm reindeer antler stick is decorated at the other with an image of a horse leaping an obstacle. The object was found at Bruniquel (Tarn-et-Garonne, France). The angle of presentation and of the body in relation to the back legs is determined by the shape of the antler, but the way the image has been adapted to the support is nonetheless remarkable. As with rock art, such portable works are proof of impressive imagination allied to technical perfection. This piece has been dated to 14,000 – 12,000 B. P.

Musée des Antiquités nationales, Saint-Germain-en-Laye, France

Two fawns with a bird

This must have been a much-prized subject in the French Pyrenees between 14,000 and 12,000 B. P., as several versions have come down to us. One is from the Mas-d'Azil site in Ariège, France and another from the Bédeilhac cave in the same region. Both examples are made of reindeer antler. The first is the end of an intact pierced rod 32 cm long. The second is on an incomplete rod: only the "fawn" —in reality a young ibex—turning to look at a bird perched on its tail has survived. The eye still contains the inlay of amber —fossilized resin—that brings such liveliness to the kneeling animal as it focuses keenly on the bird.

Musée du Mas-d'Azil, France (below)
Musée des Antiquités nationales, Saint-Germain-en-Laye, France (right)

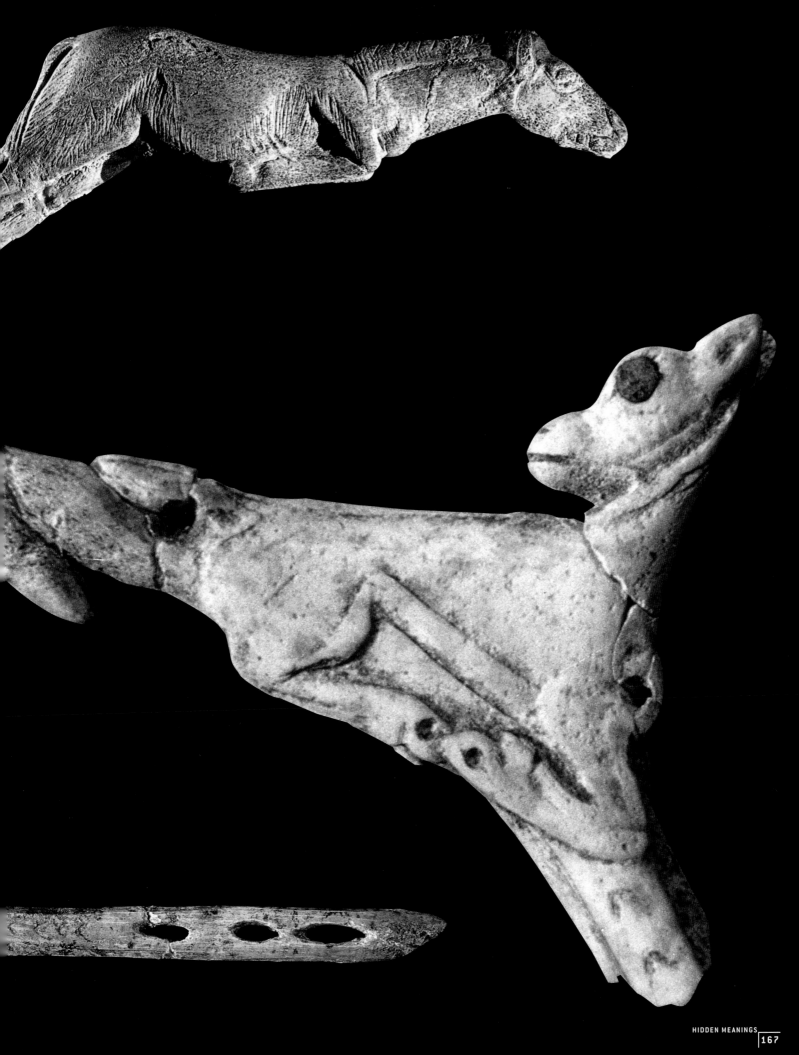

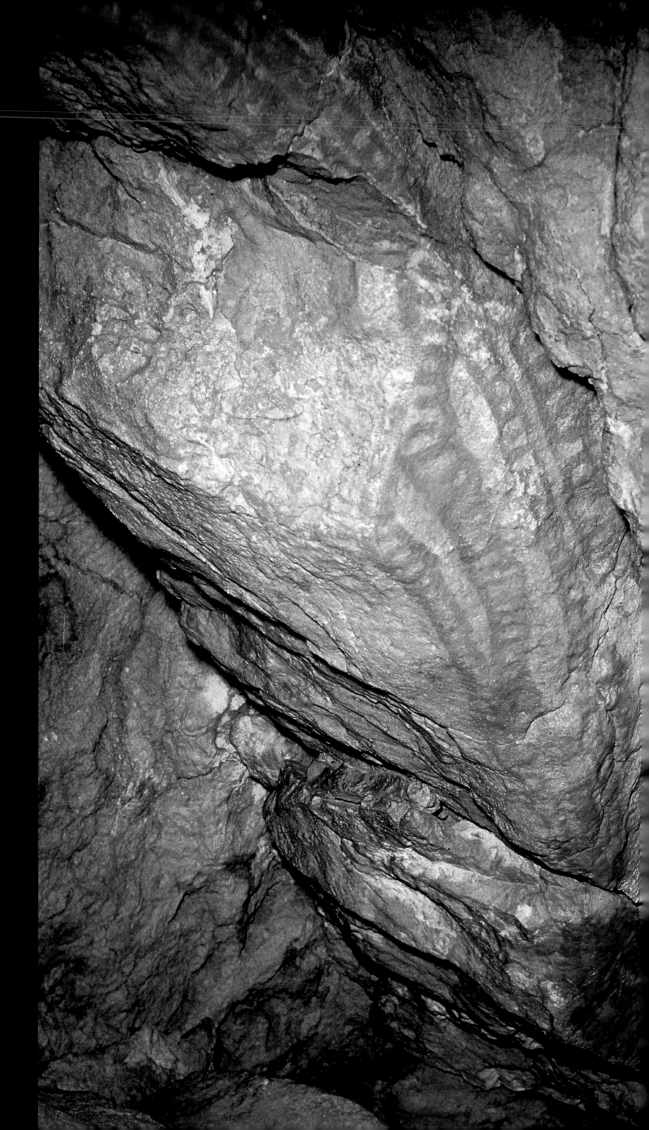

Signs or signals?

At the far end of the second chamber at Altamira in Spain is a large decorative motif painted in red and comprising several stripes. This doubtless indicates the outer limit of the sanctuary, but is that all? Dating from 16,480 ± 200 to 13,130 ± 120 B. P. , it can be seen as suggestive of other ideas: trickles of blood? A trap? We simply cannot say. Yet we cannot help but admire the way this painting brings unity to a highly complex rock face.

Cougnac—one inside a mammoth, the other inside a megaloceros—and in association with an ibex and a deer, doubtless have some relationship with the animals in question. And is the small incised horse in the belly of a larger one at Lascaux a foal inside a mare? It has also been observed that certain organs, such as the heart, are drawn on the mammoth at El Pendal in Spain and in Kapova Cave in the Urals. There seems, too, to be an indication of the digestive organs on the sculpted fish from the Gorge d'Enfer (Dordogne, France) and on a bone plaquette portraying a salmon from Lorthet, in the Pyrenees. There is room here for an interesting comparison with Australian representations of fish with their internal organs visible. These stylized organs may be intended to represent the deepest identity of the living creature.

Abstraction applied to movement and to running in particular can be seen in images of hunters "doing the splits". One example is the finger-drawing in the clay wall at Pech Merle, which shows similarities to certain paintings from the Spanish Levant, the Sahara and Arnhem Land in Australia. Movement is also splendidly portrayed on the pierced rod showing a bounding horse, in the Montastruc Shelter (Tarn-et-Garonne, France), and on the ends of spearthrowers: one, at La Madeleine (Dordogne, France), shows a bison turning to lick its flank, and others, from Mas-d'Azil and Bédeilhac (Ariège), a young deer looking over its shoulder at a "bird" perched on its rump. Another spear-thrower, from Enlène, bears two ibex confronting each other. Nor is there any shortage of painted animals "jumping", like the cow at Lascaux, or fall-ing, like another cow in the same cave. When there is no indication of ground level, these animals seems to inhabit a gravity-free environment; yet life there attains real intensity via the introduction of such themes as love (the lion and lioness series in the La Vache Cave (Ariège, France))or processions of animals as in the Great Hall of the Bulls at Lascaux, and elsewhere.

The term abstraction also extends to the world of signs, to the animal tracks we feel we recognize on some cave walls and to other descriptive or identifying marks. The large, four-sided painted signs at Altamira and La Pasiega in Spain and the rooflike marks of the Eyzies region in France are too carefully handled not to have a meaning of their own, a meaning defined by their time and place.

Abstraction reflects a psychological empowerment that makes possible artistic expression of the imaginary: one example among many is that of the monsters to be found in all prehistoric art, be it in Europe (Tuc-d'Audoubert, Gabillou, Pech Merle), Africa, Australia or America.

SYMBOLS OF LIFE

For G.H. Luquet (1930), modern man understands a painting when it reproduces what the eye sees, whereas symbolic—prehistoric—man understands a painting when it expresses what is known to his mind. In this sense looking at a painted panel at Lascaux demands an intellectual attention that is more than mere recognition of such and such an animal. Behind each drawn or painted entity exists a meaning that the levels of abstraction help us to approach, for they tend to transform motifs into symbols. Symbols are born of the need to render perceptible that which is not perceptible. Among the earliest symbols considered as such, we find, and this is certainly no accident, the deeply incised vulvas of France's Périgord region, in the Blanchard Shelter, La Ferrassie and the Cellier Shelter. In these drawings of the vulva the symbolic function is complete, for the viewer understands that it is not simply a matter of a drawing of the female sex organs, but also a sexual expression that is simultaneously psychological and sexual. The vulva becomes the symbol of a female-dominated sexuality.

Where the written word locks the concept into a fixed definition, the symbol is the starting point for a broader evocation; giving symbolic thought its power and universality. The symbol becomes a physical reality people can influence directly, driving away danger and creating protective situations. The open hand stenciled on the rock wall has been termed the "action hand": its red color and radiant form convey the idea of a "hand of life". Large-scale compositions using such hands are to be found in the caves of Gargas in the French Pyrenees and El Castillo (Spain), but also the cave of Kap Abba at Darembang (Papua-New Guinea), those to the east of Kalimantan (Borneo), at Rio Pinturas (Patagonia)) and Fort Davis (Valverde, Texas). The relation that develops between symbol and intention is an active one.

Artistic expression of the symbol is without doubt the major outcome of symbolic thought, providing a function that can be called on again on subsequent occasions. These hands become "icons" and the focus of prayers. But what prayers, exactly? The limitations of archeological analysis seem to deny us an answer to this question. And yet close examination of the finger-traces at Pech Merle reveals three or four parallel lines made with the same hand, a hand no longer simply placed on the wall to create an imprint, but positioned perpendicular to the wall so as to leave the mark of its fingertips in the soft clay. In a series of opening and closing arabesques this same hand draws women, a hunter and animals. Does what happened at Pech Merle allow us to generalize? Is there a connection between the imprint made by the hand and the act of drawing a living, human or animal being? Can we assume that a symbolic transfer takes place between the hand and the subject depicted; in other

The woman with the horn
Carved on an enormous block of stone set in front of the rock wall of the Laussel Shelter (Dordogne, France)—a site considered to be a sanctuary—it was removed from its original context by Doctor Lalanne in 1908. Created 22,000 years ago, the woman is 42 cm high and still bears traces of ocher. She is naked, with her left hand on her abdomen and her head turned towards the horn held in her right hand, at mouth level. Is this a drinking horn? Does the scene portray a relationship with the bison, which has been seen more than once as complementary to the female function? Whatever the case, the Laussel "Venus" is rightly regarded as one of the most potent representations of woman in all prehistory.
Musée d'Aquitaine, Bordeaux, France

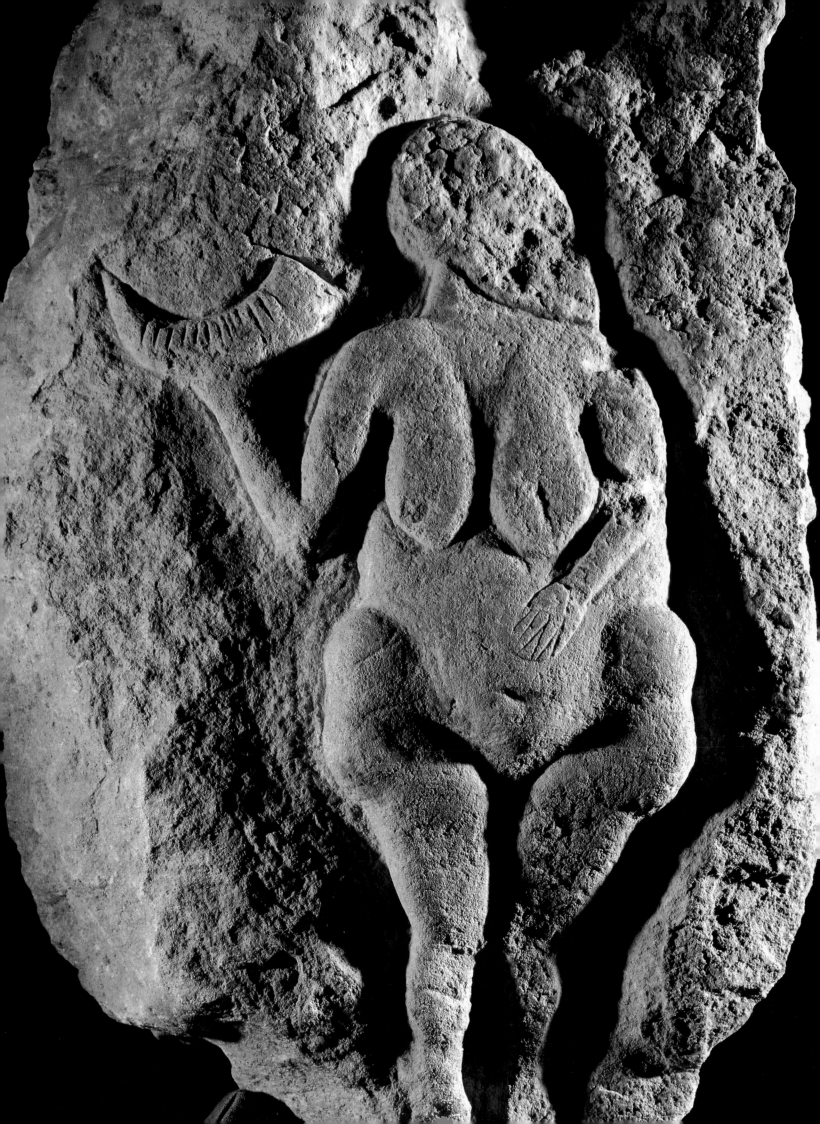

words, do the outlines representing the woman or the mammoth have the same symbolic impact as the silhouette of the hand (Lorblanchet, 1999)?

A recent discovery (1998) in the Chauvet Cave illustrates this vital transfer from the hand of the "artist" to the image it creates. Here the artist has used the palm of his hand to apply a series of ninety large, red-painted marks on the wall, juxtaposing them so as to create the shape of a bison. As with the finger marks mentioned above, this gestural creation establishes a direct link between man and animal, the vector being an image produced with handprints, soft clay and prepared paint, and the sole instrument being a hand guided by the eye.

In a world of symbols, each representation has a dual significance: the first, springing from immediate identification, emerges from abstract conventions delineating the subject; the second involves interpretation. Giving a special or numerically superior ranking to a pictorial theme can also have a meaning. The choice of animal, for example, seems to depend on the cave or shelter: the bear may be the dominant creature at Chauvet, while the bison establishes its ascendancy at Altamira and Niaux; the horse plays a leading role at Pech Merle; the chamois looms large in the final sculpture phase at Angles-sur-l'Anglin, but the sculpted images of women seem nonetheless to play the pivotal part up until the last days of the occupation of the sanctuary.

It seems more than likely that there was symbolic association of images, as Laming-Emperaire and Leroi-Gourhan have asserted in respect of Lascaux and Vialou regarding Niaux. This glimpse of a system allows the components of a narrative to fall into place: in the Great Hall of the Bulls at Lascaux the dual procession of animals, advancing by rank and led by that strange, imaginary creature the Unicorn, provides a cluster of symbols forming the basis of a mythic description. In fact, each representation of a "sorcerer" or a "man-animal" or of any reference to the human seems to indicate a kind of staging: the pit at Lascaux, where a half-dead man confronts a charging, dying bison, fascinates the viewer with a dramatic intensity that sums up the hunter's fate. In the same way the handprints on the dappled horse panel at Pech Merle hint at a confrontation that remains sufficiently explicit to be considered an allusive illustration of some mythic narrative. The bison-man at Trois Frères is following two animals, one of which turns its head to look at him; despite their discretion, such symbols are very much present and reveal the narrative function of the images.

The symbolic world of the caves and the other prehistoric sites is thus a world of narratives: varying lengths in which realism is sacrificed to the imaginary and the mythic.

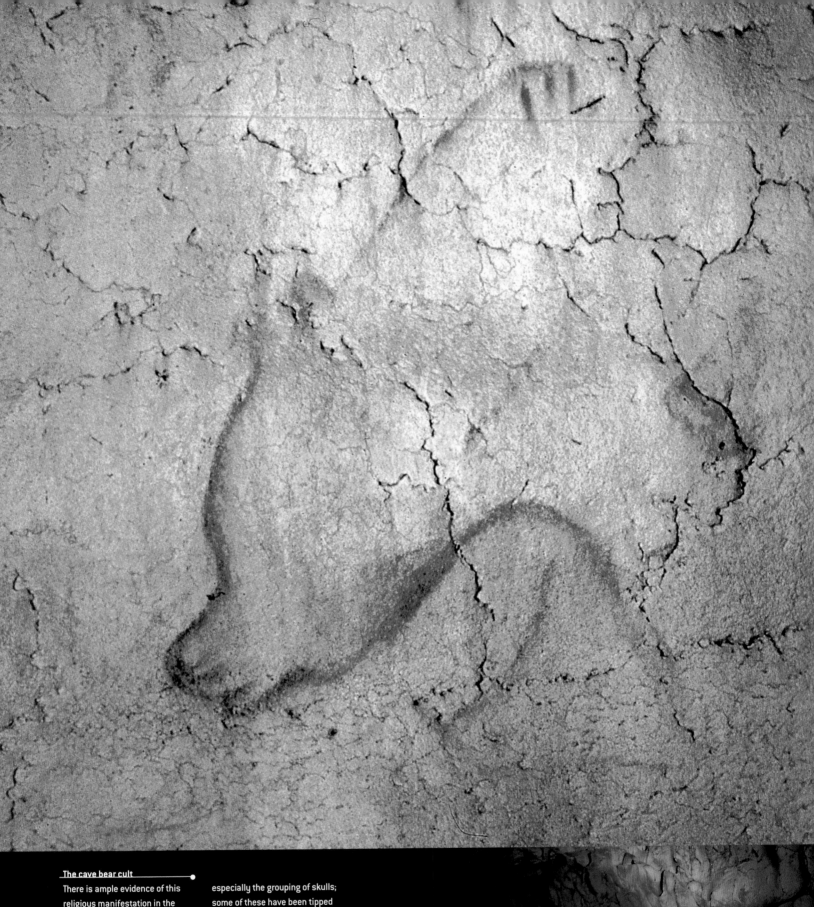

The cave bear cult

There is ample evidence of this religious manifestation in the Chauvet Cave (Ardèche, France), visited between 32,410 ± 720 and 30,340 ± 720 B. P. Archeologists have noted that men and bears were rivals for access to this cave, the latter having left claw marks on some of the paintings. The bear cult is illustrated by the number of bear bones found in the cave, and especially the grouping of skulls; some of these have been tipped over (on the right), while another was given a prominent position as an offering on a large block of stone. The paintings of bears in the cave are extremely well done, but not the most numerous. There is considerable testimony to the cult of dangerous animals during this distant epoch.

ANIMAL CULTS:
NATURE AND SOCIETY

In his book *Archetyp und Tierkreis* (*Archetype and Zodiac*, 1951) Julius Schwabe develops the idea that all symbolism relating to the foundation myths of first great civilizations is linked to an animal world humans are drawn to but into which integration is difficult.

Relationships with animals

The animals portrayed are those humans find impressive in terms of size, physical strength, odor, movements and secretive silence; but at the same time animals are troubling in their attachments, their instincts, their intelligence and cunning. Thus an anonymous engraver was moved by the sub-tlety of animals' sexual life to undertake the "lions in love" series in the La Vache Cave (Ariège, France), as was the painter of Font de Gaume (Dordogne) in his rendering of a reindeer couple: the female knees before the male with his majestic antlers, while he leans down to lick her forehead. This panel, presenting its animals according to the artistic conventions of the Magdalenian period of 14,000 years ago (two colors, tapered legs, small heads) captures the notion of loving tenderness with great accuracy and universality.

A humble witness to life, his own and that of hunted and thus sacrificed animals, the hunter relates in his illustrated narratives his encounters with the animal kingdom, with inarticulate beings who are nonetheless the possessors of magical powers, keepers of the secrets of the forest and the personification of the invisible forces of nature. Among the Chors people of Siberia, there exists an intimate, ritualized relationship between man and animal. The hunter addresses a reindeer, seeking to begin negotiations with an offering of gifts:

> "O Reindeer
> Proud creature of the earth
> Long of leg
> Large of ear
> Hair bristling on the neck
> Do not flee at my approach
> I bring leather for your shoes
> I bring moss to make wicks
> Come then without trembling
> Come to me
> Come."

The old hunter continues to intone his prayer, now addressing the bow laid on his knees and asking it to be a faithful intermediary between himself and the reindeer that has agreed to offer itself as a sacrifice. And to avoid deforming the natural order with this sacrifice, the hunter must make up for the loss by offering gifts to the spirit of the forest, the bear:

> "Spirit, master of the dark rich forest,
> Old Bai Brylakh!
> A rich feast has been made ready
> An enormous table covered with pure yellow food
> I am come to call—to beseech
> Glance this way and smile!"—

> Eveline Lot Falk, 1953

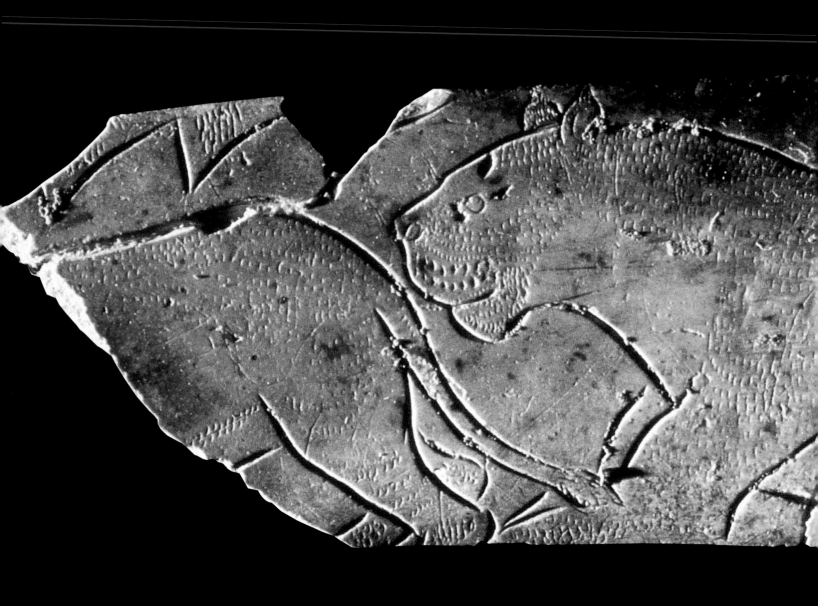

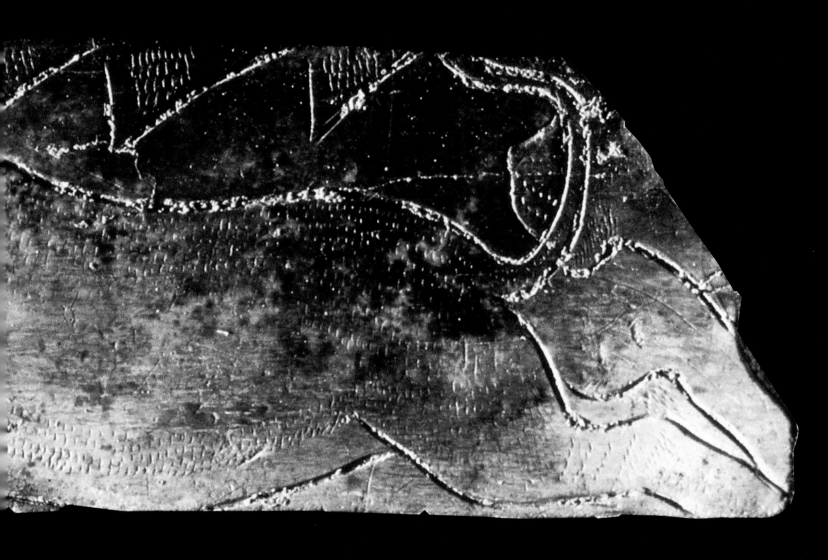

The lions frieze

This bone plaquette 13 cm long
was found in the La Vache Cave
at Alliat (Ariège, France) and
illustrates the movement of
leaping wild animals. The first
animal on the left, shown only by
its hindquarters, has drawn up its
back legs and flattened its tail,
ready to spring. The second,
completely visible, is at full
stretch, neck and head extended,
tail up and paws out. The head
of a third animal appears on
the right. Lions were fearsome
creatures for prehistoric people
and one of the first known
figurines, from Hohlenstein-Stadel
in Germany, is that of
a lion-man (p. 55).

Musée des Antiquités nationales,
Saint-Germain-en-Laye, France

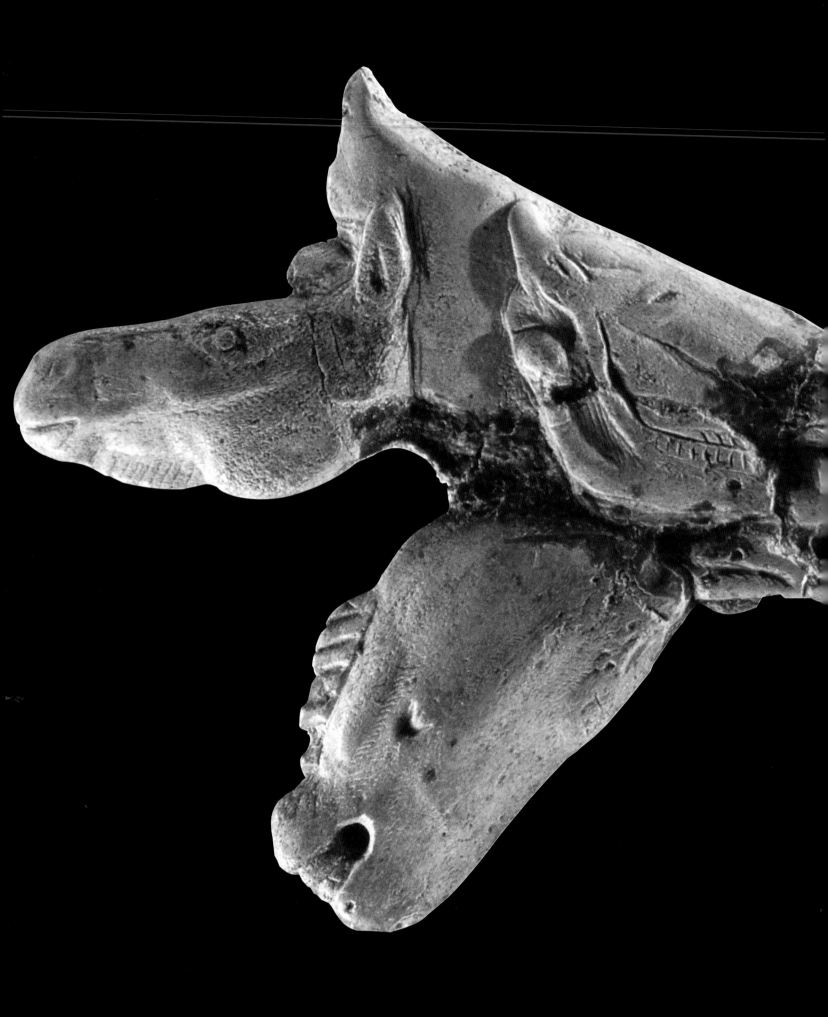

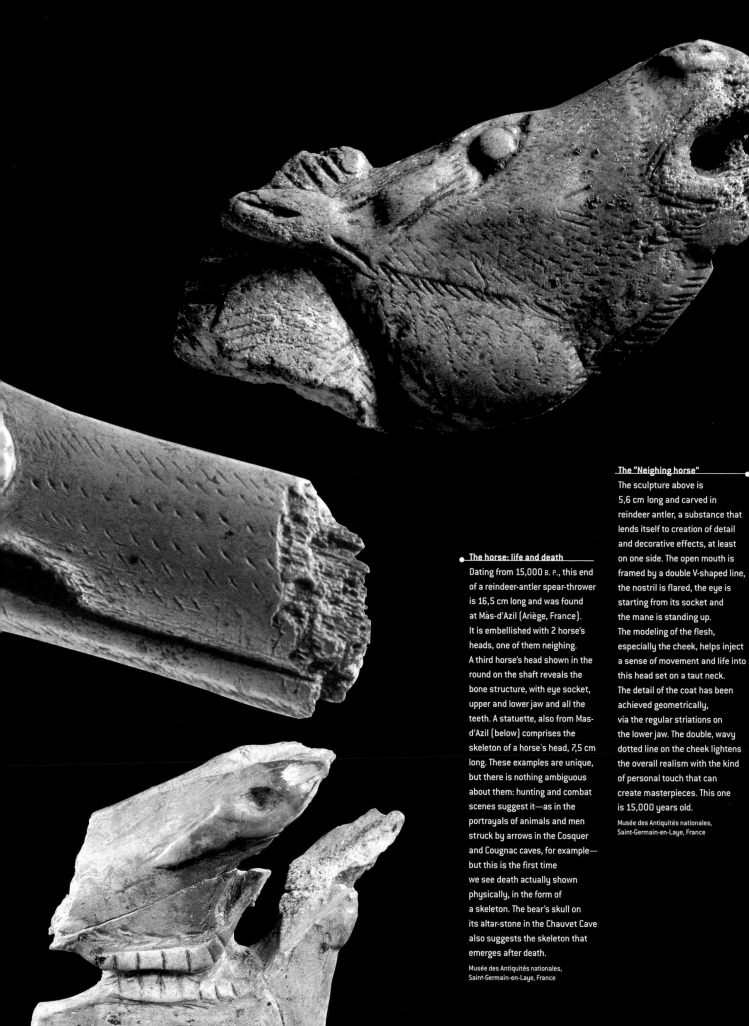

The "Neighing horse"

The sculpture above is
5,6 cm long and carved in
reindeer antler, a substance that
lends itself to creation of detail
and decorative effects, at least
on one side. The open mouth is
framed by a double V-shaped line,
the nostril is flared, the eye is
starting from its socket and
the mane is standing up.
The modeling of the flesh,
especially the cheek, helps inject
a sense of movement and life into
this head set on a taut neck.
The detail of the coat has been
achieved geometrically,
via the regular striations on
the lower jaw. The double, wavy
dotted line on the cheek lightens
the overall realism with the kind
of personal touch that can
create masterpieces. This one
is 15,000 years old.

Musée des Antiquités nationales,
Saint-Germain-en-Laye, France

The horse: life and death

Dating from 15,000 B. P., this end
of a reindeer-antler spear-thrower
is 16,5 cm long and was found
at Mas-d'Azil (Ariège, France).
It is embellished with 2 horse's
heads, one of them neighing.
A third horse's head shown in the
round on the shaft reveals the
bone structure, with eye socket,
upper and lower jaw and all the
teeth. A statuette, also from Mas-
d'Azil (below) comprises the
skeleton of a horse's head, 7,5 cm
long. These examples are unique,
but there is nothing ambiguous
about them: hunting and combat
scenes suggest it—as in the
portrayals of animals and men
struck by arrows in the Cosquer
and Cougnac caves, for example—
but this is the first time
we see death actually shown
physically, in the form of
a skeleton. The bear's skull on
its altar-stone in the Chauvet Cave
also suggests the skeleton that
emerges after death.

Musée des Antiquités nationales,
Saint-Germain-en-Laye, France

Thus the Chors hunter speaks directly to the life force of the forest, moved by a sentiment of the sacred founded on what is permitted and what is forbidden. This Siberian conception of nature involves a hierarchy of animals ready to accept human company—hunters to one side, women to the other —on condition that people respect the rituals, the code of right conduct that alone can avoid uncontrolled destruction and death. In this it resembles what we have glimpsed of the Paleolithic concept of nature as symbolized by animals. The obsessive love the hunter projects onto his prey includes the chance of continued life when the target is missed, but above all the promise of a supernatural existence for the spirit of the sacrificed animal. Thus the prey collaborates in his destiny of everlasting life, but because he has caused the animal's earthly death, the hunter must demand pardon of a prey entitled to feel real animosity. The many traces of animal cults are marked not only by this ritual of pardon as addressed to the hunted creature, but also to the king of the forest, the bear in some cases.

Evidence for the bear skull cult goes back to the Mousterian (80,000-35,000 B. P.). In the Drachenloch Cave in the Swiss Alps six bear skulls have been grouped together. Others are carefully arranged in the Bavarian cave of Petershöhle, near Velden, in the Austrian caves of Drachenhöhle, near Mixintz, and Salzhofen, and in the Grotte des Furtins between Mâcon and Cluny in eastern France. In the decorated Aurignacian Grotte Chauvet (Ardèche, France), a bear's skull is set on a block of stone, as if on an altar,

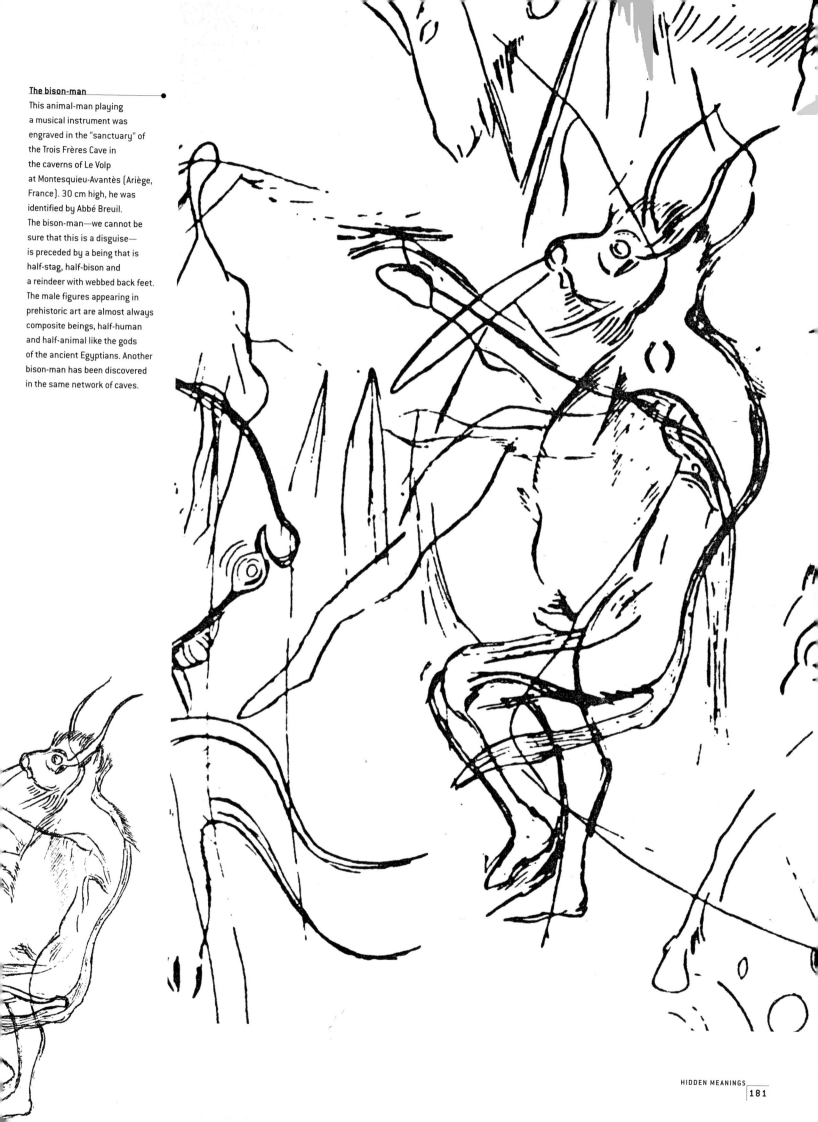

The bison-man

This animal-man playing
a musical instrument was
engraved in the "sanctuary" of
the Trois Frères Cave in
the caverns of Le Volp
at Montesquieu-Avantès (Ariège,
France). 30 cm high, he was
identified by Abbé Breuil.
The bison-man—we cannot be
sure that this is a disguise—
is preceded by a being that is
half-stag, half-bison and
a reindeer with webbed back feet.
The male figures appearing in
prehistoric art are almost always
composite beings, half-human
and half-animal like the gods
of the ancient Egyptians. Another
bison-man has been discovered
in the same network of caves.

and surrounded by others, now fused into the layer of calcite. A connection has been seen between these remains and the twelve red profiles of bears to be found in the same cave.

Animal hierarchy is a perceptible feature. It has been observed that in the oldest caves such as Chauvet for example, some 60% of the painted or engraved animals are fearsome and dangerous: lion, rhinoceros, aurochs, mammoth, bear, etc. The remainder create a less aggressive atmosphere.

The animal cult appears in another form on grave sites. Not only do animals provide the material for the personal ornamentation, tools and weapons encountered in human graves, they may themselves be the focus of ritual burials. The earliest known example is that of the Mousterian cave of Régourdou in the Dordogne (80,000 B. P.), where a Neanderthal grave seems to have been set next to a kind of stone chest; covered with a large slab, the latter contains the carefully (but not anatomically) arranged bones of a brown bear. A blue fox found at Malta, in Siberia, has doubtless been given a ritual burial, a sign of respect that tallies with extensive use of this animal's teeth in prehistoric jewelry. At Eliseevitchi in Russia, a long, buried corridor lined with mammoth shoulder blades and pelvises leads to an enclosure made of mammoth skulls; it would seem that the remains of this animal were used both for practical purposes and as reminders of a respected, venerated species. Accumulations of the bones of a specific animal have also been interpreted as signs of large-scale sacrifices: Arnvrosievka, in the Ukraine, is home to an ossuary containing the remains of some thousand bison, slaughtered and piled up without the skin or the meat having been taken. A possible link has been seen between this site and the Roche de Solutré (Saône-et-Loire, France), a rocky outcrop at whose foot were found the bones of thousands of horses, although here the flesh had apparently been removed and eaten.

The sacrifice (death, that is to say) is evoked by an astonishing reindeer horn fragment, probably from a spear-thrower, found in the entry to Mas-d'Azil (Ariège, France); it is decorated with horses' heads, of which the middle one has the flesh stripped off. This graphic contrast between the animal's two physical states—living and reduced to bare bones—is far from trivial: together with another sculpture from the same site this work gives the horse its full metaphysical status.

Animal-men

An outstanding feature of decorated Paleolithic caves is the presentation of composite figures combining a human lower half, feet, legs and a (sometimes erect) penis—with an upper part comprising the head and forequarters of a bison or deer. Perceiving the upper section as a mask, Abbé Breuil called these anthropomorphic figures "sorcerers", while their composite appearance and odd postures have led J. Clottes to interpret them as "shamans". Yet they may also be considered as creatures—imaginary beings—in their own right and not as disguised or transformed humans. "Bison-men" are quite numerous, the oldest of them probably being the one from Chauvet, painted in black on a hanging piece of rock, with its head tilted forward. Others have been identified at El Castillo (Spain) and Trois Frères. At Gabillou in the Dordogne, two "bull-men" are clearly engraved into the rock. Arguments have been put forward in favor of seeing the stylized human heads of certain anthropomorphic figures such as the painted man in the pit at Lascaux, or the incised silhouettes at Altamira and Addaura

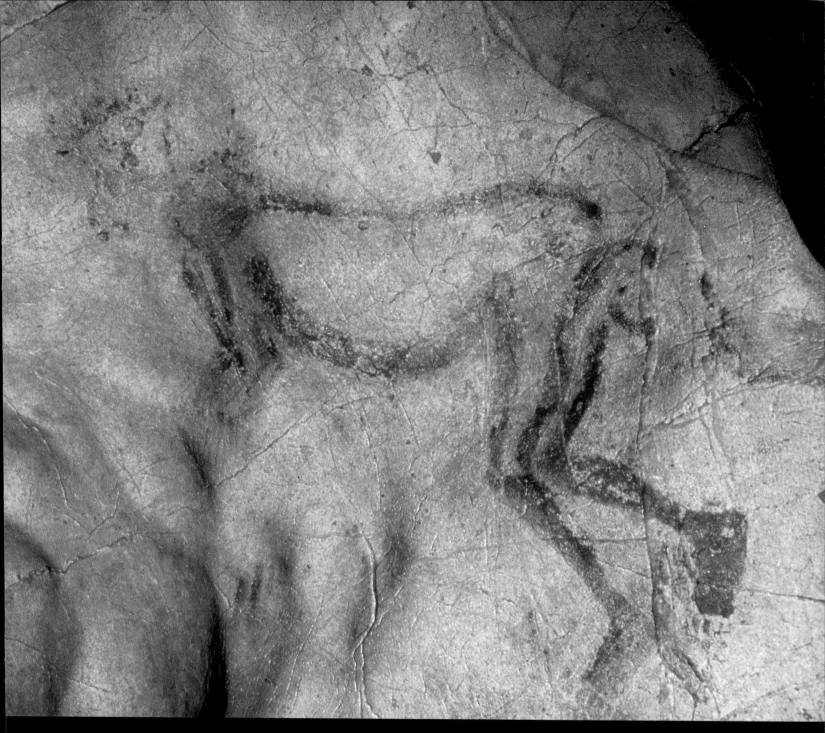

The stag-man or sorcerer

This humanlike figure, with its head obliterated and wearing deer antlers, has adopted a quadruped posture leaving its sexual organs clearly visible beneath a long, somewhat equine-looking tail. Known as "the sorcerer", this strange, composite figure plays a significant part in the Trois Frères Cave at Montesquieu-Avantès (Ariège, France). However, comparison with findings in other prehistoric art centers would lead us to believe that such figures are neither sorcerers nor shamans, but imaginary beings with their own distinct identity. They are not wearing masks or disguises; they are composite, semi-divine creatures.

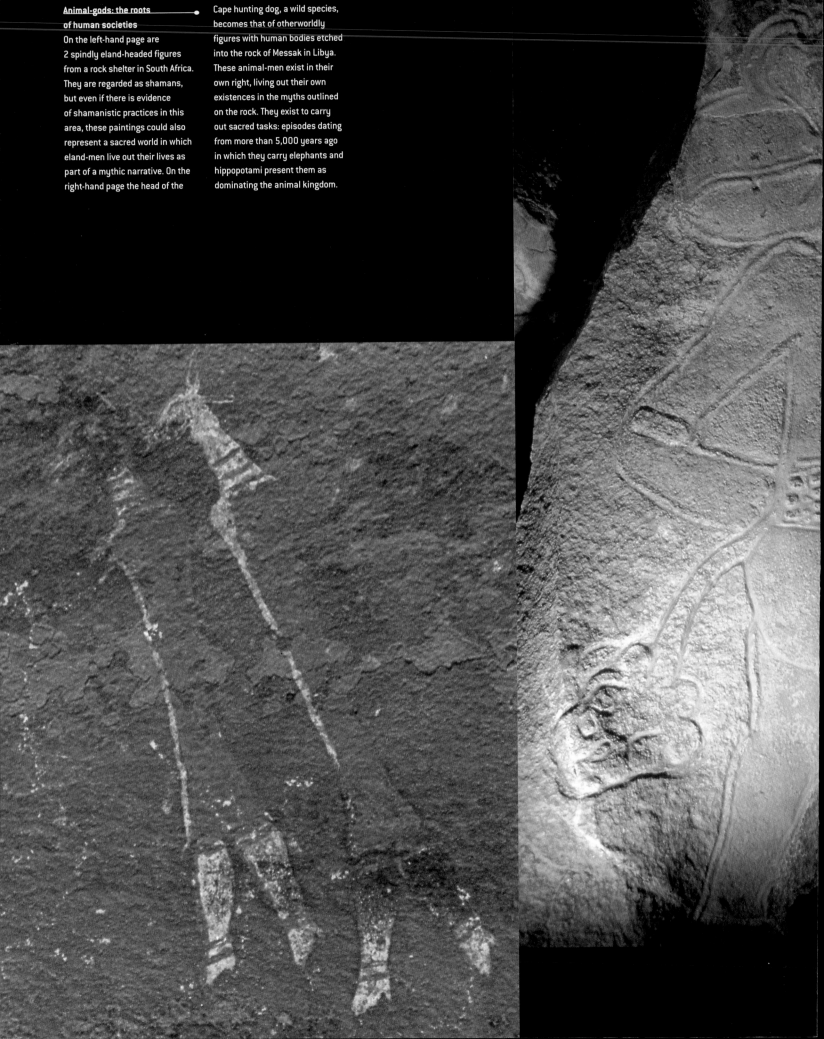

Animal-gods: the roots
of human societies

On the left-hand page are
2 spindly eland-headed figures
from a rock shelter in South Africa.
They are regarded as shamans,
but even if there is evidence
of shamanistic practices in this
area, these paintings could also
represent a sacred world in which
eland-men live out their lives as
part of a mythic narrative. On the
right-hand page the head of the
Cape hunting dog, a wild species,
becomes that of otherworldly
figures with human bodies etched
into the rock of Messak in Libya.
These animal-men exist in their
own right, living out their own
existences in the myths outlined
on the rock. They exist to carry
out sacred tasks: episodes dating
from more than 5,000 years ago
in which they carry elephants and
hippopotami present them as
dominating the animal kingdom.

(Sicily), as "bird-head men", but only the stylization justifies this. By contrast, the composite character of the painted "horned god" at Trois Frères is unequivocal: possessing a human beard, legs and feet, he has the antlers and ears of a deer, the face of an owl, a horselike tail and the sexual organs of a big cat. In Western Paleolithic art animal-headed men are mainly found in painted and engraved caves. Portable art examples are very much the exception, one being the humanlike figurine with a lion's head from Hohlenstein-Stadel in Germany; dated to the Aurignacian (c. 32,000 B. P.), this is one of the oldest of all known statuettes.

Animal-men, which are not to be confused with figures wearing masks, occur in many parietal art sites around the world, particularly interesting examples being those from Messak, in Libya, in which two categories are clearly evident (Le Quellec, 1998): among the thousands of pecked drawings of animals, Le Quellec has singled out clearly drawn figures of male humans, running or brandishing bows and wearing a bull-like mask in the form of a headdress attached to the top of the skull. Another figure is wearing an elephant-head mask, holding it in place with his hand, while other masks have the shape of a rhinoceros head. In every one of these two hundred cases, the animal head is clearly separate from the human head, the latter attached by its neck to a body in a lopsided dancing posture. By contrast the "theranthropes" or animal-men, purely imaginary mythical beings, have a human body and the head of an animal, like the jackal-men identified at In Habeter: one of them is carrying a bovine on its shoulders, while the other is dragging a rhinoceros; their strength is superhuman and they look like surrealist "masters of the wild beasts". The one hundred and forty such dog-headed theranthropes so far found express the imaginary and symbolic relationships between man and animal rather than any hunting techniques. The animals they carry or with whom they are associated cover the entire bestiary including, apart from those already mentioned, the giraffe, antelope, aurochs, ostrich, lion and donkey. Some twenty of these dog-headed theranthropes are brandishing axes and twelve of them hold daggers. They are openly aggressive towards the rhinoceros, one of which is shown sacrificed and decapitated. These creatures bring together the hunt and death: they wear pendants of rhinoceros and aurochs heads, trophies taken from animals of secondary importance. One of the Imrâwen theranthropes shown in association with a rhinoceros is mounted on an elephant: the relationship between them has none of the aggressiveness shown towards the rhinoceros, being unashamedly amorous in a totally imaginary mythic context.

It would seem that a zoomorphic age preceded the anthropomorphic period dominated by "God become Man". The universe of prehistoric art belongs mainly to this first period, as that of ancient Egypt continued to, the animal being at the root of powerful religious urges in a world still close to untamed nature.

THE HUMAN IMAGE:
SEX AND IMAGINATION

The human image is not always presented explicitly, for it can merge into composite, imaginary figures in the case of men and extreme stylization for women. Another abstract manner of suggesting a human being is to present a meaningful physical aspect of it: the hand, vulva and phallus in the Aurignacian or the face alone in the Magdalenian, although mention should also be made of the two abnormally long arms etched into a shoulder blade at Laugerie Basse (Dordogne). A further feature of Aurignacian female figures, whether sculpted or incised, is the frequent absence of the head, arms and feet; this is true of the Upper Paleolithic as a whole. The stylistic criteria applied to expressing the idea of human beings (men, women or, exceptionally, children) emphasize the abstraction of bodies for which clothing is rare and nakedness the rule; the "anorak woman" at Gabillou and a statuette from Malta (Siberia) are rare exceptions. As for the portraits, like those from La Marche, certain realistic details might give the impression of sketches taken from life; but in reality what we have is an astonishing Daumier-style gallery of the human comedy, caricatures whose basic traits express the variety of life rather than social and individual observation.

The Paleolithic treatment of the human image is also apparent in the other prehistoric art forms to be found around the world; as such it provides a clearer idea of the way the human being is split in the course of its transformation into a human image.

Human sexuality plays a fundamental part in the emergence of esthetic creativity. Drawn or sculpted, woman is approached differently from man, the images of each revealing a close concern whose expression varies from one period or type of site to another. The cultural variants in the expression of human sexuality possess a geographical and often regional significance. Thus the vulvar designs deeply incised into, at least fifty blocks of stone, are concentrated in shelters in the Dordogne whose use dates back to the Aurignacian. By contrast, a statuette and a sculptured plaquette of the same period, but from southern Germany and Austria respectively, show a man with a lion's head and another with a catlike tail. The sexual organs are not indicated. Thus in the first case female sexuality is openly indicated, while in the second the emphasis is on non-sexual males.

For the subsequent Gravettian period, inhabited sites from Siberia to the Pyrenees have yielded more than one hundred and fifty figurines representing the naked female body but, with a few uncertain exceptions, no male images whatsoever. This presence of exclusively female figures presented in all their nakedness generates a natural, more reassuring and more triumphant sexuality of the kind inherent in the Laussel "lady with a horn", a veritable prehistoric Madonna.

While explicit depictions of the vulva are common in the Pyrenean caves of the Magdalenian period, the opposite is true of the male sex organs. This led Vialou to wonder whether there might not be a relationship between the natural setting—the cave as womb—and the idea of the female sex organs, between the notion of a place of impregnation by hunter and animal and the birth of the magical power of the image. In these caves various crevices and protuberances have been singled out and emphasized by the addition of ocher

The "Venuses" of Angles-sur-l'Anglin
2 female figures are presented here, a third being situated further to the right. These sculptures play a central part in the Roc-aux-Sorciers frieze at Angles-sur-l'Anglin (Vienne, France) and are dated to 14,160 ± 80 B. P. These bodies have never had an upper part. Some commentators feel that the first woman, 90 cm tall and situated on the left, is not to be seen as pregnant; the second, on the right, measures 60 cm and shows signs of pregnancy in the shape of her upper abdomen. The third, not seen here, is thought to have recently given birth. At Angles-sur-l'Anglin the question of human birth seems to be addressed directly, with no particular story attached to it.

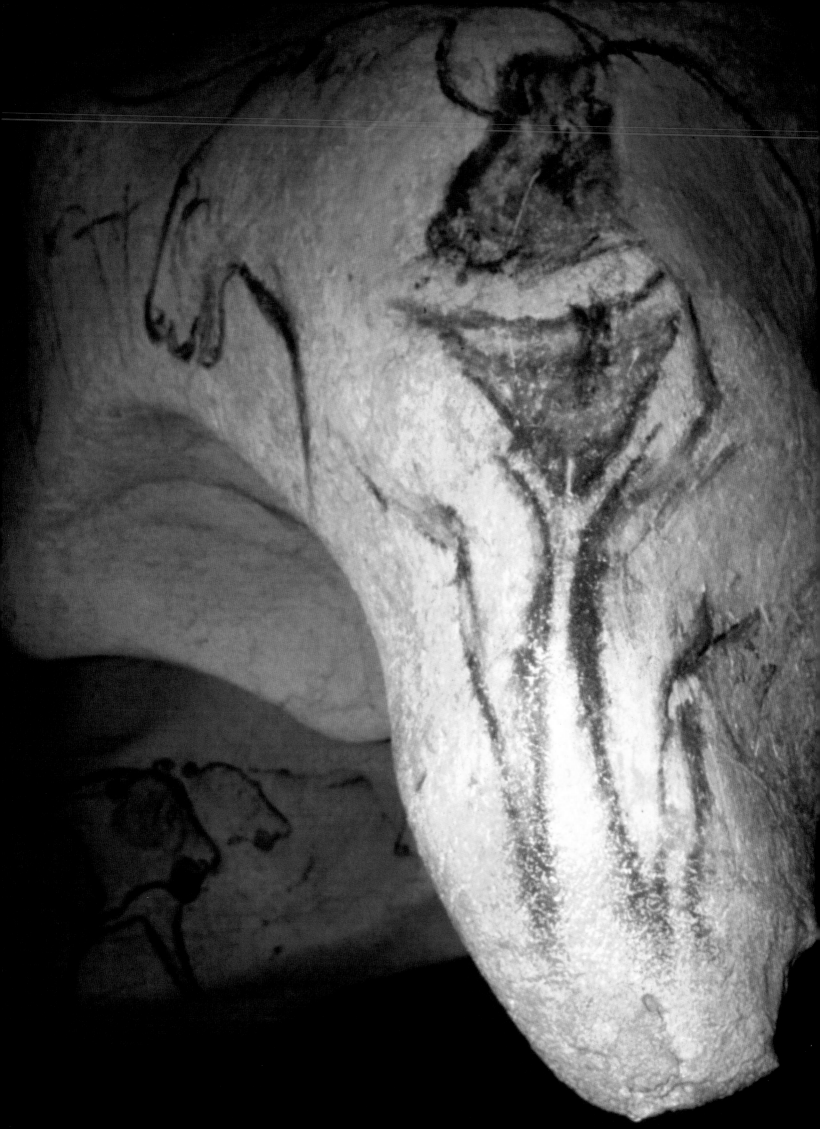

The Chauvet Minotaur

Woman expressed by the lower part of her body—the sex organs and legs—and man, represented by a human body and hand combined with the head of a bison, are brought together on a hanging piece of rock in the Chauvet Cave (Ardèche, France), in use between 32,410 ± 720 and 30,340 ± 570 B. P. In the background a lion is also taking part in the encounter. If this is in fact a vision of the sexual relationship and its role in childbirth, it may be connected to the more pared-down, realistic version from Angles-sur-l'Anglin, carved 16,000 years later.

Acknowledging sexuality

The male and female sex organs are also represented among the portable art objects to be found outside the caves. The Venus of Montpazier in Dordogne, France, picked up in a ploughed field in 1970, is 5,5 cm high and in a classical style that sets it with similar statuettes dating from 25,000 – 22,000 years ago. The vulva is particularly prominent. Another example of the representation of human sexual organs is this fragment from Gorge d'Enfer at Eyzies in Dordogne, France: 9,5 cm wide, it is the end of a pierced reindeer-antler rod and is embellished with 2 lateral compositions showing phalluses.

Musée des Antiquités nationales, Saint-Germain-en-Laye, France

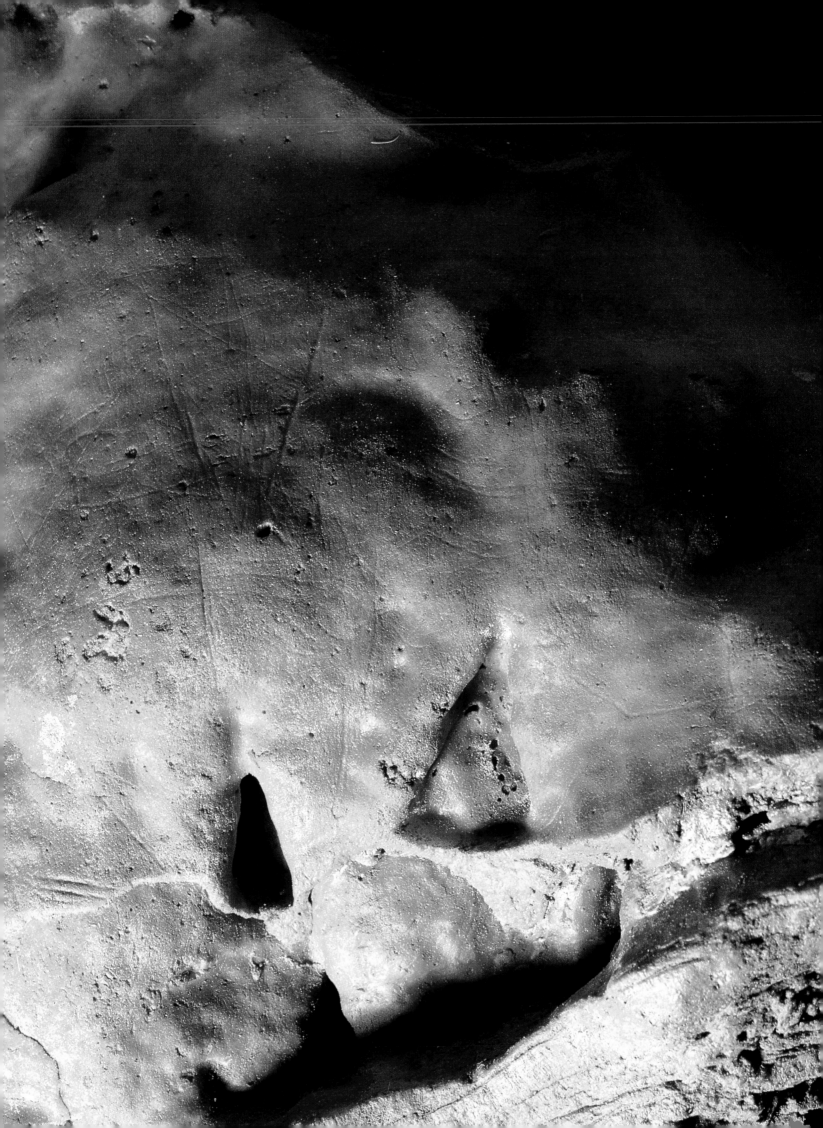

In the Guy Martin cave network at Lussac-les-Châteaux (Vienne, France), recent discoveries include 2 fissures in the rock embellished with engravings to resemble a pubis; nearby, 3 vulvas have been drawn over an area 22 cm wide, the one to the right including a freshly-emerged baby with a big head and tiny, still-folded legs and arms. The interpretation of this "obstetrical" scene—one far from easy to decipher—is the work of Jean Airvaux. It indicates that for the period 18,000 – 12,000 B. P. at least, the function of the vulva was seen as that of rendering life to small human beings.

or engravings: at Font de Gaume (Dordogne) a cleft is outlined in red, while in the neighboring Comarque Cave similar fissures have had their shape modified; the caves of Tito Bustillo and El Castillo in the Asturias, in Spain, both contain red-painted vulvas and at Bédeilhac (Ariège, France) a vulva has been modeled in the clay of the cave floor. On the other hand, the engraved phalluses at Fronsac are much less visible and at Portel (Ariège) a single outcrop has served as a phallic point of departure for the drawing of a man.

Unlike cave art, in which representations of the vulva are clearly dominant, Magdalenian portable art from cave entries and shelters is rich in phalluses sculpted from or engraved on bones and reindeer antlers.

Images of entire, naked bodies from the same period also comprise a majority of women, although men do make an occasional appearance. Combarelles, Pech Merle, Faustin, Comarque and Gabillou are home to engraved or finger-drawn profiles of the female body, with or without a head and displaying exaggerated breasts and highly prominent buttocks. The few male figures found at Saint-Cirq, Sous Grand Lac, Lascaux and Hornos de la Peña have erect penises and clearly defined heads. At Altamira the men advance in procession.

The low reliefs of naturally lit areas, cave entrances and shelters under overhanging rocks portray naked women lying down in frankly sexual poses; the figure at La Madeleine is headless, like the engraving found in the depths of the cave of Gabillou, while Angles-sur-l'Anglin contains a repeated vertical image of a woman without head, arms and legs but possessing substantial breasts and thighs and a realistically rendered pubis. What might be called discreet pornography is not common, with copulation scenes being rare; one can be found on a Magdalenian plaquette from Enlène.

CONTINUITY:
LIFE AND DEATH

It would seem that the animal cult of the various phases of the Paleolithic consists of a ritual intended to maintain a sacred, natural balance between what is permitted and what is taboo or forbidden; the overall context is one of respect for the life force as embodied by an animal hierarchy symbolic of the natural order. This interpretation certainly clarifies the dramatic confrontation between man and bison in the pit at Lascaux and the implied notion of a continuity transcending the wounded, charging animal and the possible death of the hunter fallen on his back (but still with penis erect). Could we go even further, to the idea that the image actually ensures the continuity of a life mingled with the death demanded by the ritual? Can the image be seen as a metaphor, a visual resolution of apparent contradictions as fundamental as life and death, masculinity and femininity?

The funeral rites of the Paleolithic testify unequivocally to the existence of an authentically metaphysical surmounting of the trauma of death. It is particularly interesting that some of the blocks of stone used to seal the Neanderthal burial trenches at La Ferrassie bear cup marks regarded as among the oldest of all "artistic" manifestations. Is there a connection between the funeral rite and the act of artistic creation, with each ensuring continuing respect for a sacred order that is metaphysical and social on the one hand and psychological and natural on the other? In both cases death does not put a stop to an ongoing reality. The offerings placed in the graves and the way the latter are arranged would seem to indicate a perceived continuity between life and death. In artistic terms, however, the problem seems initially more complex. The quest for understanding begins with "destructions" and with simulated, drawn or physically real "executions". But what is actually going on here? The many examples of voluntary destruction of drawings and engravings may be symbolic; this would seem to be the message of the arrows drawn on the flanks of animals and the lumps of clay hurled at their profiles. Or they may be real, as in the scratching-out of images in the Cosquer Cave and the breaking of engraved plaquettes in the La Marche Cave at Lussac le Château (Vienne, France).

Two interpretations spring to mind, the first being that these "destructions" show that a given ritual has been taken to its conclusion; in this case what the modern observer perceives as lasting artistic value is in fact no more than the fossil relic of a gesture strictly limited to the duration of the rites. The second interpretation involves a comparison with funeral rites in which destruction

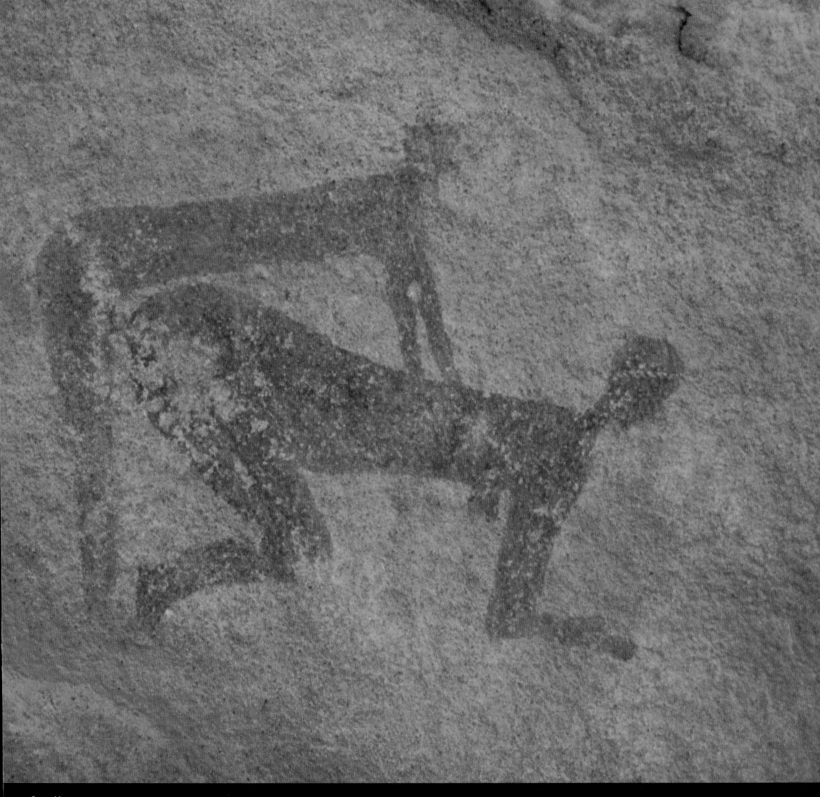

Sexual intercourse •
Copulation scenes are found in
several prehistoric art centers.
This painting from the
In Aouanrhet site in Algeria was
executed between 5,000
and 7,000 years ago.

Next page
Love prehistory style •
This other example of sexual
intercourse is more recent, dating
from 3,000 years ago and pecked
into a rock at Viteycke, near
Tanum in Sweden. Intercourse
between the man and woman is
taking place under the protection
of a large figure with penis erect
and brandishing an ax.

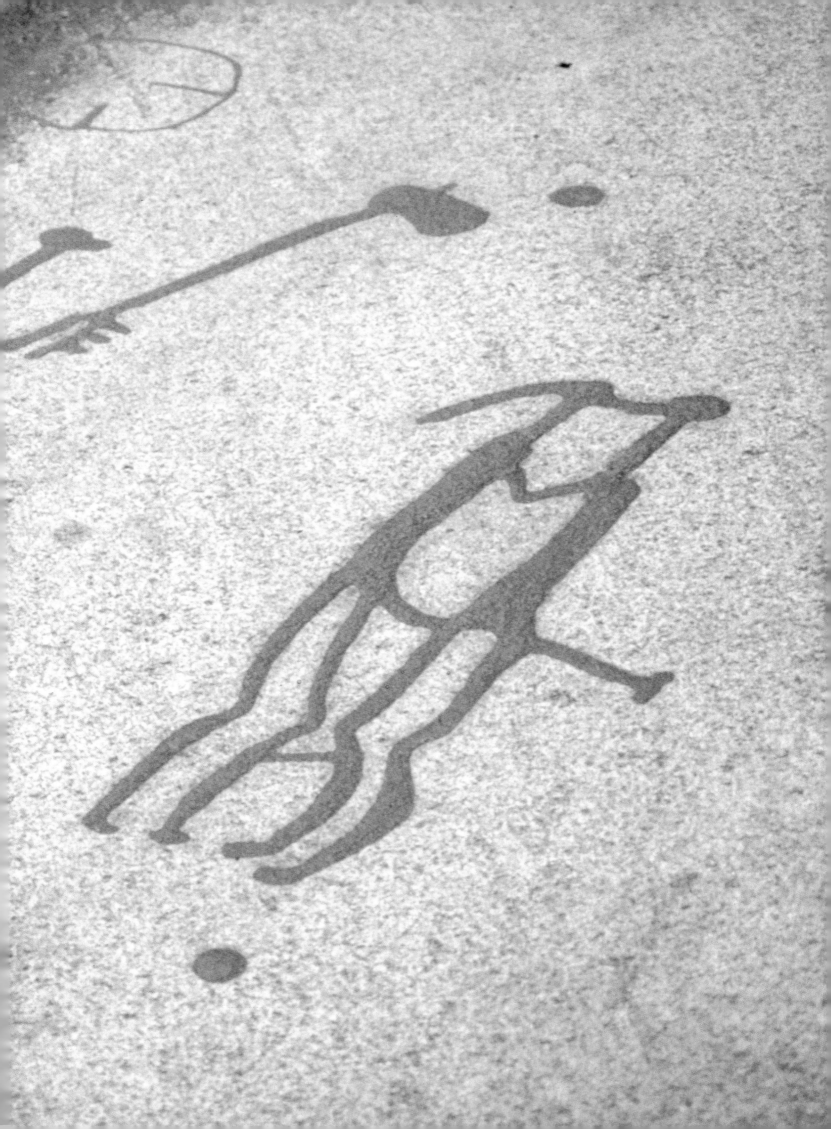

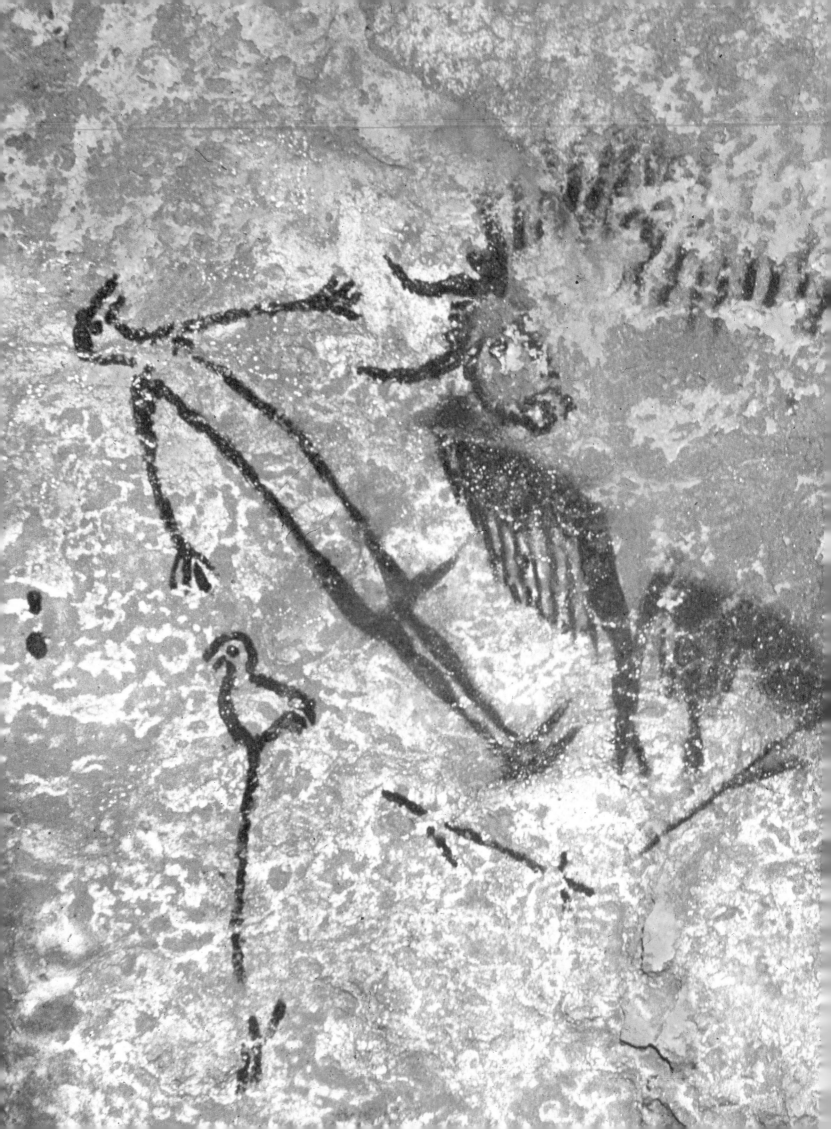

regenerates the supranatural vitality of the human beings and animals concerned. Seen in this light the destructive act becomes a sacrifice that restores the participants to life. The goal of prehistoric art, then, would be the staging of ephemeral events drawing their *mana* or efficacy from the ritual deed. The classic example of ritual's need for ephemeral art is the tracing of patterns in the sand by Australian Aboriginal people, an act of thanksgiving that enhances the moral presence of the spirits of the Dreamtime.

After surviving in many parts of the world for 40,000 years, prehistoric symbolic thought died out. However, in addition to the abundant archives left by the art of that period, there remain a number of ritual traditions that throw light on the revolution represented by the prehistoric image. In 1910 a group of Lapps came to place offerings on the paintings at Seitjaur on Kola island. In Bolivia the cave of Rio Pachene, decorated with engraved vulvas, is still visited by the Chimane Indians, who dance there. In the same region the Aymara people come to spread blood on the painting of a condor on the cliff face at the Korini 3 site, near Yaraque. On the other side of the planet, the great painted cliff face at Huashan, in China, was the scene in 1985 of offerings made to the water god, who had saved the lives of the two Zhuang brothers after a shipwreck. The brothers imitated the dance of the frog gods who intercede with the water god and the lightning divinity who controls the wind and rain. These examples provide an idea of how the people of the past venerated their sacred painted or engraved rock images; but they reveal very few of the secrets embodied by these gods and spirits, who remain in most cases anonymous, yet always powerful and terrifying.

● **Between life and death: man and bison at Lascaux**
The scene in the pit at Lascaux shows a dead man, but with penis erect, fallen on his back; his rod decorated with a bird has fallen from his hands. He is being charged by an enraged bison whose entrails are falling out through a javelin wound. Both figures embody signs of life and death, the clash between them demanding an enormous energy symbolized by the erection and the maddened charge. Endless stylistic means must be used, together with an infinity of artistic vocabularies, to ensure a viable future for the individual and the group. Prehistoric foundation narratives, often complicated and indecipherable—because they are secret—seem nonetheless to suggest verbal and artistic solutions to finding a road to future pardon: for the man who cannot think about and face death is responsible for it, except when he succeeds in linking it to birth.

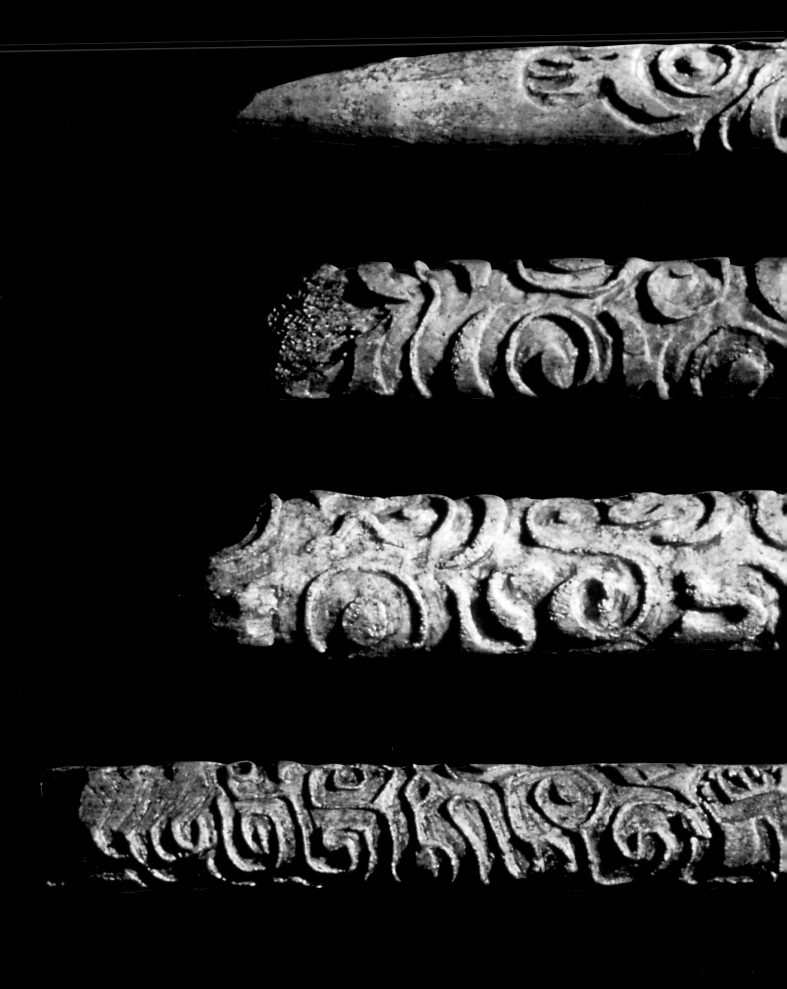

Dreams
and Beliefs
of an Emerging
Humanity

6

The different forms of prehistoric thought appeared only gradually. Technical thinking is reflected in tools dating back two and a half million years, while social and emotional thinking is evident in the remains of collective elephant hunts and the founding of the first households between a million and 400,000 years ago. Ancestral thinking with attested funeral rites goes back more than 100,000 years. Ornamentation of the living body became commoner and more varied 50,000 years ago, and with the development of graphic and sculptural means of expression, groups of modern humans invented a new form of interactive thought, using it to explore their endless stream of mental images in search of answers to questions and solutions to individual and collective anxieties. The surfaces chosen for artistic expression—primarily rock faces, it would seem—lent themselves to creative manipulation of shapes and ideas and provided a lasting means of instruction and transmission. The forty millennia of prehistoric art saw human groups, some of them very small, leave an impressive legacy—estimated at five hundred million items in all—of images and signs, messages engraved, pecked or painted on rocks, cave walls, cliff faces, chaotic screes, the slopes of sacred mountains, stone and bone plaquettes, standing stones and objects modeled in clay. This is what remains of the distant times of our ancestors, who also doubtless left us traces made in sand, wooden sculpture, esparto and bark objects, feathered ornamentation, songs, rhythms, and dances that gradually fragmented and finally vanished from human memory.

Yet the visible survivals remain impressive: as Picasso acknowledged, our anonymous ancestors brought a more than modern skillfulness to their work, creating not illustrated plates of animal anatomy, but entire imaginary worlds

as they adorned sanctuaries where the dramas of human and animal life were played out. The magic of the image functioned in circumstances that are still unclear; but the long tradition of prehistoric art stands as an effective expression of the needs of early societies throughout the world.

The list of theories about prehistoric art is a long one, embracing art for art's sake, hunting magic, willful injury, totemism, sites and sanctuaries founded on sexual dualism or image hierarchies, and the straightforward illustration of major or trivial events with a historic meaning. Yet no single theory can account for the nature and sheer variety of the art forms concerned.

However, prehistoric images and signs seem to be the product of a liberated creative imagination striving to portray supernatural worlds linked to oral traditions and non-verbal behaviors recalling the group's mythic and ritual origin. It is as if the appearance of a line or a patch of color and its miraculous self-transformation into a recognizable outline or sculpture were a kind of birth; as if this new presence could not remain inert when faced with human curiosity or some specific technical exigency on the part of its creator-provocateur.

The distinctive character of the arts of prehistory lies not only in their subject matter, but also in the cosmic force that imbues them. This is the result of a determined quest for the invisible and the supernatural of whose existence prehistoric peoples had such a potent intuition. The created image is the vehicle for an exploration charged with danger but vital to the life of the group: this is the great lesson passed on, albeit with a certain discretion, from those peoples to the societies of today. Dream beings are possessed of a mythic dimension and a sense of life that must be preserved as part of humanity's cultural heritage. Those early human beings shared with the animal kingdom the breath of life, a force more given to silence than to empty chatter, but supernatural in its scope. Animals and their secrets were closely observed, the better to reveal men and women not only in their vital, sexual dimension, but also in terms of their imaginary capacity, their exploration of areas of the unknown approached with a certain rationality via conscious, concretely expressed dreaming. This phase brought the worldwide revolution of recent prehistory and with it the birth of modern humanity.

Chronology

38,000 B. C. 18,000 B. C.

From 350,000 to 80,000 before the present	40,000 before the present	20,000 before the present
AFRICA		
SOUTHERN AFRICA		
Blombos Cave 77,000	**Border Cave** 38,500-37,000	**Apollo 28** 400-26 300 ± 400
Engraved red ocher pebbles		painted plaquettes
SAHARAN AFRICA		
EUROPE		
CENTRAL AND EASTERN EUROPE		
Bilzingsleben 350,000-230,000 **Bacho Kiro** 43,000	**Geissenklösterle** 36,000-30,000	**Kapova** 14,000
Incised bones (big cats?) ocher	sculpted plaquette	**Mézine** 15,000
Becov 150,000	**Vogelherd** 32,000-30,000	
ocher	statuettes	
	Hohlenstein-Stadel 32,000-30,000	
	Willendorf 32,000	
WESTERN EUROPE		
La Ferrassie 50,000-35,000	**El Conde, La Vina, Cueto de la Mina** 36 500	**Cosquer Cave** 19,200±200 18,010±190
Cup marks on blocks	major incisions	**Foz Côa** 18,000
	Chauvet Cave 32,410±720-30,340±570	**Lascaux** 17190±140-15116±900
	Laussel Shelter 28,000	**Altamira** 16,480±200-13,130±120
	Cosquer Cave 27,110±390	**Ste Eulalie** 15200±15100±270
	Gargas Cave 27,000	**Tito Bustillo** 14,350±320
	Arcy 26,700±410-24,660±330	**Covaciella** 14,260±130-14,060
	Pech Merle Cave 24,640±390-19,500	**Angles-sur-l'Anglin** 14,160±80
	Cougnac Cave 25,120±390-19,500±270	**Tuc-d'Audoubert, Enlène** 14,000
	Bidon Cave 21,650 ± 800	**Labastide** 14,260±440
		Niaux 13,850±150-12,890±16
		Cougnac 14,290±180-13,810±
		Fontanet 13,280±110
		Castillo 13,060±200-12,910±
		Le Portel 12,180±125-11,600 ±
		Mas-d'Azil 11,000
		Levanzo 11,500
ASIA		
SIBERIA		
	Tobalga	
	Buret and Malta 35,000	
NEAR EAST		
Qafzeh 100,000		
Pierced shell and ocher in grave		
INDIA AND THE FAR EAST		Chanderv
	Lohanda Nalla (India)	Kaaykunoiva 12,000 (Jap
INDONESIA-AUSTRALIA		
SOUTHERN AUSTRALIA		
Mallakusnge	**Carpenters Gap** 39,700-39,200 **Ewaninga**	
	Paranamitee 40,000	
AUSTRALIA: ARNHEM LAND		
	Wongewongen	
		18,000 marsupial
		15,000 Golben
		echidna
		dynamic style
AMERICA - OCEANIA		
SOUTH AMERICA		
	Pedra Furada (Brazil) 26,000-22,000	**Monte Alegre (Amazonia)**
		Toca do Baixao do Perna (Brazil)
NORTH AMERICA		
		Wyoming 18,000-11,000

All dates followed by ± have been obtained by the Carbon 14 method and match one or more phases of artistic activity. All other dates are archeological estimates.

ndewerk 10,000 **Megaliesberg** **San 500-350**
cised plaquettes paintings

Bubaline Capsians 8,000-6,000 bovids 5,000-4,000 equines 2,500-2,000 **Mali: Songo**
domestic 7,000 paintings
"roundheads" 7,000-5,000

Varna 6,500 **Zalavruga 4,000-2,500**

Spanish Levant 8,000 – 6,000 **Tanum (Scandinavia) 3,000**
paintings
Western megaliths 6,700-5,000
Gavrimis **Mont Bégo 5,000-4,000**
dolmen orné **Val Camonica 5,000-3,000**

Ust-Tuba II **Galitch**
Tchernovaia **Altai**

reybet (Syria)
icho **Catal Hüyük (Turkey)**
mbetka
henjo **Decan**
ro dolmens
an Shan (China) **Korea** dolmens **Japan** dolmens

Walbiri
Papunya
dreamtime beings

uarine period: fish
8,000-1,500
Dampier - Queensland - engravings Europeans

ui 12,000-6,000 rustic tradition 6,000-4,000 geometric tradition 3,000 **Easter Island**
togrosso **Calif Raton 5,290-4,845** **San Augustin**
ta Elena **Nazca**
Canada Mud Portage **Canzon Basin 5,000** **Agawa: Michupichu**
Mazama Ash 6,700

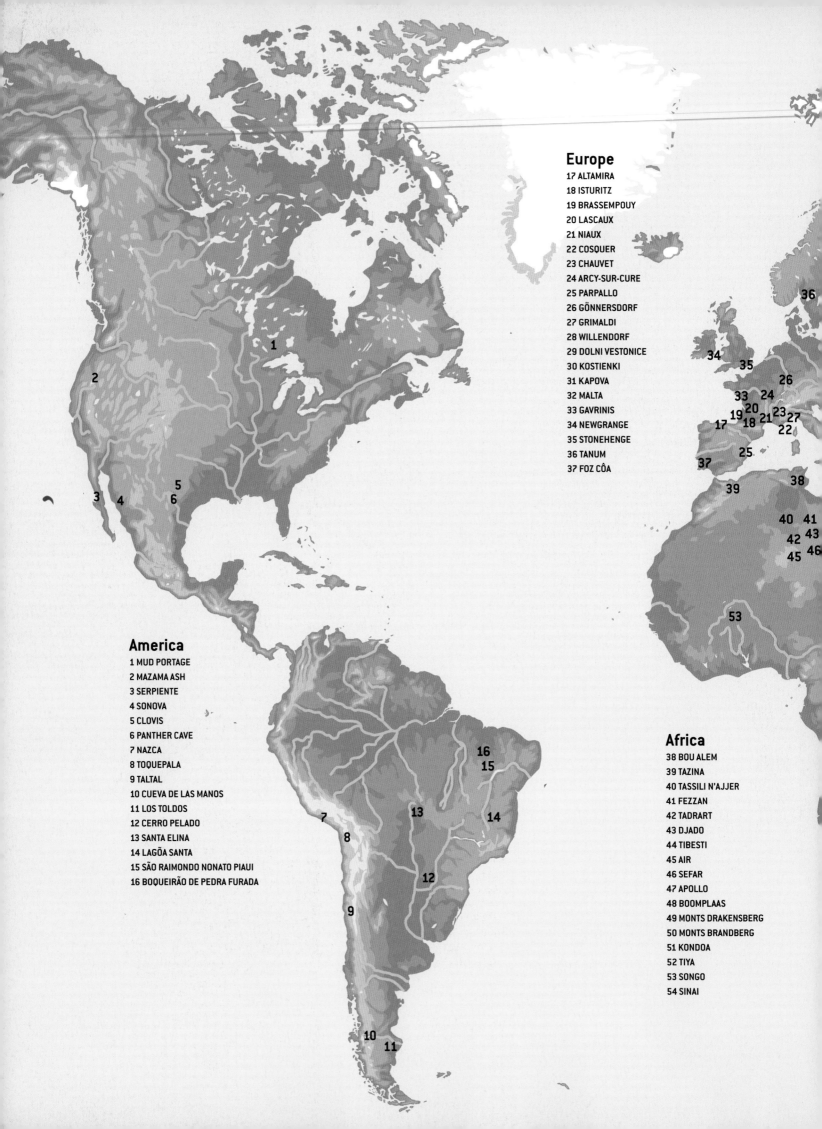

Europe

17 ALTAMIRA
18 ISTURITZ
19 BRASSEMPOUY
20 LASCAUX
21 NIAUX
22 COSQUER
23 CHAUVET
24 ARCY-SUR-CURE
25 PARPALLO
26 GÖNNERSDORF
27 GRIMALDI
28 WILLENDORF
29 DOLNI VESTONICE
30 KOSTIENKI
31 KAPOVA
32 MALTA
33 GAVRINIS
34 NEWGRANGE
35 STONEHENGE
36 TANUM
37 FOZ CÔA

America

1 MUD PORTAGE
2 MAZAMA ASH
3 SERPIENTE
4 SONOVA
5 CLOVIS
6 PANTHER CAVE
7 NAZCA
8 TOQUEPALA
9 TALTAL
10 CUEVA DE LAS MANOS
11 LOS TOLDOS
12 CERRO PELADO
13 SANTA ELINA
14 LAGÕA SANTA
15 SÃO RAIMONDO NONATO PIAUI
16 BOQUEIRÃO DE PEDRA FURADA

Africa

38 BOU ALEM
39 TAZINA
40 TASSILI N'AJJER
41 FEZZAN
42 TADRART
43 DJADO
44 TIBESTI
45 AIR
46 SEFAR
47 APOLLO
48 BOOMPLAAS
49 MONTS DRAKENSBERG
50 MONTS BRANDBERG
51 KONDOA
52 TIYA
53 SONGO
54 SINAI

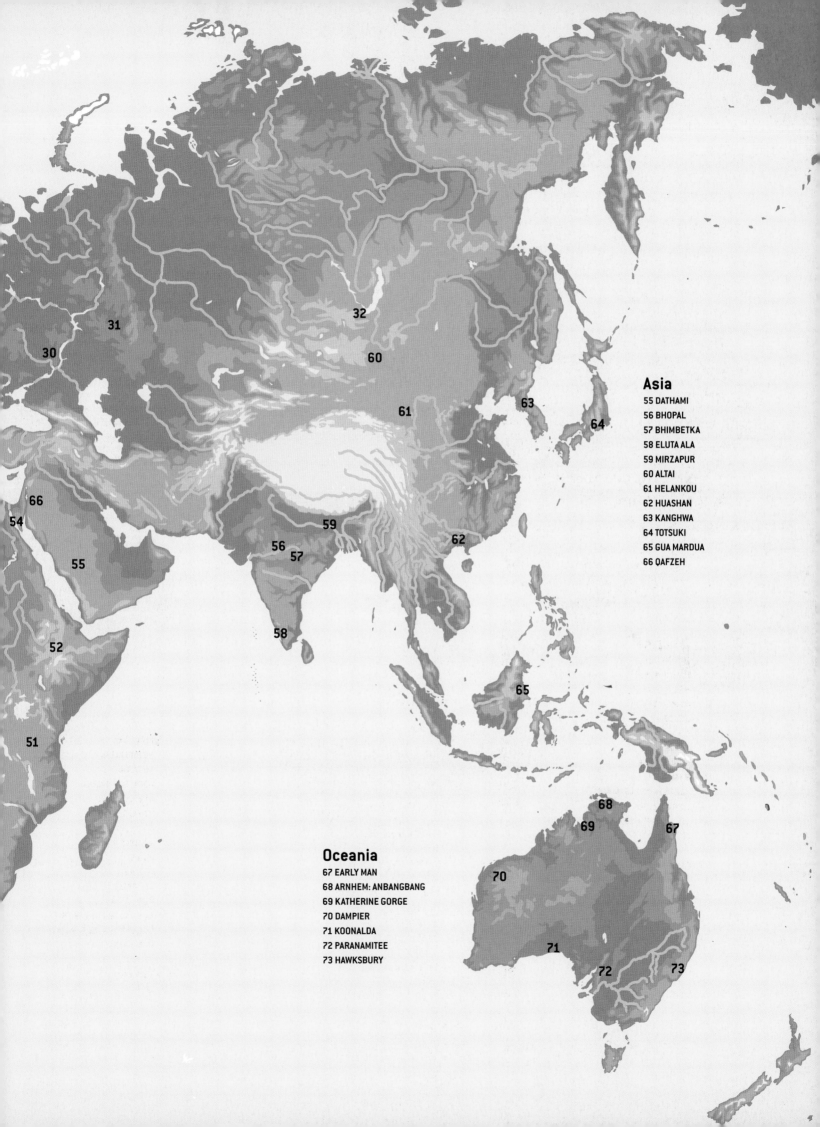

Asia
55 DATHAMI
56 BHOPAL
57 BHIMBETKA
58 ELUTA ALA
59 MIRZAPUR
60 ALTAI
61 HELANKOU
62 HUASHAN
63 KANGHWA
64 TOTSUKI
65 GUA MARDUA
66 QAFZEH

Oceania
67 EARLY MAN
68 ARNHEM: ANBANGBANG
69 KATHERINE GORGE
70 DAMPIER
71 KOONALDA
72 PARANAMITEE
73 HAWKSBURY

Bibliography

• Louis A. Allen, *Time before morning: Art and Myth of the Australian aborigines*, Thomas Crowell, 1975
• Paul G. Bahn, Jean Vertut, *Journey Through the Ice Age*, University of California Press, 2001
• Paul G. Bahn, *The Cambridge Illustrated History of Prehistoric Art*, Cambridge University Press, 1998
• Paul G. Bahn, Jean Vertut, *Images of the Ice Age*, Facts on File Inc, 1989
• Hans-George Bandi, *Art of the Stone Age*, Crown Publishers, 1979
• Hans-George Bandi, *Eskimo Prehistory*, University of Washington Press, 1969
• E. J. W. Barber, *Prehistoric Textiles*, Princeton University Press, 1992
• William K. Barnett, John W. Hoopes (eds.), *The Emergence of Pottery*, Smithsonian Institution Press, 1995
• Ariane Ruskin Batterberry, Arian Ruskin, *Prehistoric Art and Ancient Art of the Near East*, McGraw-Hill 1971
• Stan Beckensall, *British Prehistoric Rock Art*, Tempus, 2000
• Antonio Beltran (ed.) et al, *The Cave of Altamira*, Harry N. Abrams, 1999
• Magín Berenguer, *Prehistoric Cave Art in Northern Spain*, Asturias, Frente de Afirmación Hispanista, 1984
• Ronald Berndt (ed.) et al, *Aboriginal Australian Art*, New Holland/Struik, 1999
• Lewis R. Binford, *In Pursuit of the Past: Decoding the Archaeological Record*, Thames & Hudson Hardcover - May 1983
• Franz Boas, *Primitive Art*, Dover, 1986
• Richard Bradley, *The Significance of Monuments*, Routledge, 1998
• Martin Brennan, *The Stones of Time: Calendars, Sundials and Stone Chambers of Ancient Ireland*, Inner Traditions International, 1994
• Wally Caruana, *Aboriginal Art*, Thames & Hudson, 1993
• Roberto Carvalho De Magalhaes et al, *Art and Civilization: Ancient Prehistory*, NTC/Contemporary Publishing, 2000
• Chakravarty K. K., Bednarik R. G., *Indian Rock Art and its Global Context*, Motilal Banarsidass Publishers, Delhi, 1997
• George Chaloupka, *Journey in Time: the world's longest continuing art tradition: the 50,000 year story of the Australian aboriginal rock art*

of Arnhem land, Reed, Australia
• Jean-Marie Chauvet et al, *Dawn of Art: The Chauvet Cave: The Oldest Known Paintings in the World*, Harry N. Abrams, 1996
• C. Chippindale C., P.S.C. Tacon (eds), *The Archaeology of Rock Art*, Cambridge University Press, 1998
• Jean Clottes et al, *The Cave Beneath the Sea: Paleolithic Images at Cosquer* Harry N. Abrams, 1996
• Jean Clottes et al, *The Shamans of Prehistory: Trance and Magic in the Painted Caves*, Harry N. Abrams, 1998
• Margaret Conkey (ed.), *Beyond Art: Pleistocene Image and Symbol*, University of California Press, 1997
• David Coulson, Alec Campbell, *African Rock Art: Paintings and Engravings on Stone*, Harry N. Abrams, 2001
• Jo-Anne Birnie Danzker, *Dreamings = Tjukurrpa: Aboriginal art of the western desert*, Prestel Publishing, 1993
• Robert Edwards, Bruce Guering, *Aboriginal Bark Paintings*, Rigby, Adelaide, 1969
• Sheila M. Elsdon, *Later Prehistoric Pottery in England and Wales*, Shire, 1999
• Jesse Walter Fewkes, *Prehistoric Hopi Pottery Designs*, Dover, 1981
• J. Leslie Fitton, *Cycladic Art*, Harvard University Press, 1990
• J. Flood, *Rock Art of the Dreamtime. Images of Ancient Australia*, Angus and Robertson, Sydney, 1997
• R. B. Foote *Antiquities of South India*, Apt Books, 1986
• Julie E. Francis, Lawrence L. Loendorf, *Ancient Visions: Petroglyphs of the Wind River and Bighorn Country, Wyoming and Montana*, University of Utah Press, 2002
• Fraser J. G., *Totemism*, Edinburgh, 1887
• Peter Garlake *The Hunter's Vision: The Prehistoric Art of Zimbabwe*, University of Washington Press, 1995
• S. Giedion, *The eternal present: the beginnings of art*, Bollingen, 1962
• Marija Gimbutas, *The Language of the Goddess: Unearthing the Hidden Symbols of Western Civilization*, Thames & Hudson, 2001
• Marija Gimbutas, *The Civilization of the Goddess: the World of Old Europe*, Harper Collins, 1991
• E. Godden, J. Malnic, *Rock Paintings of Aboriginal Australia*,

Prometheus Books, 1982
• Mariana Gvozdover, Paul Bahn (eds.) *Art of the Mammoth Hunters*, Oxbow Books, 1995
• Thor Heyerdahl, *The Art of Easter Island*, Doubleday, 1976
• Peter J. Holliday *Narrative and Event in Ancient Art*, Cambridge University Press, 1994
• Bill Holm, *Northwest Coast Indian Art: An Analysis of Form*, University of Washington Press, 1965
• Sinclair Hood, *The Arts in Prehistoric Greece*, Yale University Press, 1992
• Henri J. Hugot et al, *Rock Art of the Sahara*, Vilo International, 2001
• Jennifer Isaacs, Reg Morrison, *Australia's Living Heritage: Arts of the Dreaming*, Australia in Print, 1989
• R. Townley Johnson, *Major Rock Paintings of Southern Africa: facsimile reproductions*, D. Phillip, 1980
• James D. Keyser, Michael A. Klasser, *Plains Indian Rock Art*, University of Washington Press, 2001
• Sylvia Kleinert (ed.), et al, *The Oxford Companion to Aboriginal Art and Culture*, Oxford University Press, 2000
• Robert Layton, *Australian Rock Art: A New Synthesis*, Cambridge University Press, 1993
• Mary Douglas Leakey, *Africa's Vanishing Art: The Rock Paintings of Tanzania*, Doubleday 1983
• D. Neil Lee, *Art on the Rocks of Southern Africa*, HarperCollins, 1975
• André Leroi-Gourhan, *Treasures of Prehistoric Art*, Harry N. Abrams, 1980
• André Leroi-Gourhan *The Dawn of European Art* Cambridge University Press, 1982
• J. David Lewis-Williams, *Images of Power: Understanding Bushman Rock Art*, Southern Book Publishers
• J. David Lewis-Williams, *Believing and Seeing: Symbolic Meanings in Southern San Rock Paintings*, Academic Press, 1981
• J. David Lewis-Williams, *A Cosmos In Stone: Interpreting Religion and Society Through Rock Art*, Rowman and Littlefield, 2002
• J. David Lewis-Williams, *Rock Art of Southern Africa*, Cambridge University Press, 1983
• J. David Lewis-Williams, *Discovering Southern African Rock Art*, D. Phillip, South Africa, 1990
• J. David Lewis-Williams, *Rock paintings of the Natal Drakensberg*, University of Natal Press, 1996
• Henri Lhote, *The Search for the Tassili Frescoes: the story of the prehistoric rock-paintings of the*

Sahara, Hutchinson, 1973
• A. Lommel, *The world of the Early Hunters*, Adams and Mackay, London, 1967
• Michel Lorblanchet, Paul Bahn (eds.), *Rock Art Studies, The Post-Stylistic Era, or Where Do We Go from Here?* Oxbow Monograph 35, Oxbow Books, Oxford, 1993
• Jean McMann *Riddles of the Stone Age*, Thames & Hudson, London, 1980
• Chris Mansell, *Ancient Rock Carvings from Great Britain and Ireland*, Wooden Books, 1997
• Alexander Marshack *The Roots of Civilization: The Cognitive Beginnings of Man's First Art, Symbol and Notation*, Moyer Bell, 1991
• Anatolii Ivanovich Martynov et al, *The Ancient Art of Northern Asia*, University of Illinois Press, 1991
• Yashodhar Mathpal, *Rock Art in Kumaon Himalaya*, South Asia Books, 1996
• Yashodhar Mathpal, *Prehistoric Rock Paintings of Bhimbetka, Central India* Humanities Press, 1996
• Jean-Pierre Mohen, *Megaliths: Stones of Memory*, Harry N. Abrams, London, 1999
• Sabra Moore, *Petroglyphs: Ancient Language/Sacred Art*, Clear Light, 1999
• Ramon Dacal Moure, Manuel Rivero De La Calle, *Art and Archaeology of Pre-Columbian Cuba*, University of Pittsburgh Press, 1997
• David Muench, Polly Schaafsma, *Images in Stone: Southwest Rock Art*, Browntrout, 1995
• Erwin Neumayer, *Lines of Stone: The Prehistoric Rock Art of India*, South Asia Books, 1993
• Michael Norris (ed.), *Greek Art from Prehistoric to Classical: A Resource for Educators*, Yale University Press, 2001
• Alexei Okladnikov, *Art of the Amur: Ancient Art of the Russian Far East* Outlet, 1983
• Dorothy Hinshaw Patent, *Mystery of the Lascaux Cave*, Marshall Cavendish, 1998
• Alex Patterson, *A Field Guide to Rock Art Symbols of the Greater Southwest*, Johnson Books, 1992
• James L. Pearson, *Shamanism and the Ancient Mind*, AltaMira, 2002
• Edward Peterson, Sheana C. Peterson, *The Message of Scotland's Symbol Stones*, PCD Ruthven Books, 1999
• Edward Peterson, Sheana C. Peterson, *Stone Age Alpha*,

PCD Ruthven Books, 1998
• John E. Pfeiffer, *The Creative Explosion: An Inquiry into the Origins of Art and Religion*, Harper & Row, 1982
• Robert Romano, Ravi Brooks *Stone Age Painting in India*, Yale University Press, 1976
• Mario Ruspoli, Yves Coppens, *The Cave of Lascaux: The Final Photographs*, Harry N. Abrams, 1987
• N. K. Sandars *Prehistoric Art in Europe*, Yale University Press, 1992
• Polly Schaafsma, *Rock Art in New Mexico*, University of New Mexico Press, 1975
• Polly Schaafsma, *Indian Rock Art of the Southwest*, University of New Mexico Press, 1986
• Ann Sieveking, *Cave Artists*, W. W. Norton & Co, 1979
• Ann Sieveking, *A catalogue of Palaeolithic Art in the British Museum*, Trustees of the British Museum, London, 1987
• Dennis Slifer, *Guide to Rock Art of the Utah Region: Sites with Public Access*, University of New Mexico Press, 2000
• Peter Stanbury et al, *A Field Guide to Aboriginal Rock Engravings: With Special Reference to Those Around Sydney*, Sydney University Press, 1991
• Jack Steinbring (ed.), *Rock Art Studies in the Americas*, Oxbow Books Paperback - December 1995
• Matthias Strecker, Paul Bahn (eds.), *Dating and the Earliest Known Rock Art* Oxbow Books, 1999
• Peter Sutton (ed.) et al, *Dreamings: The Art of Aboriginal Australia*, George Braziller, 1997
• Elizabeth Shee Twohig *Megalithic Art of Western Europe*, Clarendon Press, 1981
• Peter J. Ucko, *Paleolithic Cave Art*, McGraw-Hill, 1967
• Peter J. Ucko (ed.), *Form in Indigenous Art*, Australian Institute of Aboriginal Studies, Camberra, 1977
• Denis Vialou, *Prehistoric Art and Civilization*, Harry N. Abrams, 1998
• Elizabeth C. Walsh, *Easy Field Guide to Southwestern Petroglyphs*, Premier, 1995
• David S. Whitley, *A Guide to Rock Art Sites: Southern California and Southern Nevada*, Mountain Press, 1996
• David S. Whitley, *The Art of the Shaman: Rock Art of California*, University of Utah Press, 2000
• A. R. Willcox, *The Rock Art of Africa*, Holmes and Meier, 1984

Photographic credits

Printed by EuroGrafica
Vicenza - Italy
September 2002